THIS LAND

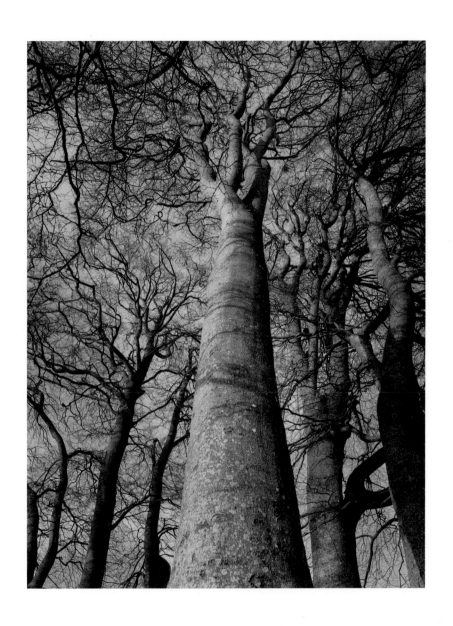

This book

is dedicated to

Jenny and Val,

as are we

THIS LAND

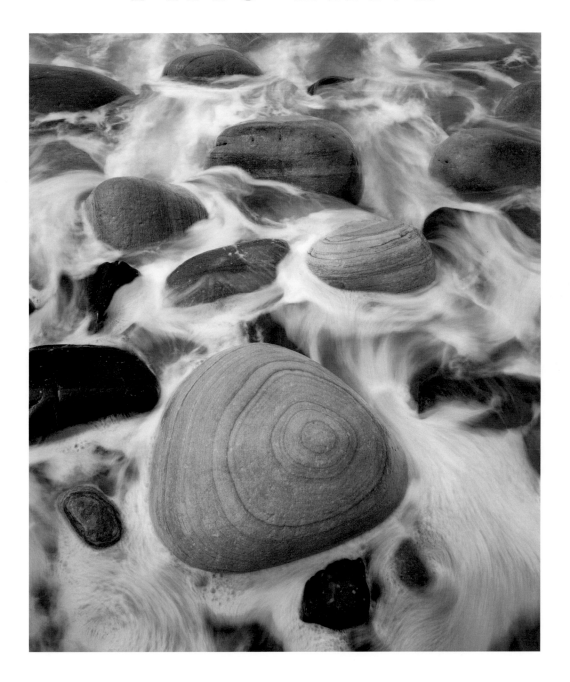

JOE CORNISH & ROLY SMITH

CONTENTS

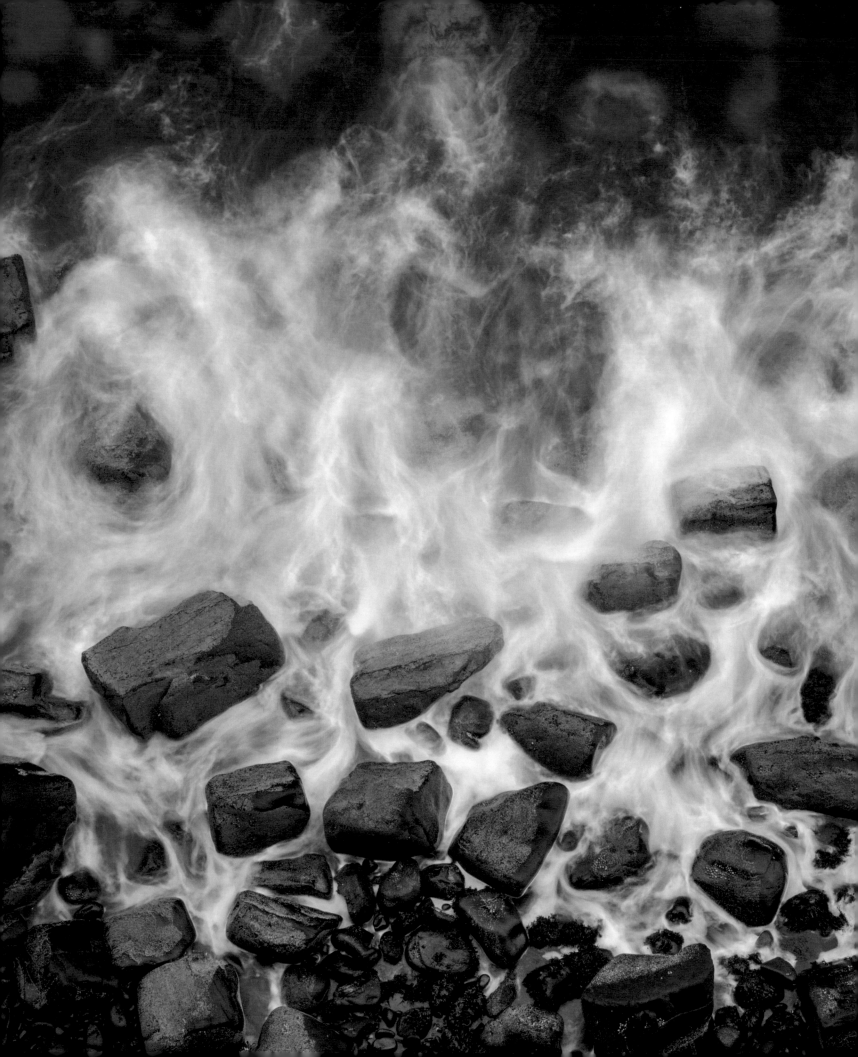

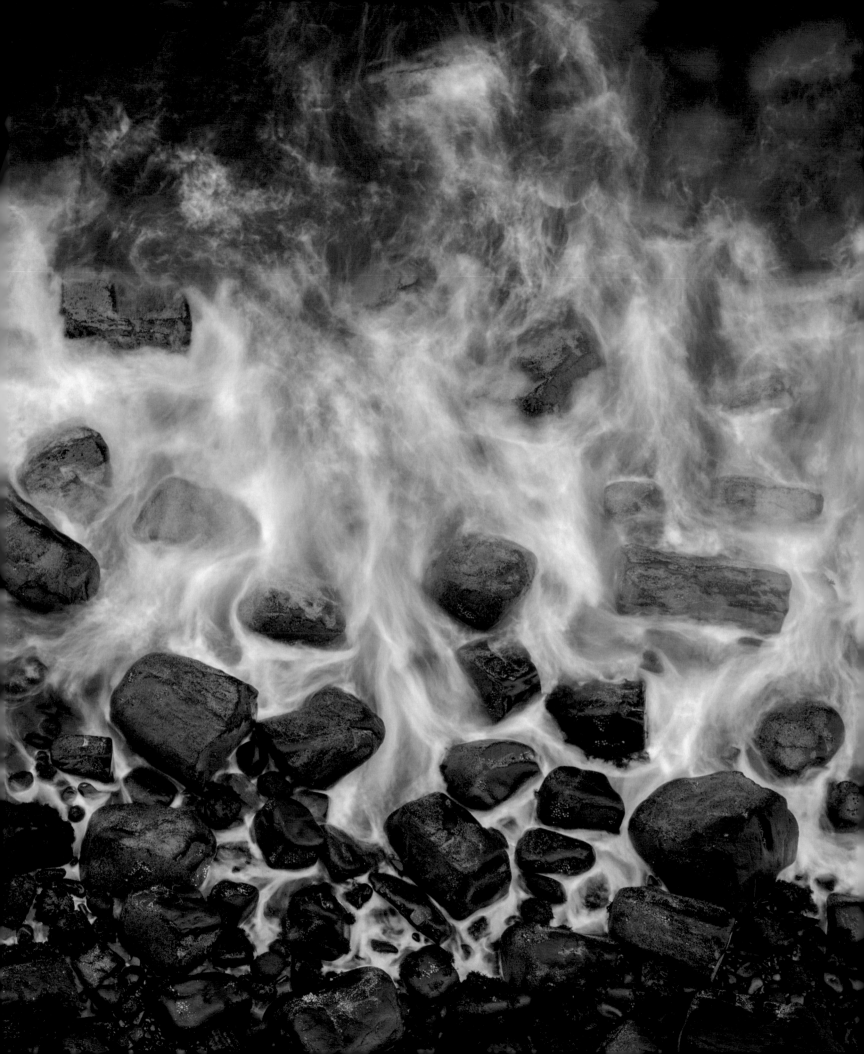

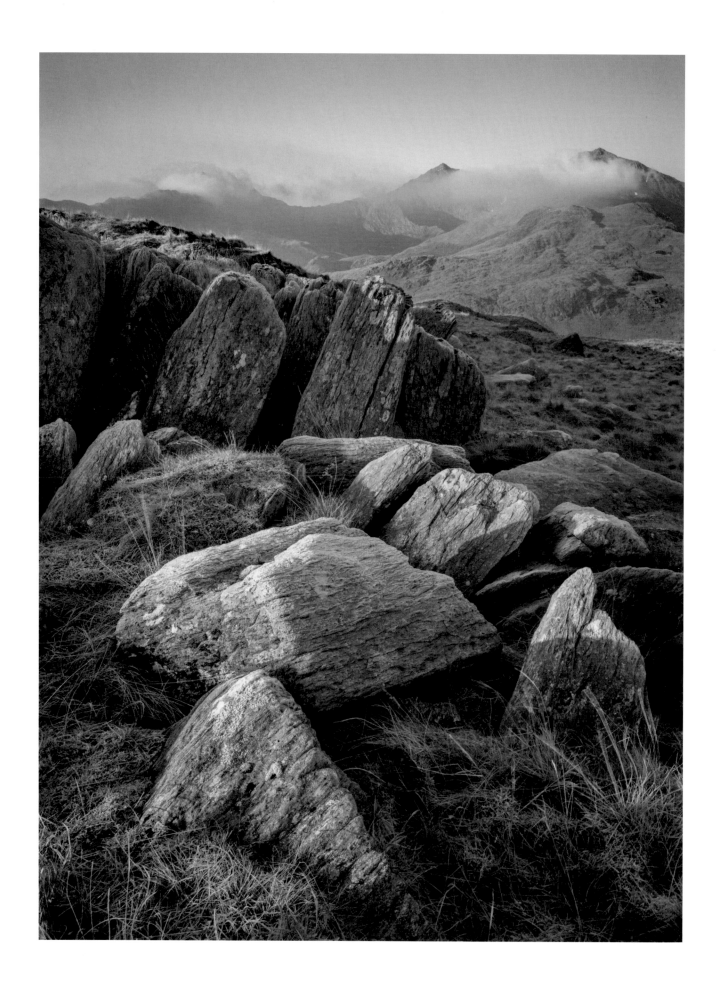

LANDSCAPES OF THE IMAGINATION

To journey across the grain of Britain from the east to the west coast is to travel 500 million years back in time. The extraordinary diversity of British geology means that this time-travelling experience transports you back into the unfathomable depths of geological time, to the very dawn of Planet Earth.

Starting from the other-worldly shingle spit of Orford Ness on the Suffolk coast, formed relatively recently during the Cretaceous, Pleistocene and Paleocene epochs, between 65 and 140 million years ago, our journey heads west across Britain towards the setting sun.

Gentle Cretaceous chalk hills enclose the Thames and the London basin like the jaws of a crocodile, spreading south and east to the fabled English icons of the White Cliffs of Dover and Sussex's South Downs and north as far as the rolling Yorkshire Wolds.

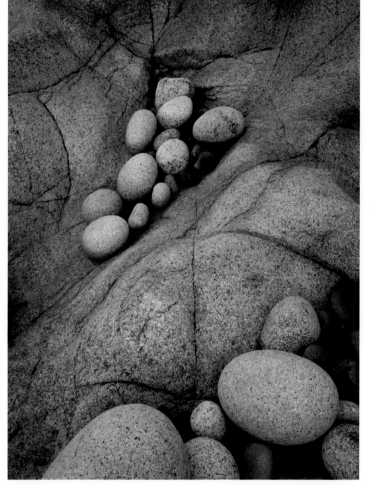

The Jurassic limestones and clays of the Chilterns, which stretch down to the World Heritage Site Dorset coast on the English Channel and up to the honey-stoned Cotswolds and rugged heather-clad moors and beetling coastline of the North York Moors, are the next geological period encountered, dating from around 140–195 million years ago. This was the era of the dinosaurs, when creatures like the ichthyosaur and plesiosaur swam across what is now the Dorset coast, their fossilised remains waiting to be rediscovered in the nineteenth-century by the humble Lyme Regis seashell collector, Mary Anning.

Passing over the pastel-coloured slates of the 4,500–545-million-year-old Precambrian rocks of the whale-backed Malvern Hills, we cross the mighty Severn to enter Wales. Here, after passing a band of limestones, shales and coal measures formed in the tropical, swampy Amazonian-like rain forests and coral reefs and lagoons of the Carboni-ferous period, we encounter the ruby-red cwms and pens formed by the Old Red Sandstones of the Brecon Beacons. These had their genesis in the swirling winds, shifting dunes and stifling heat of the Devonian desert – a sort of South Walian Sahara – some 345–395 million years ago.

Finally, the ancient 395–510 million-year-old Ordovician and Silurian shales and slates of the Cambrian Mountains and Preseli Hills of Pembrokeshire, together with the Lewisian gneiss of the Scottish Highlands, represent some of the oldest rocks on earth, and drop steeply down into the boiling waters of the Irish Sea.

Our cross-country journey through time is complete.

It's only been 300 miles from coast to coast, but in geological terms, we've gone back in time at least half a billion years.

What's in a Name?

It's no coincidence that many of the world's geological eras take their names from British sources, because the science of geology was virtually invented in these islands. So it was natural that pioneering eighteenth- and nineteenth-century geologists like Adam Sedgwick, James Hutton and William Smith chose British, and more particularly Welsh, names for the types of rocks they first identified. So the words Cambrian and Precambrian come from Cambria, the Roman name for Wales. The Ordovices were one of the last of the ancient Celtic tribes to submit to Roman rule, along with the Silures of modern South Wales. These tribes provided those earliest practitioners of the new science with appropriate labels for naming their locally found rocks, and those names are now understood and accepted around the world.

Of course, each type of rock creates its own distinctive landforms and vegetation. As the Victorian conservationist and critic John Ruskin, describing the then-fashionable sublime scenery in his *Modern Painters* (1843–56), wrote:

> Ground is to the landscape painter what the naked human body is to the historical. The growth of vegetation, the action of water, and even of clouds upon it and around it, are so far subject and subordinate to its forms, as the folds of the dress and the fall of the hair are to the modulation of the animal anatomy.

If you substitute the words photographer and writer for painter, you get the point.

Not surprisingly, because of their remoteness, mystery and grandeur, many of the places we have chosen as subjects for this book have been the subject of local wonder, folklore and legend. Many larger-than-life legendary characters, such as King Arthur, the medieval outlaw Robin Hood, the Celtic giant Fingal and even the Devil himself have lent their names to such places, while others became the lairs for dragons and other mythical beasts in the fertile rural imagination. Examples include the sweeping scars of Robin Hood's Bay on the North Yorkshire coast, the naturally columnal cathedral of Fingal's Cave on the Hebridean island of Staffa, and the weird Worm's Head on the beautiful Gower peninsula in South Wales, which takes its name from the Old Norse word for a dragon.

A Journey through Time

Rather than using the imaginary east–west journey across the country described above, this book starts from geology, the essential bones of the landscape, and then treats its subjects in roughly chronological order. Of course, the rocks of Britain are not conveniently arranged in a chronological order, so there are bound to be anomalies, which we hope the reader will forgive. Starting from the oldest rocks, we move on to the abrasive final polish that Ice Age glaciers gave to the land, and then to the major landforms and physical features, such as the mountains, woodland, coasts and islands. Finally, we look at the all-pervading influence that mankind has had on the working landscape.

As we saw in our imaginary journey across Britain, the rocks are ranged in order of their age. They run from the ancient Precambrian rocks of the Malverns and the glaciated gneiss of Torridon, through to the granite of the Cairngorms, the slates of Snowdonia, the Lakeland and Teesdale volcanics, the grit, sand and limestones of the Pennines and Brecon Beacons, and finally to the dazzling white chalk cliffs of the south coast.

The all-powerful sculpting glaciers of the Ice Age are recorded at various sites, such as the semi-Arctic Cairngorms, the closest place in Britain where we approach the freeze-box conditions of the Ice Age; the ice-carved cwms of Snowdonia and the corries of the western Highlands, and the great bite taken out of the northern Pennines by the glaciers which created High Cup Nick, a highlight on Tom Stephenson's epic Pennine Way.

Despite the almost casual modern use of the word 'wilderness' when describing our British hills, there are actually very few British landscapes that have not been affected in one way or another by the hand of Man. Only the sheer rock faces of the Scottish Highland corries, the Snowdonian cwms, our beetling sea cliffs, and crags like Malham Cove and Gordale Scar in the Yorkshire Dales, can be truly said to have been left completely untouched.

The High Land

We start our exploration of the 'High Land' of Britain in the Highlands of Scotland because many, including we suspect most Scots, would say that Mountain Britain only exists north of the Border. They may have a point, because only seven tops in the Lake District would qualify for the magic 3,000-foot Munro status, which, in Scottish eyes at least, would make them 'proper' mountains.

Scotland's mountain fastnesses, some of whose hidden corries are just a few feet short of having permanent snow cover, are explored from the highest, 'the Ben' (Ben Nevis), to the most remote, the Torridonian peaks of Beinn Eighe, Liathach and Slioch, rising spectacularly from the 'knock and lochan' landscape of the Lewisian gneiss. The highest land south of the Highlands is found in Wales, where the razor-edged peaks and ridges of Snowdonia, the beckoning Brecon Beacons, and the heather-covered 'badlands' of The Rhinogs form the roof of the Principality.

Although it may seem an exaggeration to speak about England's mountains, aficionados of the Lake District, Peak District and the Three Peak country of the Yorkshire Dales will claim that despite their lack of altitude, their modest summits lack nothing in attitude, especially when winter dusts their summits with a sprinkle of snow. So we visit the 'jaws' of Borrowdale in the Lake District, the peaty wastes of the iconic Kinder Scout, highest point in the Peak District, and the noble *lion couchant* heraldic profile of Ingleborough in the Yorkshire Dales. At the foot of these hills, places like High Cup Nick, the

'Grand Canyon' of the North Pennines, the limestone precipices of Malham Cove and Gordale Scar in the Yorkshire Dales and the mysterious chasm of Lud's Church hidden behind The Roaches in the Staffordshire Peak all form fascinating features of highland England.

Left ungrazed, the natural or 'climax' vegetation of Britain would be woodland, and that's exactly what would happen even on some of our highest mountains, moors and fells were it not for the voracious nibbling teeth of the ubiquitous sheep. Rare examples of that original woodland cover – dubbed the 'wildwood' by distinguished woodland historian Oliver Rackham – can still be found in places like Wistman's Wood, in the moorland heart of Dartmoor, and at Kingley Vale, the largest yew forest in Europe, hidden away in a fold of Britain's newest national park, the South Downs.

Edges of Land

There are about 10,800 miles (17,380km) of the British coastline, and they show a variety of scenery which is unmatched elsewhere in the world. These 'edges of land' range from the rocky bastions of Cornwall's Penwith peninsula and the dramatic sea cliffs of East Yorkshire, through to the rattling shingle spit of Orford Ness in north Norfolk. The Jurassic Coast of Dorset includes spectacular features such as the gigantic flying buttress of Durdle Door and the scallop-shell bay of Lulworth Cove. Finally, the chalk cliffs of Seven Sisters and Beachy Head have become iconic symbols of Britain, especially to those leaving for or returning from the Continent.

Although we sometimes tend to forget it, we are inescapably an island nation. There are reckoned to be around 6,000 islands around Britain, some substantial kingdoms of their own, such as the Isles of Skye, Arran, Wight or Man, but many others which are mere uninhabited rocks or skerries. A few of these 'small worlds', such as Lindisfarne and Iona, have a special spiritual charisma of their own, while on the wild cliffs of Shetland or Orkney, you can really get the feeling that you have reached the edge of the world.

The Coming of Man

Man's first appearance is evidenced by our rich legacy of monumental prehistoric sites. These include the standing stones of Calanais on the Isle of Lewis and the massive Neolithic stone circles of Avebury on the Wiltshire Downs.

The modern science of archaeology has shown us that prehistoric Man was not the woad-painted savage we were taught about at school, and had a much greater influence on the landscape than was previously understood. Clearance of the primeval wildwood to provide space for hunting and grazing animals was certainly well under way in the Stone Age, and perhaps as long as 10,000 years ago.

The imposing Iron Age hillforts of Ingleborough in the Yorkshire Dales, the British Camp on the Malvern Hills and Tre'r Ceiri, the 'Town of Giants' which crowns Yr Eifl on The Llŷn Peninsula in North Wales, all still impress in their overbearing dominance of the local landscape. Most of these hillforts, given their militaristic name by Victorian antiquarians, are now thought to have been peaceful summer shielings, from which herds could be safely watched. There is also some evidence that they were prominent status symbols and statements of power between chieftains, built to deter and show off to potential rivals – a sort of Iron Age nuclear deterrent. Having said that, there is no doubt that some also served a military or defensive purpose, which is clear from the recorded assaults by Roman legions on some, like Hod Hill and Maiden Castle in the south of England.

Imperial Rome's northernmost limit was indelibly demarcated by Hadrian's Wall, which still marches for 70 uncompromising miles (115km) across Britain, linking the North Sea with the Solway Firth. The builders cleverly utilised the igneous intrusion of the Great Whin Sill as a natural north-facing defence against the Picts and Scots on its rollercoaster march across the neck of the country. This was the last outpost of the Empire, and the Wall still imparts a sense of imperial power as the most impressive remains of Roman military architecture in western Europe.

During the Middle Ages, much of upland England was commandeered by the vast sheep-ranching estates of the all-powerful monasteries, such as the white-robed Cistercians of the beautiful ruin of Rievaulx Abbey in Ryedale, North Yorkshire. They were probably responsible for starting the overgrazing that has given us the open hills and fellsides we recognise as 'natural' and love so much today. The monastic granges (outlying farms) were responsible for many of the first stone-built farms in the Pennines, some of which still exist on the same sites. Five hundred years after their building, the evocative remains of their abbeys such as Rievaulx are still magnificent in their ruination.

Britain's industrial past left long-lasting scars on the landscape, many of which have since been healed by the forgiving hand of Nature. Weathered by years of wind, rain and frost, the Rosedale iron mines on the North York Moors and the lead mines of Swaledale in the Yorkshire Dales, the Cornish tin mines which punctuate the Penwith peninsula with their exclamation-mark chimneys and engine houses, and the wastelands of the Dinorwig Slate Quarries in Snowdonia, can now seem like an almost natural addition to the landscape.

The truth is that the Britain has always been a working landscape, ever since those first Neolithic farmers started to clear the wildwood with their flint axes. Modern intrusions, such as the chilling Cold War 'pagodas' at Orford Ness on the Suffolk coast and the brutalist nuclear power station of Dungeness in Kent are deliberately included. They should be looked upon as merely the latest manifestations of the works of Man in the on-going shaping of the landscape of Britain.

It should be emphasised that *This Land* does not constitute a 'Best of Britain', or any other kind of arbitrary listing. Rather it is a considered personal extract from the thousands of places from which Britain is formed, an extract that aims to represent the variety and scope of the British landscape. It is an essentially personal choice, one that allows both writer and photographer to reflect on experiences in places that have defined our sense of what landscape itself can be,

both in reality and in the imagination.

The selection process of places has been long and at times tortuous. While some images come from Joe's archive, he has also visited places for the first time and made new work to fulfil some of Roly's selections. Without this obligation he might never have made pilgrimages to such magical spots as Kingley Vale, Wistman's Wood or Lud's Church, all of which he says have enriched his sense of the variety of these islands.

But the essential point is that, while about fifty places are included, hundreds more were excluded that have equally vivid stories to tell. The decision on what to include has ultimately been guided by a sense of balance, instinct, and occasionally, sheer bloody-minded favouritism. For example, Roly could not resist one of his local haunts, the evocative Magpie Mine, and Joe would not be without his local favourite hill, Roseberry Topping.

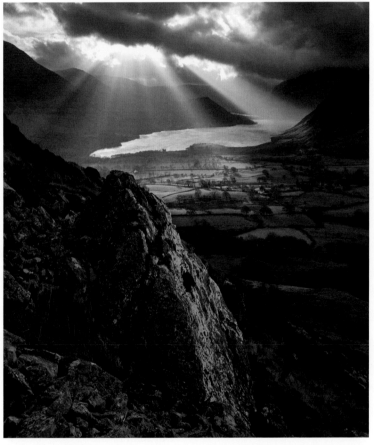

So it must be emphasised that the subjects are very much the personal choices of the author and photographer, and we apologise in advance if your favourite is missing. Given such richness and variety of choice, such a selection is bound to be subjective, and everyone is bound to have their own particular special place.

A sprinkling of personal anecdotes tell of the experiences we have had in reaching and enjoying these places, and there's some background information on their geology, history and wildlife, and what you might look out for when you go there.

A word should perhaps be said about the title. *This Land* has references to Woody Guthrie's unofficial American national anthem, 'This Land is Your Land', written in 1940. But it also encapsulates the wide-ranging nature of our choices, which are designed to appeal to all who agree with us that we are privileged to live in one of the most diverse, historic and beautiful landscapes on the planet.

The title also has deliberate echoes of archaeologist Jacquetta Hawkes's classic 1951 study of the British landscape, *A Land*, which was illustrated by Henry Moore; and master landscape photographer Fay Godwin's monumental study, *Land*, which she did with John Fowles in 1985. Neither the author nor the photographer makes any claim to match those masterpieces, but we readily confess they were among our many inspirations.

Finally, it should be made clear that to see these sublime landscapes, it is necessary to forsake the comforts of home, to sometimes get out early and stay out late, to ignore the view as seen through the windscreen of the car, and often to wander far beyond the beaten track. You will sometimes need to walk – as Nancy Newhall so memorably put it in *This is the American Earth* (1960) – 'where only the wind has walked before' to really appreciate and savour 'This Land'.

And it must always be remembered that, as Guthrie sang to a patriotic America seventy-five years ago, this land is not just *our* land, it is also *your* land. Our sincerest hope is that our words and pictures will inspire you to go out and explore it, and discover for yourself the wonder and richness of the incomparable British landscape.

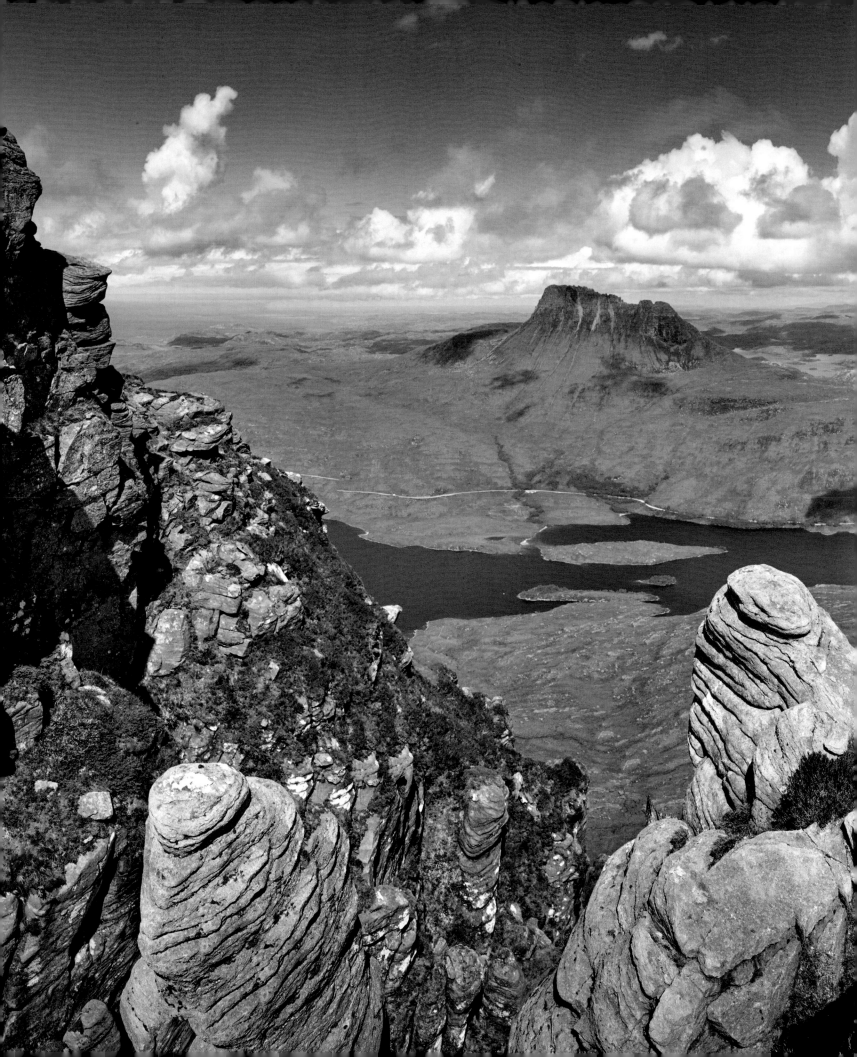

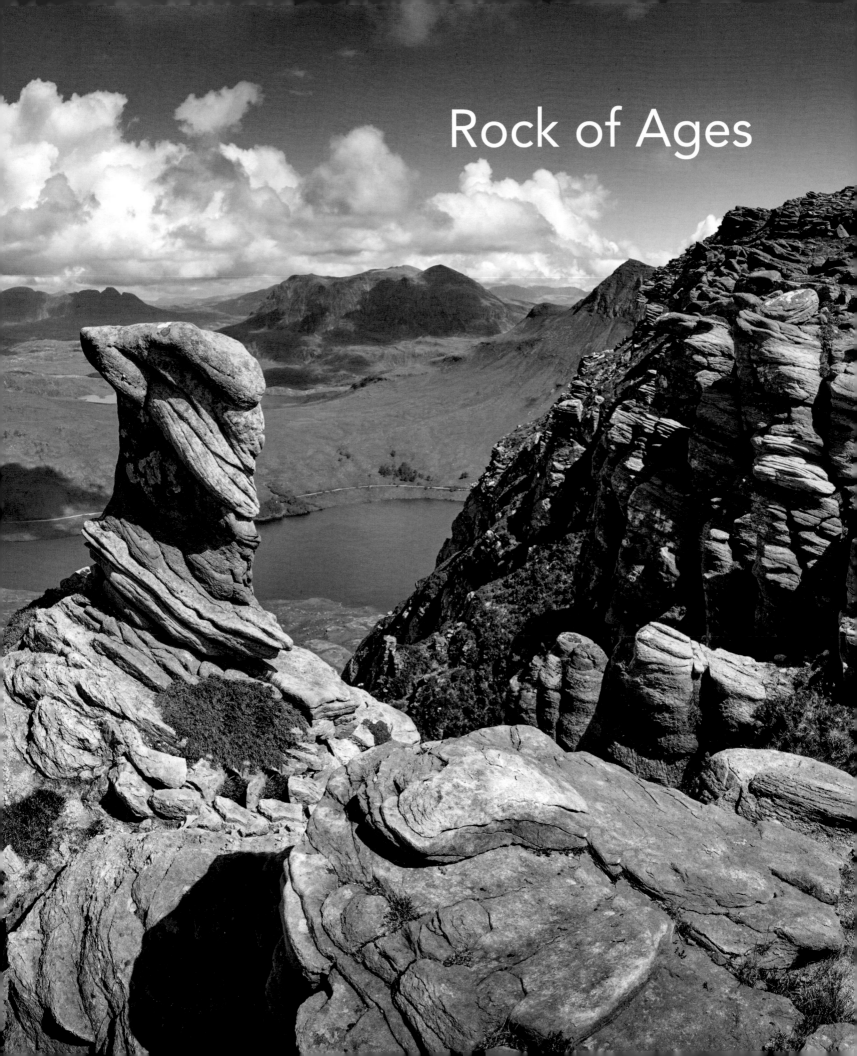

Rock of Ages

ROCK OF AGES

Some of the oldest rocks on Earth get their
names from Britain, where they were first identified by
pioneering geologists. Precambrian and Cambrian rocks
form the bedrock of the British Isles, reaching the surface at
places like the island of Anglesey, in the 'inselbergs' of the
Torridonian highlands and the mini-mountain range
of the Malvern Hills in the English Midlands.

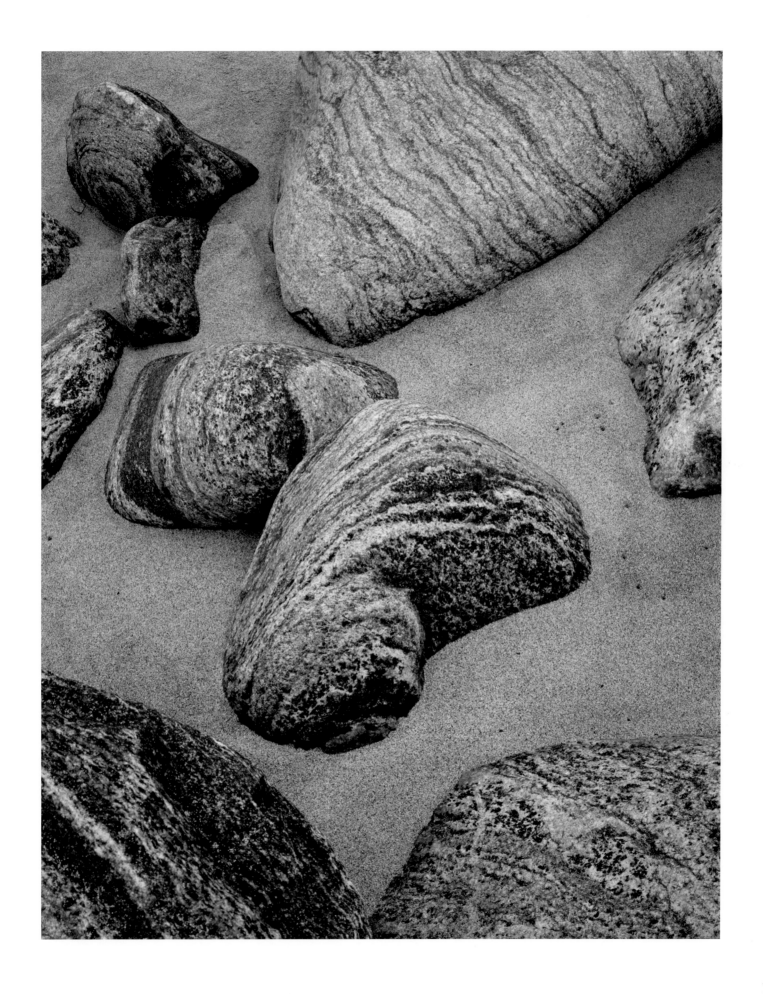

THE SACRED MOUNTAIN
Suilven and Stac Pollaidh, Highlands

According to Joe, if any of Scotland's mountains could be classed as sacred, it would be Suilven, that apparently inaccessible shark's fin of a peak when seen from Lochinver or Elphin.

It rises in splendid isolation from the lochan-spattered gneiss of the Inverpolly National Nature Reserve, 'the most magical and still mysteriously beautiful of all Scotland's landscapes,' he says. Its modest height of just under 2,400 feet (730m) means that it doesn't even qualify as a Munro. But in terms of its overpowering presence, it's a true giant.

Joe's description of Suilven affirms its formidable appearance: 'Rising from a plateau ringed with rocky bluffs and soaked in lochans, this is a well-defended location; Suilven seems a true fortress of a mountain.' The Gaelic name, Sula Bheinn, comes from the Old Norse and means 'The Pillar', which is exactly what it would have looked like to raiding Vikings as they cruised in their longships along the western seaboard.

Suilven is what geologists call an 'inselberg' – literally, an 'island-mountain' – formed of Torridonian sandstone standing in a landscape of metamorphic Precambrian Lewisian gneiss dating back up to 3 billion years. Over the millennia, the softer surrounding rocks have eroded away, leaving twin-topped Suilven and neighbouring peaks like Stac Pollaidh, Cul Beag and Ben Mòr Coigach standing proud.

But that apparently impregnability is false, and the summit saddle (*bealach*) can be easily reached from the surrounding peat bog by about 1,000 feet (300m) of steep scrambling up a scree shoot. Joe recalled his feelings on his first ascent of the higher western summit: 'Casteal Liath, the summit of Suilven, is a shallow dome of soft, mossy, springy dry turf; surely a civilised surface on which to hold a gathering of the gods.'

The 360-degree view from the summit of Suilven extends north across the sharply pointed eastern summit of Meall Mheadhonach to Foinaven, Arkle and Quinag, and south to Cul Mòr and the serrated cockscomb of Stac Pollaidh (Stac Polly).

Stac Pollaidh (2,008ft/612m) is another example of an inselberg, but this is one whose sandstone crest has been severely eroded into a fantastic array of pinnacles and steep gullies. This extreme weathering and erosion, more pronounced here than on any other Torridonian peak, suggests that it was not smoothed by ice during the last glaciation.

It is easily accessible from the minor Drumrunie–Aird of Coigach road by the shores of Loch Lurgainn, but that ease of access has resulted in severe human erosion of the direct route to its crest. Scottish Natural Heritage has now reconstructed the path into a broad 'yellow brick road', which unfortunately detracts from the wildness of the situation until you have reached the crest.

Generations of walkers have given fanciful names to the pinnacles that adorn the splintered summit ridge. These range from the sublime to the ridiculous, including the Madonna and Child, the Sphinx, Tam o'Shanter and Andy Capp. Perhaps best known is a particularly fine, free-standing pillar known as the Lobster's Claw, which partly collapsed a few years ago due to those inexorable forces of erosion.

Those same irresistible forces will eventually see the hedgehog ridge of Stac Pollaidh and the twin towers of Suilven crumble into the surrounding Lewisian gneiss, joining many other long-forgotten peaks of the past.

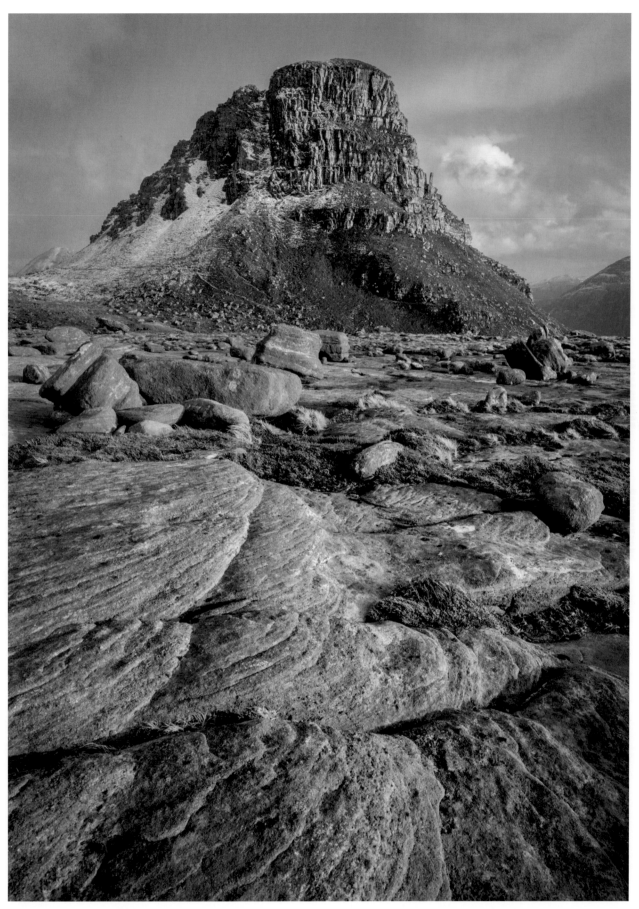

Stac Pollaidh, western flank

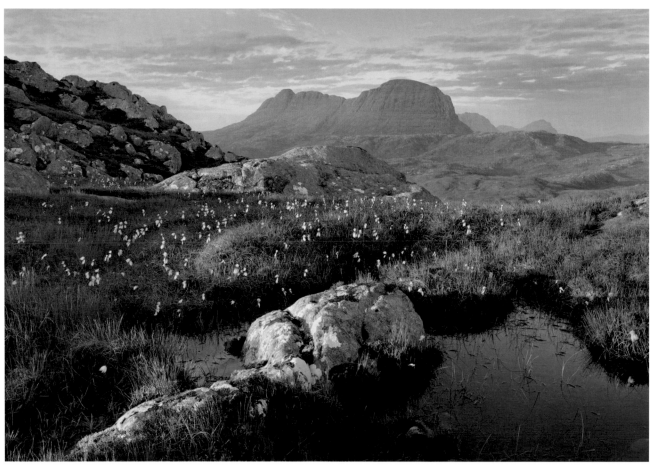

Cotton grass, Suilven, early summer morning

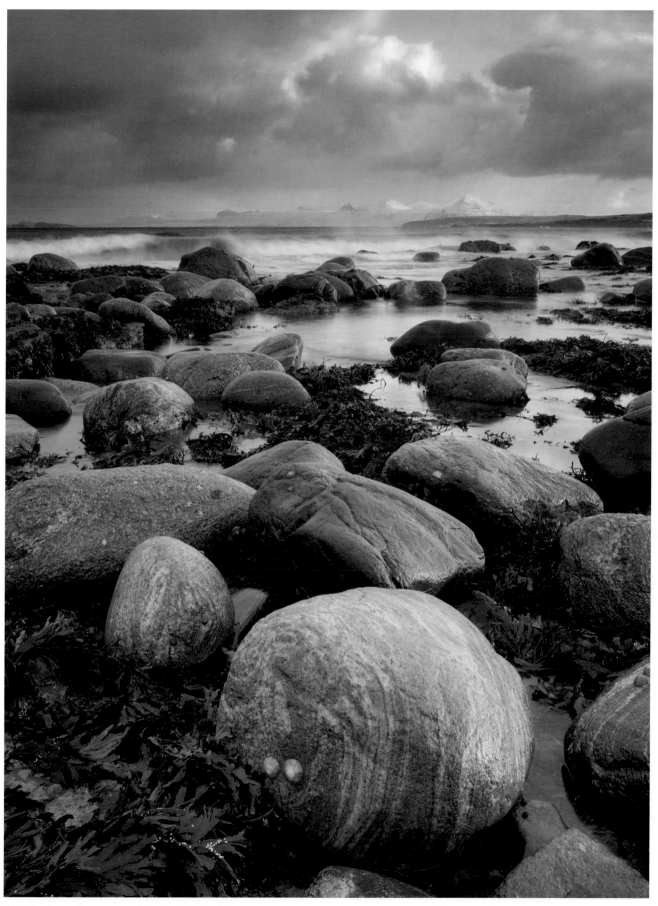

Udrigle shore, distant view of Coigach group, late winter

A LIGHT ON THE PAST
South Head, Anglesey

There are a dizzying 400 zig-zag steps to descend to the truss bridge, which connects the island of South Stack – with its venerable, 200-year-old, white-painted lighthouse – to the western tip of Anglesey's mainland. As you cross the aluminium bridge to reach the lighthouse, the turbulent waters of the Irish Sea boiling and crashing beneath your feet, you may just notice in the cliffs opposite one of the most astonishing sights in British geology.

The striated light grey rocks have been contorted and cleaved into a series of surrealistic waves and folds by unimaginable pressures, giving the impression of a Fair Isle patterned sweater draped across the headland. Pioneer geologist Edward Greenly first made the 'amazing revelation' of these spectacular folds in the rocks, and they were later mapped in the *Memoir of the Geological Survey*, published in 1919. Geologists now know them as 'Greenly's Bedded Succession', and they form part of what is known as the Monian Supergroup of Anglesey.

The rocks of the South Stack Group, including the famous climbing cliff of Gogarth, consist of alternating sandstones and siltstones, including some massive quartzites. These are mainly turbidites – that is, sedimentary rocks deposited by turbulent, debris-laden underwater currents in an ancient marine basin. These folded, fine-grained turbidites are clearly seen in the cliffs alongside the steps and on South Stack itself. There are even some dramatic large-scale anticlinal folds with small-scale folds superimposed on them.

Geologists have been debating the age of Anglesey's rocks since Greenly's time in the early nineteenth century. It was thought at one time that they were entirely Precambrian, but it is now known that they straddle the period between late Precambrian and late Cambrian times, that is between about 700 and 500 million years ago, so they represent some of the oldest rocks in southern Britain.

Though not quite as venerable as the rocks on which it stands, South Stack's imposing lighthouse is also one of the oldest on our shores. Charles I was first petitioned for a lighthouse on the treacherous western tip of Anglesey as long ago as 1645. It was eventually built by Trinity House for £12,000 in 1809, using the ancient local rock transported to the island across the 100-foot (30m) chasm intervening channel by a precarious system of ropeways and baskets.

The 92-foot (28m) high tower flashed its oil-fuelled light over a distance of up to 30 miles (48km) once every two minutes, and the lighthouse keepers lived out their solitary lives in two neat keepers' cottages adjacent to the lighthouse. The light has been fully automated since 1984, and the main lamp is somewhat surprisingly now only a 2-inch 150-watt halogen bulb, which flashes once every ten seconds. But because of the sophisticated optics of the reflectors, it has exactly the same range as the old oil lamp.

The name of South Stack comes from the Old Norse, where *stakkr* literally means 'a stack.' It's also known as Ynys Lawd in Welsh, where *llawd* is thought to mean 'boiling' or 'seething' – another perfect description of this storm-tossed bastion of incredibly ancient bedrock.

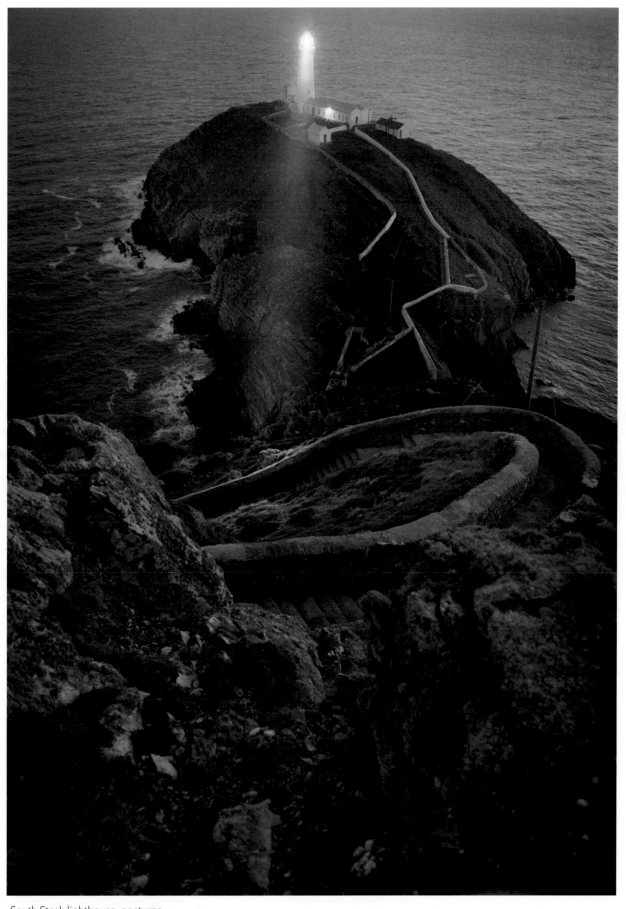

South Stack lighthouse, nocturne

23

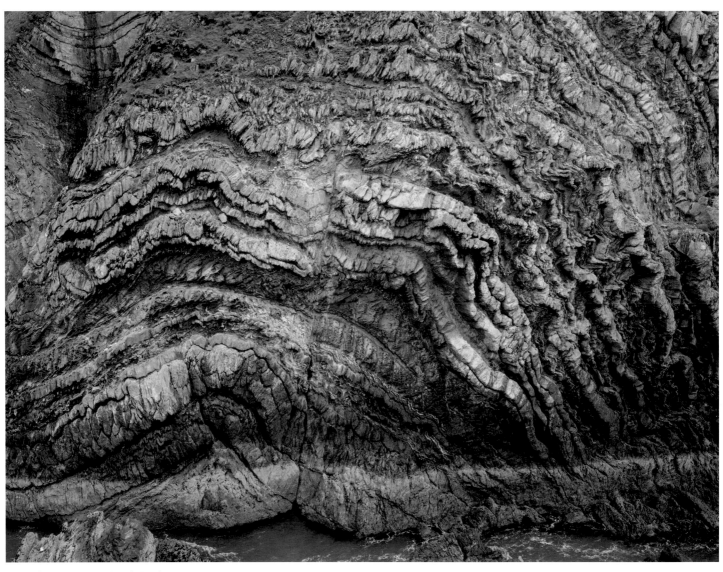

Greenly's Succession, South Stack

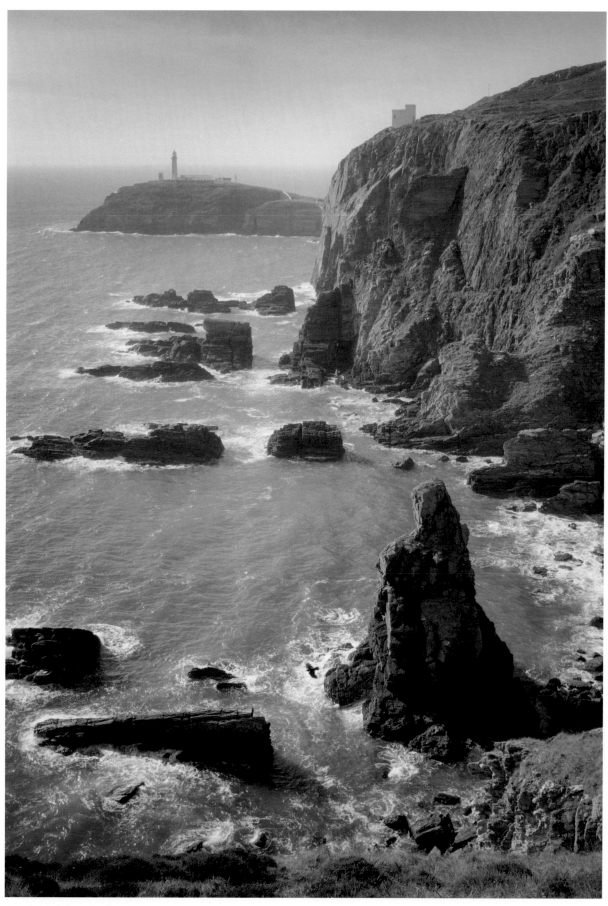

South Stack from Penrhyn Mawr

ALIVE WITH THE SOUND OF MUSIC
Malvern Hills, Hereford and Worcester

Edward Elgar once said of his *Cello Concerto:* 'If ever after I'm dead you hear someone whistling this tune on the Malvern Hills, don't be alarmed. It's only me.' That thoughtful, elegiac concerto has become a test piece for the solo cellist. A gently pastoral yet emotionally charged idyll, for many it conjures up a vision of the essentially English patchwork-quilt countryside of Elgar's beloved Worcestershire and the Severn Plain, when seen from from the Malvern ridge.

Everest mountaineer Wilfred Noyce once claimed that of all British hills, the miniature 10-mile (16km) ridge of the Malverns came the closest to the Himalaya in the way they rise so suddenly and steeply from the plain. They may be modest in height – the highest summit of the Worcestershire Beacon only reaches 1,385 feet (422m) – but, especially after a dusting of winter snow, the Malverns can belie their lowly altitude. And the traverse of that rollercoaster ridge is an exhilarating day's outing for any hillwalker, even those used to the greater hills of the north.

Straddling the border between the old counties of Herefordshire and Worcestershire, the Malvern Hills represent some of the oldest rocks in Britain, dating from the Precambrian eon between 4,500 and 500 million years ago. Their incredibly hard, pastel-shaded, pink and mauve rocks were tempting to Victorian quarrymen, and we have to thank the Malvern Hills Conservators, one of the earliest conservation bodies, that the distinctive skyline of the Malverns, seen to such striking effect from the M5 or Birmingham–Cheltenham

railway line, is still intact.

The Malverns have long been the border country between Middle England and the first blue foothills of Wales to the west. The thirteenth-century Red Earl's Dyke, or Shire Ditch, still runs from the Herefordshire Beacon to the terminal summit of Midsummer Hill at the extreme southern end of the range.

The early English poet William Langland may well have been dozing 'under a broad bank' of the Red Earl's Dyke one bright May morning in the fourteenth century when he dreamed his dream of 'A fair field full of folk . . . the rich and the poor, working and wandering' in his *Vision of Piers Plowman.* In this classic alliterative poem, part theological allegory and part political satire, Piers embarks on a search for the true Catholic Christian life through a series of dreams.

The Herefordshire Beacon at the southern end of the range is encircled by the sinuous, curving earthworks of a 32-acre (13ha) hillfort dating from the Iron Age which is popularly known as the British Camp. At its centre and on the highest point are the remains of a Norman motte and bailey castle, named by the romantic Victorians as The Citadel.

Legend claims that this was the site where the Celtic guerilla leader Caractacus fought his last battle with the Romans, before being captured and whisked off to Rome to be exhibited as a spoil of war by the Emperor Claudius. This brings us neatly back to Elgar and his 1898 cantata *Caractacus*, which was set in the Malverns and describes the defeat and capture of the defiant rebel chieftain.

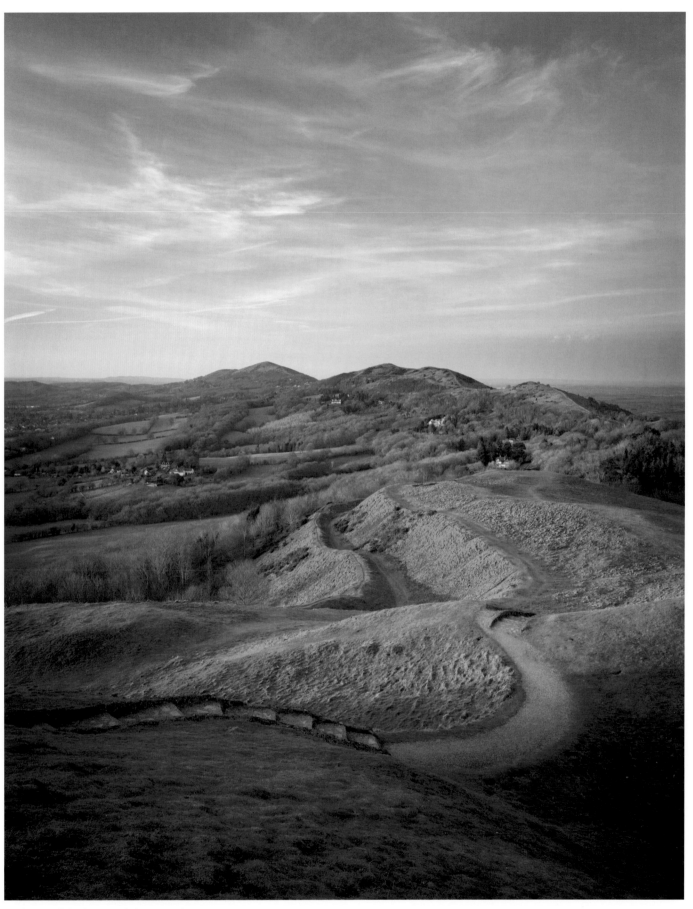

Malvern Hills looking north from British Camp

NAILING THE FORGE
An Teallach, Wester Ross

The magnificent, riven buttresses of An Teallach, as seen from the aptly named Road of Desolation or from the shores of Toll an Lochain in the heart of the Torridon Highlands, is one of the wildest mountain prospects in Britain. In grandeur, it is possibly matched only by the imposing triple buttresses of Ruadh-stac Mor, the western outpost of the Beinn Eighe ridge when seen from the depths of Choire Mhic Fhearchair (see page 58).

Bill Murray, in his *Highland Landscape* (1962), described An Teallach (3,478ft/1,060m) as 'one of the half dozen most splendid mountains in Scotland': high praise indeed from this most distinguished mountaineer. 'Its summit ridge of rock, a twisting and pinnacled knife-edge, is the sharpest on the mainland, without match except on the Black Cuillin,' wrote Murray. 'Its eastern corrie, Toll an Lochain, is one of the great sights of Scotland. A black lochan lies at the foot of its huge cliffs, which rise 1,500 feet (450m) above not as a blank wall, but as a mountain range of divided spires.'

It's an approbation with which Joe heartily agrees. 'If the Romantic philosophers had sought a perfect example of the sublime among the Scottish mountains, they would have found it right here,' says Joe, who regards An Teallach as 'Scotland's finest mountain, if not its highest.'

This view is shared by many Munroists, who make the 14-mile (22.5km) trek from Dundonnell House in Strath Beag, returning via Gleann Charaorachain to 'tick off' Sgurr Fiona,

the reigning peak, and Bidein a'Ghlas Thuill (3,484ft/1,062m) at the northern end of the curving An Teallach ridge. There are ten tops above the magic 3,000-foot contour on the ridge, including the incredible leaning sandstone fang of Lord Berkeley's Seat, which looks as though it could topple into the frigid waters of Toll an Lochain at any minute.

Joe's first encounter with An Teallach was not blessed with perfect weather, and he endured a stormy night in his lightweight tent pitched in Coire Toll an Lochain. 'That night torrential rain and buffeting winds passed over us,' he recalls. 'Inside my tent was like being within a fabric kettledrum being beaten by malevolent mountain spirits. It seemed that our campsite would be ripped up and hurled into the loch at any moment.'

But Joe survived and ascended the ridge the next day via the Cambrian quartz-covered southern summit of Sail Liath. 'Views are the great reward of climbing any Scottish mountain, but these particular sights came as a special revelation, giving glimpses into the heart of the Great Wilderness to the south. Beyond the Fisherfield Forest, the other Torridonian giants, Beinn Eighe and Liathach, were clearly visible.'

He concluded: 'Sleeping in that most spectacular of campsites, feasting on its views, seeing the sun come and go and the cloud build and clear, feeling the rain fall and the wind rage on this prince of peaks – these experiences will never leave me.'

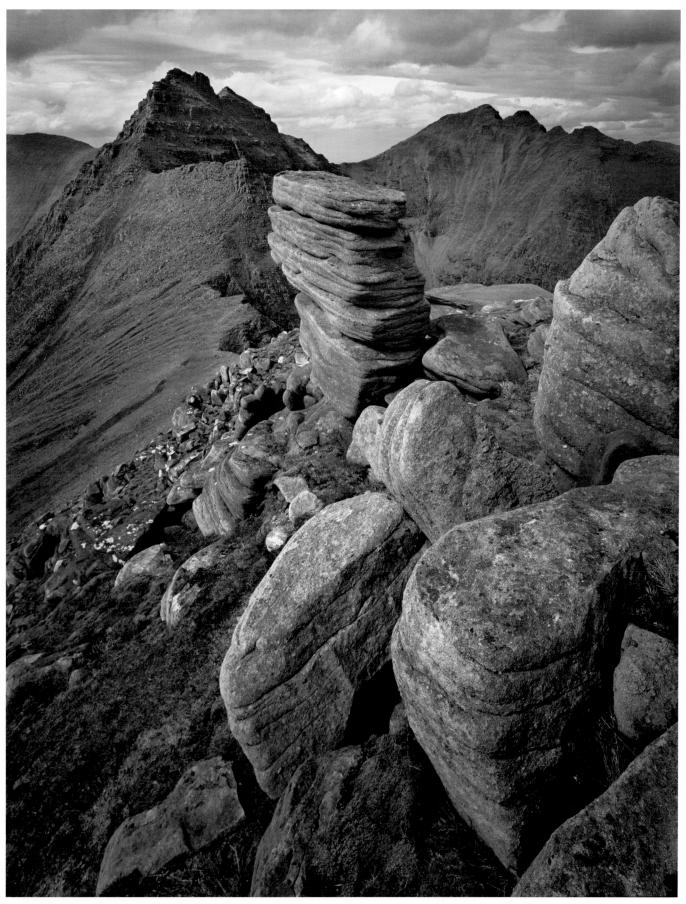

An Teallach, Corrag Buidhe buttress

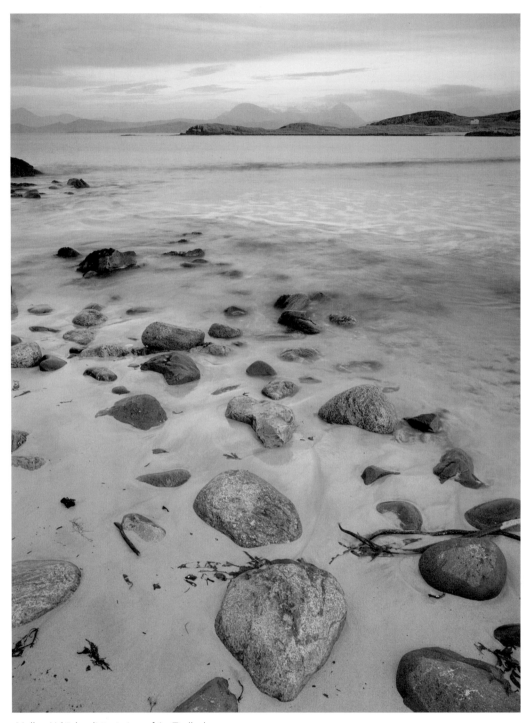

Mellon Udrigle, distant view of An Teallach

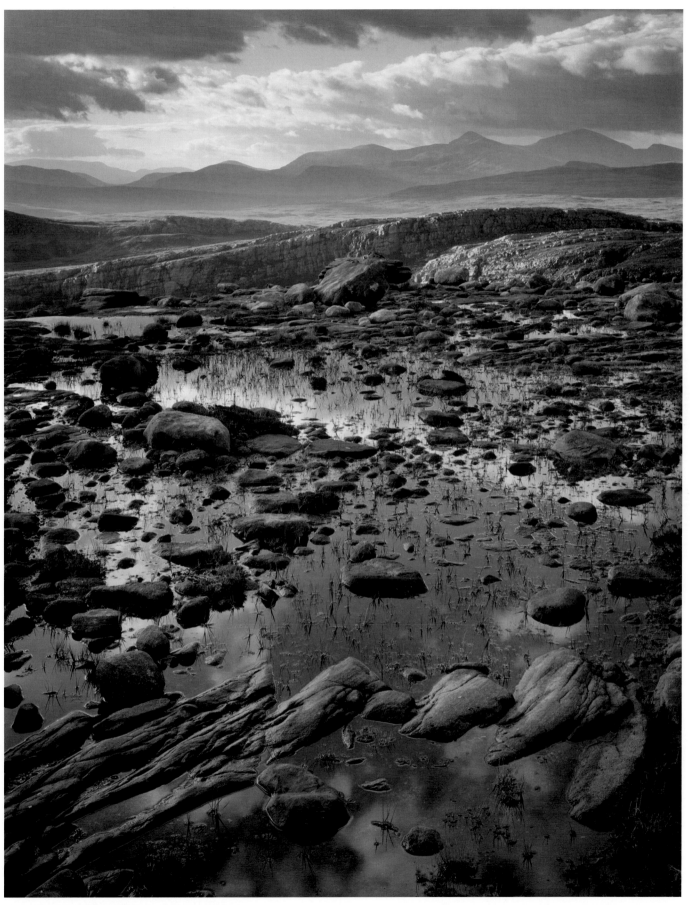

Sgurr Mor from Choire Toll An Lochain, An Teallach

A LITTLE BIT OF HEAVEN ON EARTH
Harris and Lewis, Outer Hebrides

'If time could stand still, this is one of those places where you believe it would,' says Joe, describing the lovely white shell-sand beaches of Berneray on the Sound of Harris in the Outer Hebrides. 'The sense of space, the visual simplicity of the beach, the colours of the sea, the mountainous backdrop of Harris to the north and the absolute solitude all combine to defy the twenty-first century.'

Joe found the beaches of Berneray so profoundly relaxing it seemed almost inappropriate for him to work there. 'Work usually extracts an emotional toll that can only be repaid with food and sleep, but I felt strangely energised by that afternoon on Berneray,' he said. 'I fell under its spell, and it left its enchantment on me.'

Small wonder then that the magical white strand beaches of Berneray, Seilebost and Luskentyre in the south of the Isle of Harris, and Mangersta on the Isle of Lewis, have been voted among the best in the world.

Lewis and Harris are not separate islands at all, although they are always regarded as such. Harris in the south is joined to Lewis in the north by an invisible line between the deep fjords of Loch Resort in the west and Loch Seaforth in the east. Harris itself is divided into North and South by the narrow isthmus at Tarbert, and there are long-standing plans to make North Harris Scotland's third national park.

While South Harris boasts some of the best beaches in the country, the desolate 'knock and lochan' landscape of North Lewis contrasts strongly with the craggy mountains of North Harris.

These are the highest peaks in the Outer Hebrides, culminating in Clisham (2,622ft/799m), near Tarbert. On a clear day, the views from Clisham span from Cape Wrath in the north to the Cuillins of Skye in the south. And, if you are really lucky, the shark's-tooth outline of St Kilda can also be spied, 40 miles (64km) out in the grey Atlantic to the west.

The geology of the Outer Hebrides is fascinating, taking us far back into Earth's history. The predominant rock, known as Lewisian gneiss (pronounced 'nice'), is the oldest in Britain and takes its international name from the Outer Hebridian island. This rock is metamorphic (i.e. altered by volcanic heat) and up to 3 billion years old – or to put it another way, two thirds of the age of our planet.

It is also a very pretty rock, mainly grey with coarse bands of white and dark minerals running through it. The pale bands contain sparkling quartz and feldspar, while the darker bands contain more dense minerals such as mica schist and hornblende.

These rocks were buried deep beneath the surface for hundreds of millions of years, and the intense heat and pressure of the earth's molten core formed the new metamorphic minerals within them.

All of this makes Joe's love of the multi-coloured boulders of Harris and Lewis all the more understandable. 'I feel about boulders the way a train-spotter must about trains,' he says, 'and Scotland's coast is for the boulder-spotter what Clapham Junction must be for the train-spotter – a little bit of heaven on earth.'

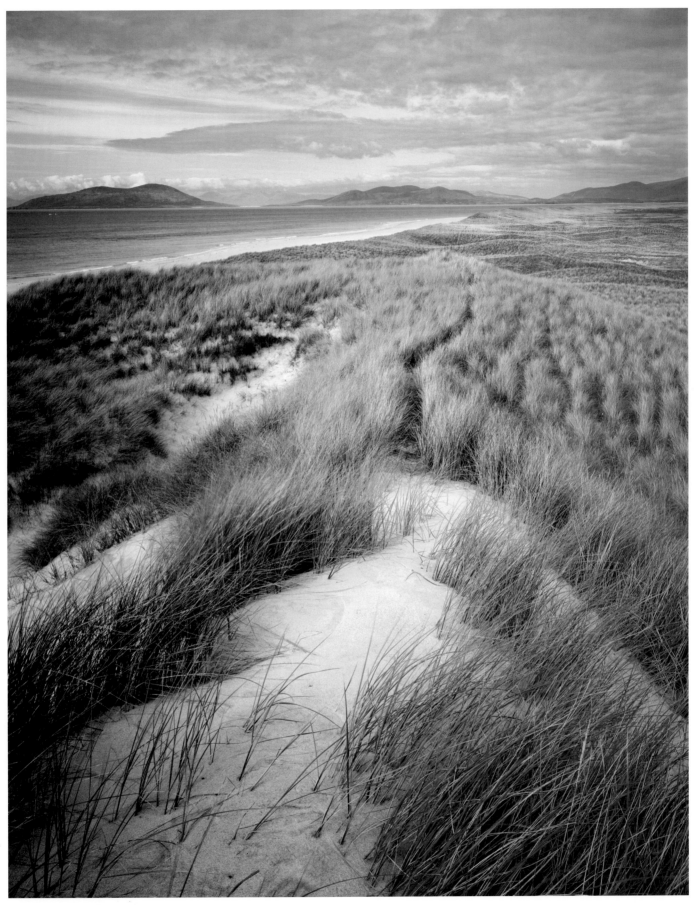

Berneray, Sound of Lewis

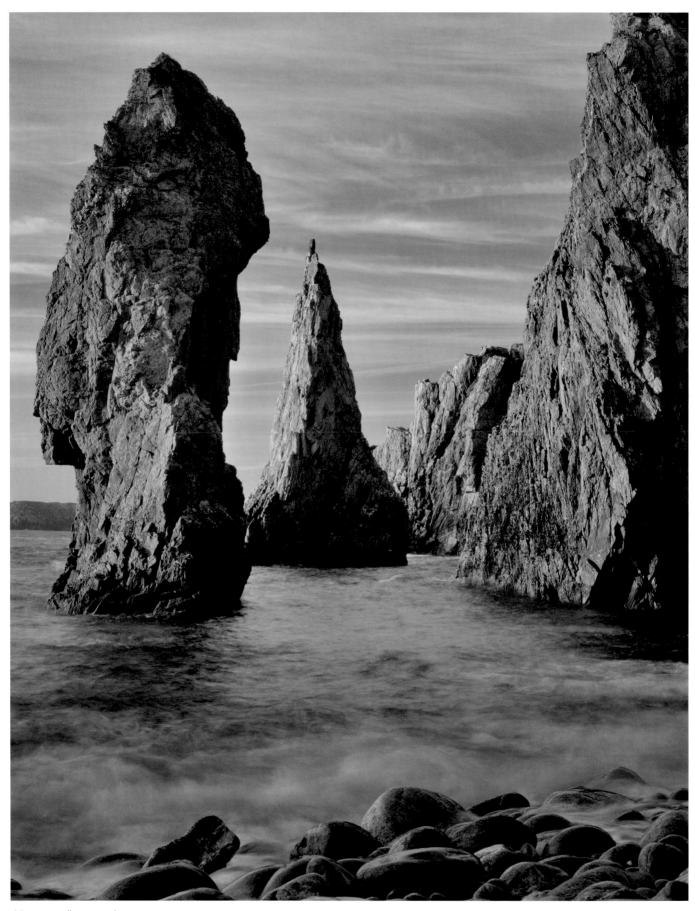

Mangurstadh sea stacks

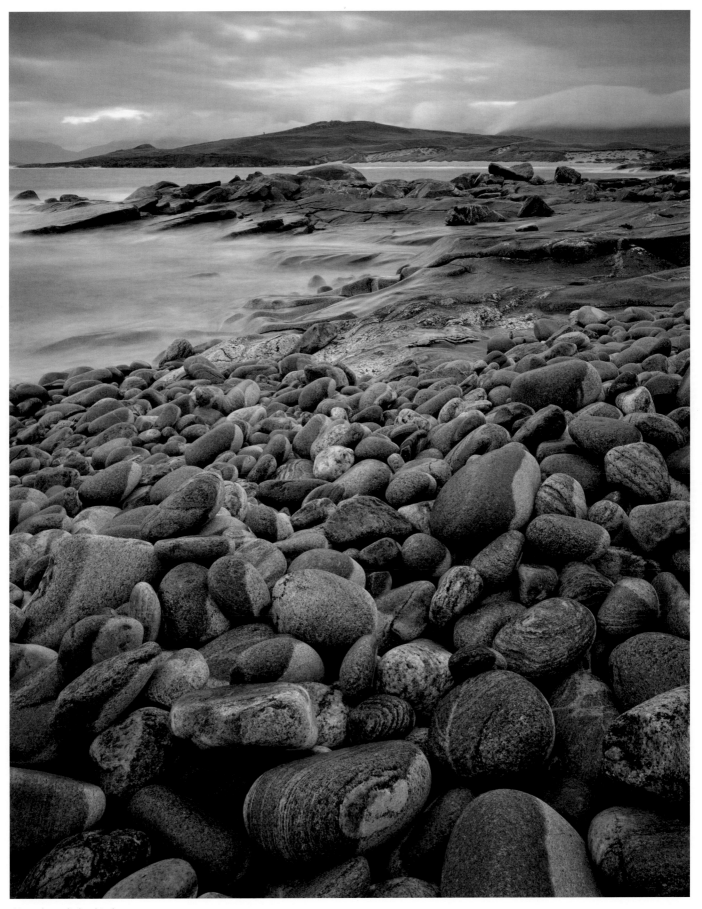

Horgabost, light drizzle

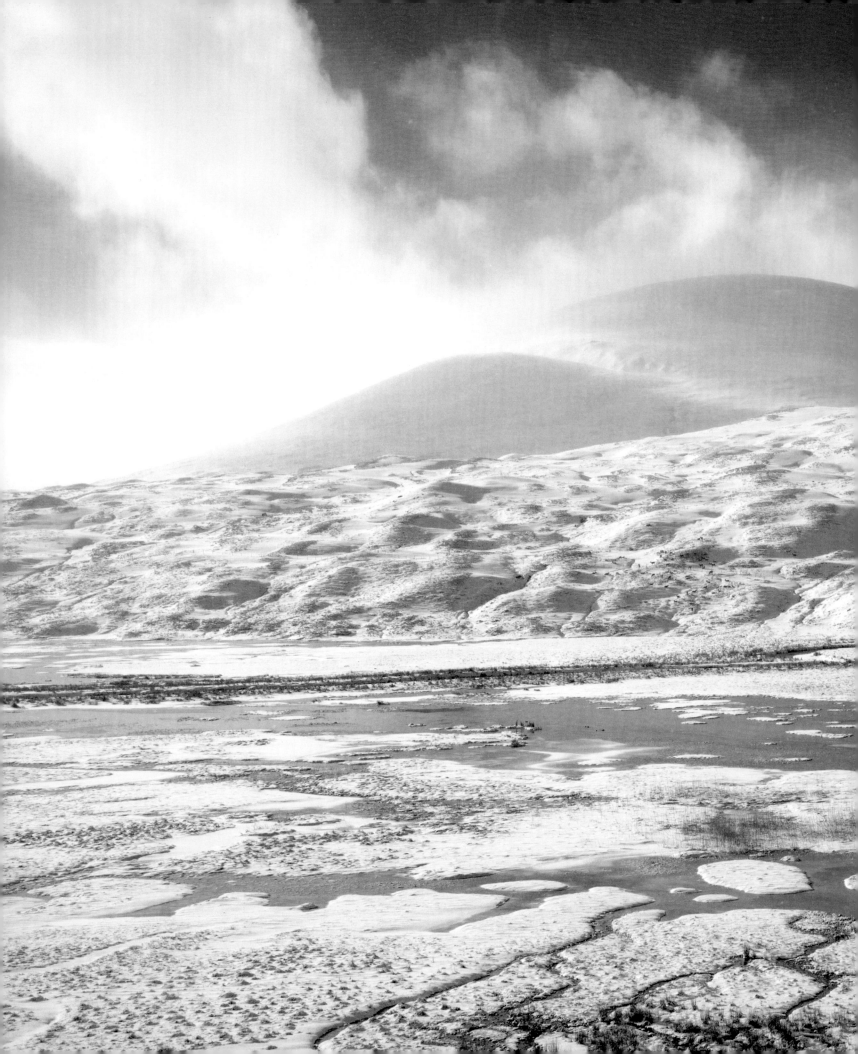

Out of the Freezer

OUT OF THE FREEZER

It was the grinding power of Ice Age glaciers

that provided the finishing touches to the masterpiece

that is the British landscape. The closest thing we still have to

Ice Age Britain is the bleak and lofty Cairngorms plateau in the Scottish

Highlands, where it's been said that if it was a few feet higher, it would be

under permanent snow. Vivid evidence of the passage of the glaciers,

which retreated a mere 10,000 years ago – a blink in the geologist's

eye – can also be found at places like Cwm Idwal and Cwm Cau

in Snowdonia, and the dramatic valley of Wasdale

in the western Lake District.

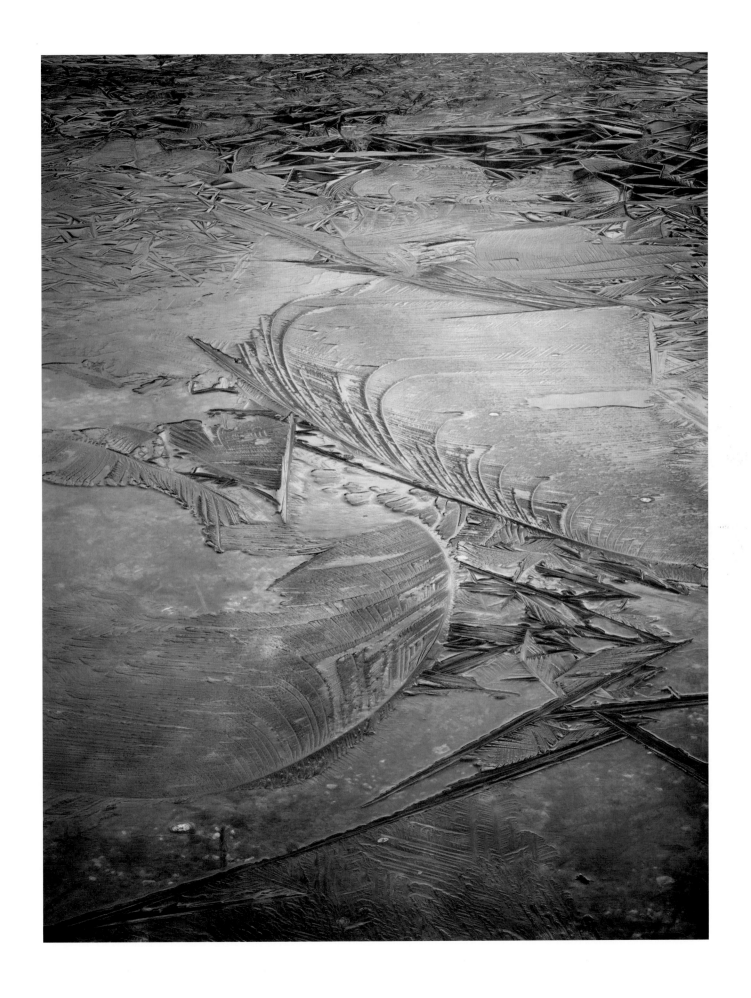

ARCTIC BRITAIN
The Cairngorms, Highlands

Joe had to admit that, deep down, he was dreading it. It was his first visit to the Cairngorms, the last relict of Ice Age Britain, and it was early January in the depths of a bitter winter. When he reached the Highlands in his campervan, Braemar was effectively cut off by blizzards and all the paths were obliterated by deep-lying snow. After an abortive walk up Glen Lui from the Linn of Dee towards the Lairig Ghru, he decided discretion was the better part of valour, and he returned to Braemar in an unsuccessful search for snowshoes.

The forecast was better for the following day, but the weather closed in again and he had to retreat once more, this time to the welcoming warmth of a Braemar guesthouse. 'I had walked ten miles for two bleak close-ups,' he recalls. 'A sense of futility and desolation was hard to avoid. Yet I was safe, and though wet, I had learned more about the territory. It was no time to be defeatist.'

The following morning he set off for the third time from the Linn of Dee, this time taking the Glen Dee approach to the Lairig Ghru, the 20-mile (32km) glaciated gash which slashes through the heart of the wildest and most inhospitable parts of the Cairngorms, between Braemar and Blair Atholl. Joe's objective was the Corrour bothy at the foot of Devil's Point, the 3,294-foot (1,004m) southern bastion of the Lairig Ghru, whose Gaelic name Bod an Deamhain means the Devil's Penis.

But the going was hard. 'I ploughed on through increasingly deep and crusty snow,' said Joe. 'A Chinese proverb says that a journey of a thousand miles begins with a single step; right now a single step was beginning to feel like a thousand miles.'

Eventually, the tiny, garden-shed-sized stone and corrugated-iron bothy appeared as a dark speck in the snowfields. Joe gratefully lit a fire and settled in for the night. An hour later he stepped outside into the polar-cold darkness to witness 'the most majestically clear, starry sky I have ever seen in Britain'. Arising early the next morning, as pink mists swirled in the Lairig Ghru, he captured some memorable images of first light on the crags of the Point.

The expedition was typical of a winter's day in the Cairngorms, and Joe's admirable persistence resulted in images of these unforgiving mountains that only a dedicated professional could obtain.

Recent research has discovered that the last glacier in the Cairngorms melted a mere 400 years ago – 11,000 years later than previous estimates. And when you look down on the glacial lakes of Loch Etchachan or Avon from the shattered pink granite boulders on the summits of Beinn Macdui or Beinn a'Bhuird, it's easy to believe that one day the glaciers could easily return to reclaim their icy hold on Arctic Britain.

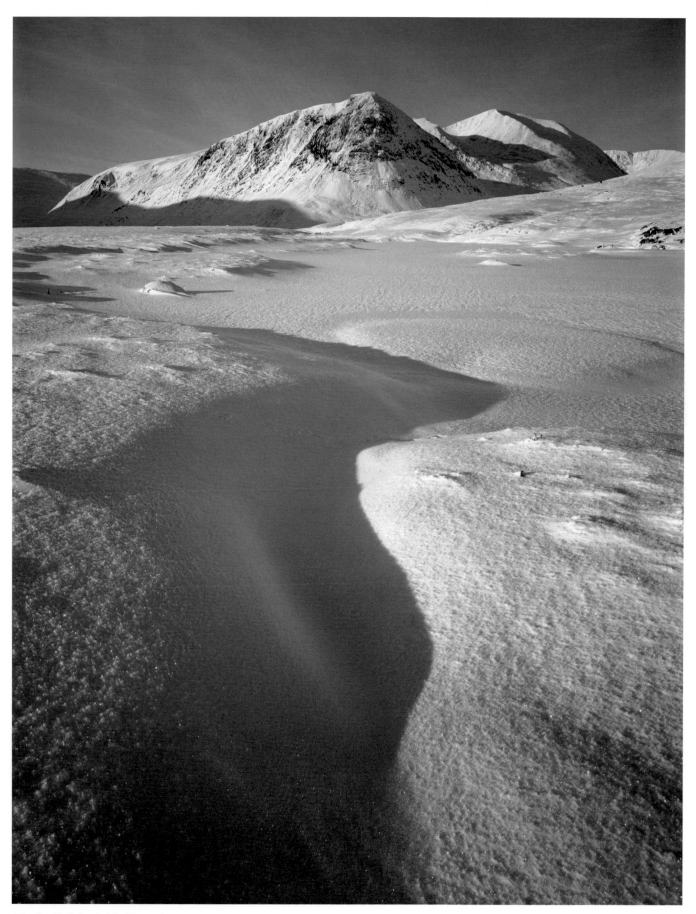

The Devil's Point, Lairig Ghru, winter

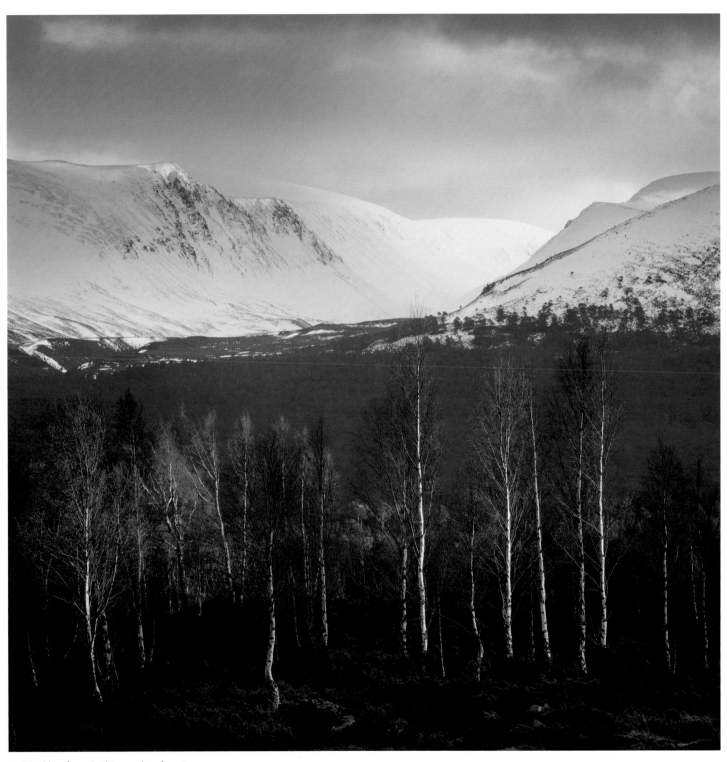

Lairig Ghru from Rothiemurchus forest

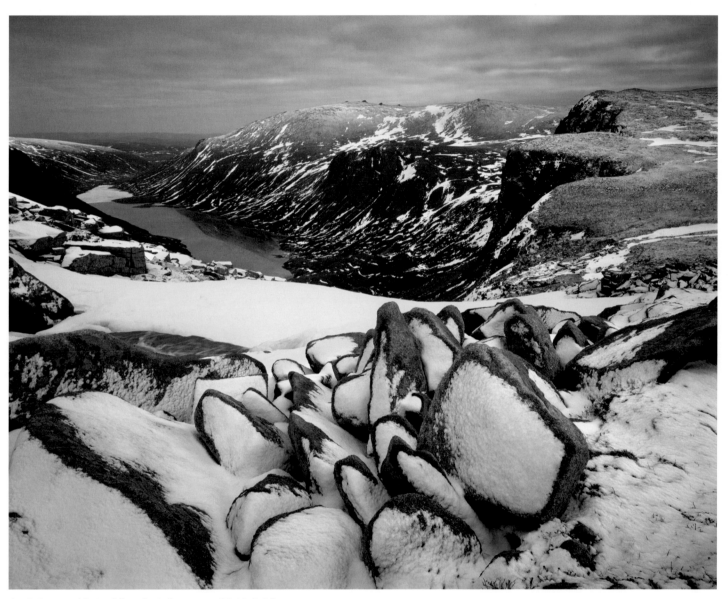

Loch Avon and Beinn Mheadhoin from east of Feith Buidhe

THE CHAIR OF IDRIS
Cwm Cau, Cadair Idris, Gwynedd

Cadair Idris ('the chair of Idris'), the 2,930 ft/893m summit dominating the Mawddach Estuary in southern Snowdonia, is the most English of Welsh mountains. The reason for this is its popularity with walkers from the nearby Midland shires, so you're quite likely to hear a Brummie accent if you take the stepped path up the mountain from the Idris Gates at the head of Tal-y-llyn.

The dramatic glacial corrie of Cwm Cau was described by pioneer mountain photographer Walter Poucher as 'one of the wildest places in all Wales'. You don't see the perfect little lake of Llyn Cau, nestled behind its surrounding *roche moutonnées* and grassy moraines in the glacier-carved hollow beneath the cliffs of Mynydd Pencoed and Craig Cau, until the very last minute. It's always a dramatic and truly magical moment.

The effect was beautifully described by Showell Styles in his 1973 account of *The Mountains of North Wales* as '. . . nicely stage-managed by Nature so that any glimpse of Llyn Cau is denied until the last possible moment, the lie of the terrain edging the path into position for a memorable *coup de théâtre*. On a still day when the llyn is a mirror of turquoise reflecting the vertical precipices of Craig Cau, this cwm has no equal in Wales.'

The sixteenth-century English antiquarian, historian and topographer William Camden had claimed in his *Britannia*, published in 1586, that you could find mountain round-leaved sorrel 'in the rivulets among the broken rocks of Cader-idris above a certain lake call'd Llin y cau.' Thankfully, it's still there today.

The route to the summit of Cadair climbs over the rocky southern ridges to the shapely summit of Craig Cau, with dizzying aerial views down its precipitous gullies to the glittering waters of Llyn Cau below. It's then just a short step down and across the saddle to reach the reigning peak of Penygadair.

Cadair Idris can also be climbed from the north via the more boring Foxes Path, which breaches the battlemented, 6-mile long (9.5km) northern wall of the mountain as seen from Dolgellau, Barmouth and the Mawddach, in the shadow of the Cyfrwy ridge, with its prominent Table perched midway.

Legend claims that the Idris who used the summit for his chair was the mythical giant Idris Gawr, who is said to have been skilled in astronomy, poetry and philosophy and used the summit as a celestial observatory. But a more likely candidate is Idris, a Prince of Merioneth in the seventh century, who overcame an invading Irish army at the Slaughter of the Severn, but died a hero's death in the process.

The longstanding legend that anyone who sleeps in Idris's chair on the summit will awake either as a poet or madman is now thought to be the product of the over-fertile Victorian imagination. But it could possibly stem from the ancient tradition of bards sleeping on mountain tops in search of heavenly inspiration.

Anyone who does decide to sleep on Cadair's exposed summit may not be guaranteed bardic immortality or gibbering insanity. But they could be rewarded with the unforgettable sight of the golden disc of the sun setting over Barmouth Bay and the shimmering silver sandbars of the Mawddach Estuary, threaded by the seemingly insignificant latticework span of the 1867 wooden railway bridge (see picture opposite).

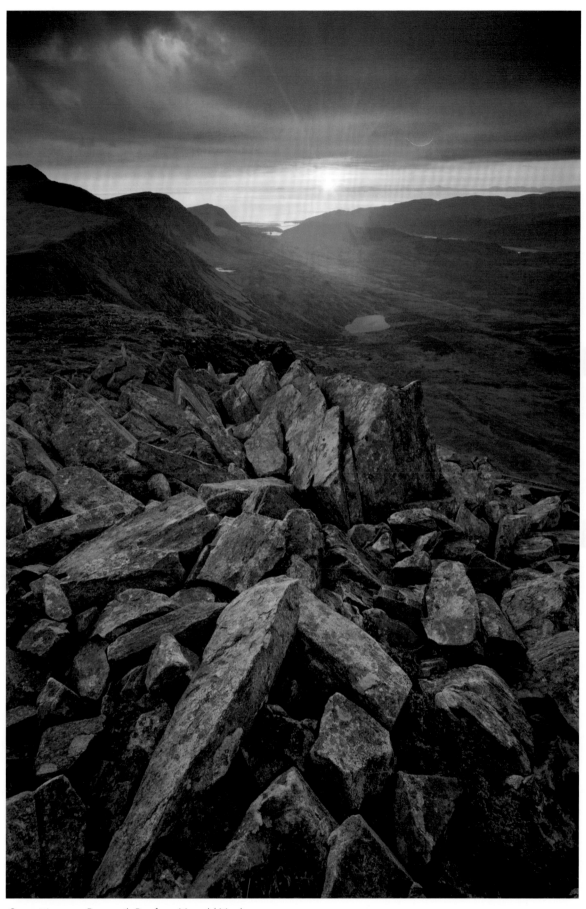

Sun setting over Barmouth Bay from Mynydd Moel

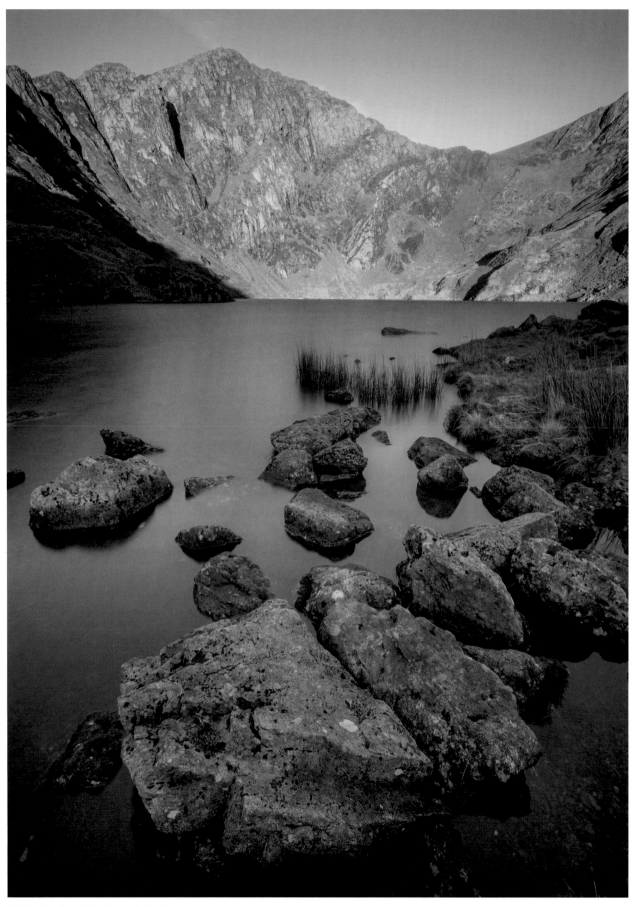

Craig Cau from the shore of Llyn Cau

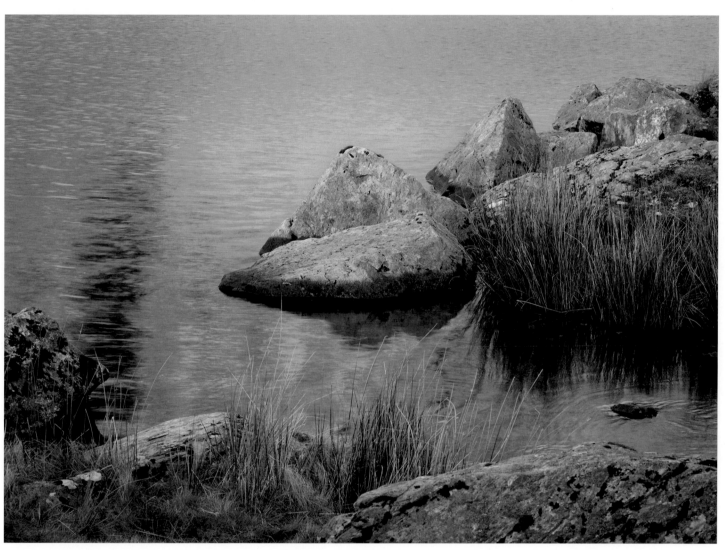

Reflections, Llyn Cau

SAM'S EPIPHANY
Scafell Pike and Wasdale, Lake District

England's highest mountain, Scafell Pike, holds a special place in Joe's family history. It was the place where his son Sam, then thirteen, found his appetite – both for the hills and for a good square meal.

Joe explains: 'The two of us had camped at Wasdale Head and got up an hour before sunrise the following morning. It was a beautiful day, and we set off up Lingmell Gill for the long grind up Brown Tongue. We were so early we had the route to ourselves – a rare thing on Scafell Pike – and got to the summit in an hour and fifteen minutes, just as the sun rose. It must have inspired Sam, because much to my surprise, he turned to me and said: "Can we go up Gable now?" Of course, I couldn't refuse, so we descended to Sty Head and then straight up Great Gable.'

But by the time they had started the long descent of the grassy crest of Gavel Neese back to Wasdale, Sam's enthusiasm was beginning to wane, and according to his dad, he started showing the unmistakable signs of a hunger-induced sense-of-humour failure. A skinny dip in the icy waters of Lingmell Beck revivied their spirits, and by the time they reached the Wasdale Head Inn, they were ravenous. Joe recalls: 'Sam, who had never taken much of an interest in food before, had two straight helpings of chicken and chips!'

It used to be said that Wasdale was home to England's highest mountain, deepest lake, smallest church . . . and biggest liar. Certainly Scafell Pike, at 3,208ft/978m, has no rival to its claim to be the highest point in England – although most mountain connoisseurs would agree that its near neighbour Scafell (3,162ft/964m), with its superb, gulley-riven northern buttresses, is a far finer mountain.

And Wastwater is certainly the country's deepest, and many would say most beautiful, lake. Its dark, brooding, glacier-sculpted waters, bordered to the south-east by the magnificent Wastwater Screes, have been measured at a chilly 258ft/79m deep.

The Wasdale Screes, funnelling down in huge, spreading fans from the 2-mile-long (3.2km) escarpment of Illgill Head on the eastern shores of the lake, are a fine example of ice and frost erosion on the Borrowdale volcanics.

And the church of St Olaf's at Nether Wasdale is said to be one of the smallest in England and dates from 1550, but was probably built on a much earlier foundation.

Wasdale Head's perfect symmetry of shapely mountains – Yewbarrow, Great Gable, Lingmell and the Scafells – clustering around the head of the lake was the natural choice as the symbol for the Lake District National Park when it was designated in 1951.

But who was the liar? As much a part of the Wasdale scene as the lake and surrounding fells is the white-walled and slate-roofed Wasdale Head Inn at the foot of Great Gable. Will Ritson (1808–90) was the landlord of the Wastwater Hotel (as it was then called) in the late nineteenth century, and was renowned for telling tall stories.

Unlike Sam Cornish, who certainly could tell a few after his many subsequent mountain expeditions with his dad. And gastronomically speaking, he's never looked back after that mammoth Wasdale Head meal, and is now a strapping six foot two and has stroked his college's first eight at Oxford.

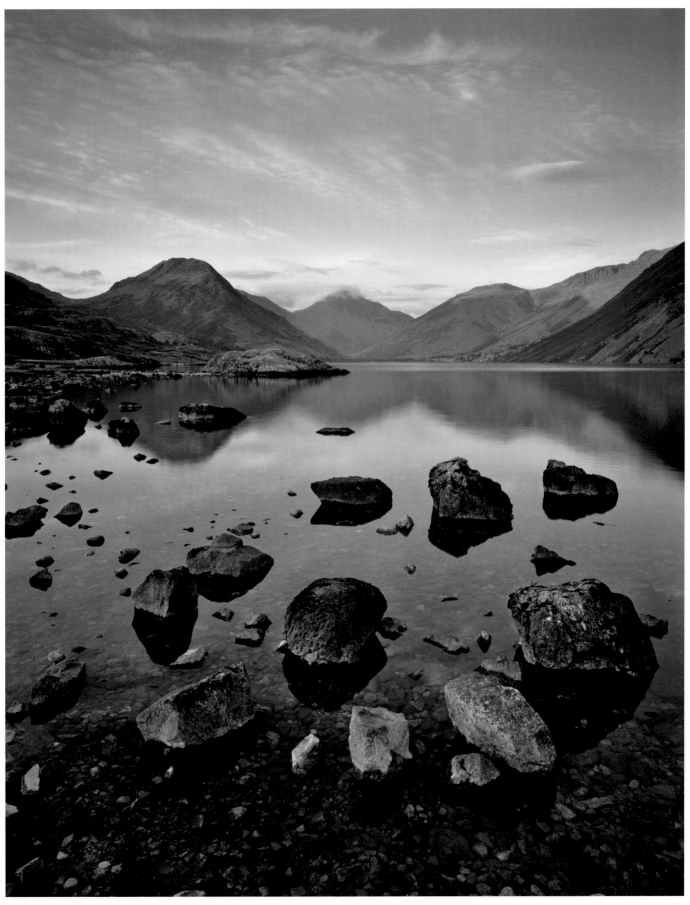

Wastwater, summer evening

THE CASTLE OF THE WINDS
Tryfan, the Glyders and Cwm Idwal, Snowdonia

We'd been closely involved in the high-pressure organisation of a major Festival of National Parks, attended by Princess Diana and 15,000 other people and held in the palatial setting of Chatsworth Park. Pete rightly observed that we needed to get away and relax.

'Let's go to Snowdonia,' he suggested. 'We need to stretch our legs and get some good mountain air into our lungs.' So, sneaking a day off our work with the Peak District National Park Authority, we set off along the A5 and M54. There was Pete McGowan – irrepressible area ranger and marathon walker – my good friend and Chief Ranger the late Ken Drabble, and me.

We parked on the A5 beneath the shark's fin of Tryfan, and Pete led us up the diagonal traverse of Heather Terrace. Rounding a rocky corner, I had the shock of my life by being faced by a rather smelly, fully horned and magnificently bearded feral billy goat. 'Don't worry,' laughed Pete, 'he was as frightened of you as you were of him.' I wished I could have been so sure.

We topped out after a quick scramble up to the 3,010ft/988m summit, but declined Pete's invitation to accept the traditional Freedom of Tryfan by jumping between the Adam and Eve monoliths which crown the litter of boulders at the top.

'Now it gets more interesting,' said Pete, as he led us down the precipitous south ridge of Tryfan towards Bwlch Tryfan and the impending aptly named Bristly Ridge of the Glyders. Now neither Ken nor I classed ourselves as

rock climbers, but Pete had done a bit, and he scrambled up the ridge with all the adroitness of that billy goat we'd just encountered. Although I later learned that Bristly Ridge is only rated as a Grade 1 scramble, Ken and I struggled in his wake, and there was a fair amount of sweating (of the clammy, fearful kind) and some under-the-breath swearing about our leader.

However, we survived and eventually emerged on the extraordinary summit plateau of Glyder Fach. If there's anywhere in Britain where the forces of frost and ice left over from the last Ice Age are more obviously apparent, I have yet to find it. The whole of the summit is covered by a chaos of frost-splintered rocks, culminating in the extraordinary, precariously balanced 70-ton slab of the Cantilever Stone, and the bristling hedgehog-spiked tor of Castell y Gwynt (the Castle of the Winds), truly a perfect fortress for the Snow Queen.

We walked on to the broad and desolate 3,279ft/1,076m summit of Glyder Fawr, and then descended the deep, dark cleft of Twll Du (the Devil's Kitchen) via a series of steep steps into Cwm Idwal, its glacial lake shining like a glittering jewel in the valley below.

The hanging valley of Cwm Idwal is another great example of an ice-carved landscape, with Llyn Idwal sitting comfortably in the hollow formed by a cirque glacier and dammed by humpy moraines at its northern end. The ice-polished slopes of the Idwal Slabs at the head of the lake – a popular training ground for *real* rock climbers – provides further evidence of the grinding power of the ancient Idwal glacier.

We were just glad to get down in one piece . . .

Below Llyn Bochlwyd, winter

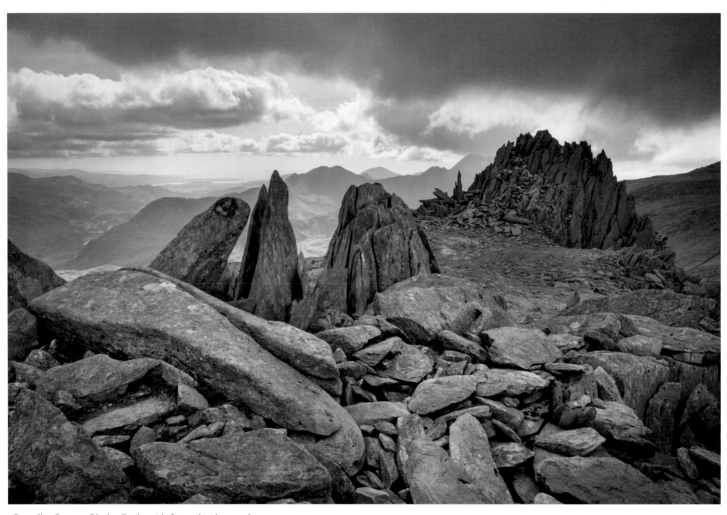

Castell y Gwynt, Glyder Fach, with Snowdon beyond

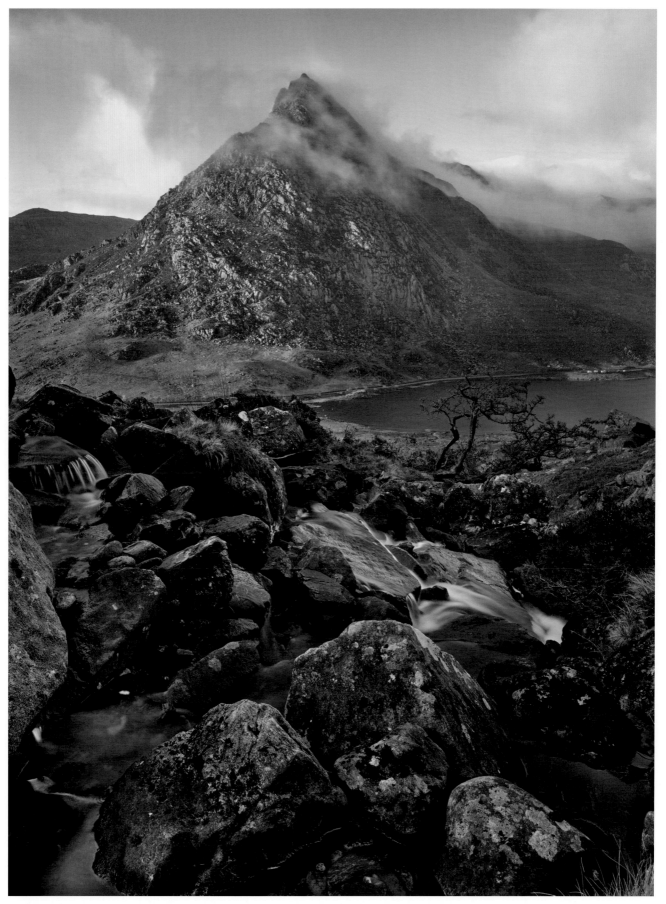

Tryfan, early morning

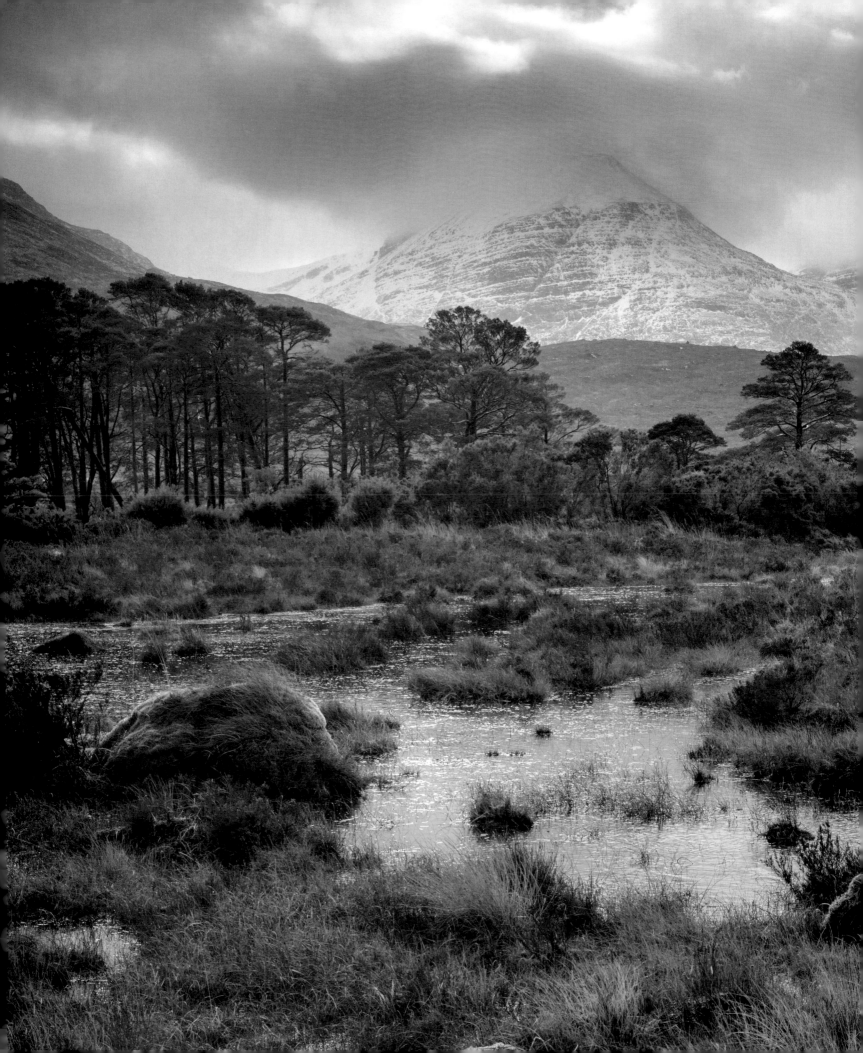

High Land – Scotland

HIGH LAND – SCOTLAND

Some would say that Highland Britain only exists

north of the Border. Scots would argue that England has

few mountains at all, and only seven tops in the Lakes would

qualify for the magic 3,000-foot Munro status, which makes a

proper Scottish mountain. Certainly Scotland's mountains

have shaped its history and the character of its people

in a way found nowhere else in Britain.

The overpowering grandeur of places like the dramatic

defile of Glencoe, and the isolated 'inselbergs' of Suilven and

Slioch and the Torridon peaks, give the impression of ranges far

greater than their actual altitude, and the prevailing Atlantic

weather makes them every bit as serious a climbing

proposition, especially in winter.

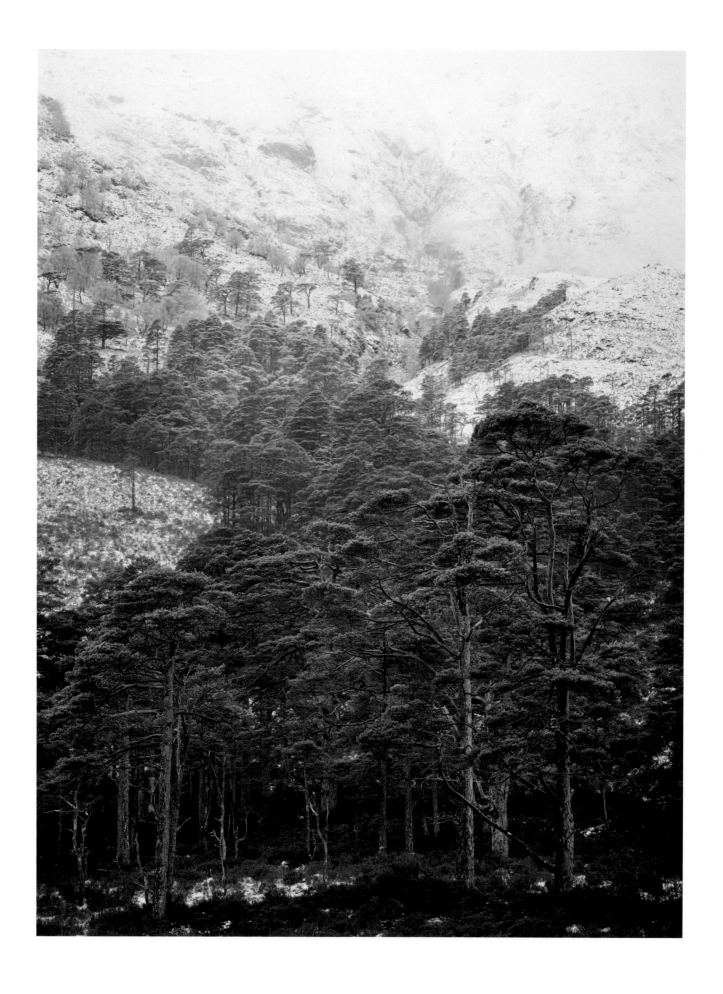

CORRIES WITH A FRINGE ON TOP
Beinn Eighe and Liathach, Upper Loch Torridon, Highlands

It's a tough, 5-mile (8km) walk in from Glen Torridon to reach Choire Mhic Fhearchair (pronounced 'Corry Veek Errecher'): surely one of the grandest and most imposing sights in the Scottish Highlands.

Its 1,250-foot-high (380m) face is riven by deep gullies into three huge bastions, giving it the popular name of Triple Buttress. The lower halves of these tremendous buttresses are banded with horizontal layers of red sandstone, and the upper half with shining white quartzite.

The Triple Buttress of Choire Mhic Fhearchair forms the north-western end of the summit ridge of Beinn Eighe (pronounced 'ay' and meaning 'File Mountain'), which was created Britain's first National Nature Reserve (NNR) in 1951. Its pale, barren, quartz-covered summit slopes are often mistaken by visitors for snowfields, although in the depths of winter, the snow can be very real and lingers long in the gullies of Choire Mhic Fhearchair.

Joe was unlucky on his first visit to this fabled spot. 'Surrounded by colossal facts of geology and reasonable weather, the photographic possibilities should have been infinite,' he recalled, 'but the light and environment seemed in conflict and I realised inspiration had deserted me for the day.'

But the Torridonian sandstone and sharp-cut quartzite rocks, which had tumbled down into the corrie from the summit ridge, struck him 'like the rough offcuts of temple building from some ancient classical civilisation'.

Beinn Eighe was designated the nation's first NNR chiefly because of its ancient Caledonian pinewoods, home to secretive crossbills, soaring golden eagles and, more recently, a pair of majestic white-tailed sea eagles, which nested in the woodlands by the shores of Loch Maree.

Lording it over Glen Torridon to the north stands Liathach ('the grey one'). This is another vastly imposing Torridonian giant, usually cloud-capped and, brooding over the still waters of Loch Clair, giving a fair impression of Conan Doyle's Lost World of the Amazon. But no dinosaurs haunt the quartzite summit cap of Liathach. If you are lucky, the only pterodactyl you might see haunting the sky over the shattered quartzite summit spires known as the Fasarinen Pinnacles will be a soaring golden eagle.

The tiered mural precipices of Liathach, an irresistible challenge to any red-blooded hillwalker, consist of layer upon layer of Torridonian sandstone, topped again by that band of snowy-white Cambrian quartz. And the reward of the reigning summit of Spidean a' Choire Leith (3,461ft/1,055m) is a breathtaking view which can extend over 150 miles (240km) from Ben Hope in the north to Ben Nevis in the south.

W.H. Murray described Liathach as 'the most soaring mountain of the North', and despite its apparent inaccessibility its summit is easily reached by a direct if arduous assault starting from just east of Glen Cottage and then a grind up the steep upper slopes of Toll a'Meitheach via a series of rocky steps in Allt an Doire Ghairbh.

The 5-mile (8km) summit ridge traverses no less than eight separate tops, two of which – Spidean a' Choire Leith and Mullach an Rathain, (3,356ft/1,023m) – are treasured Munros.

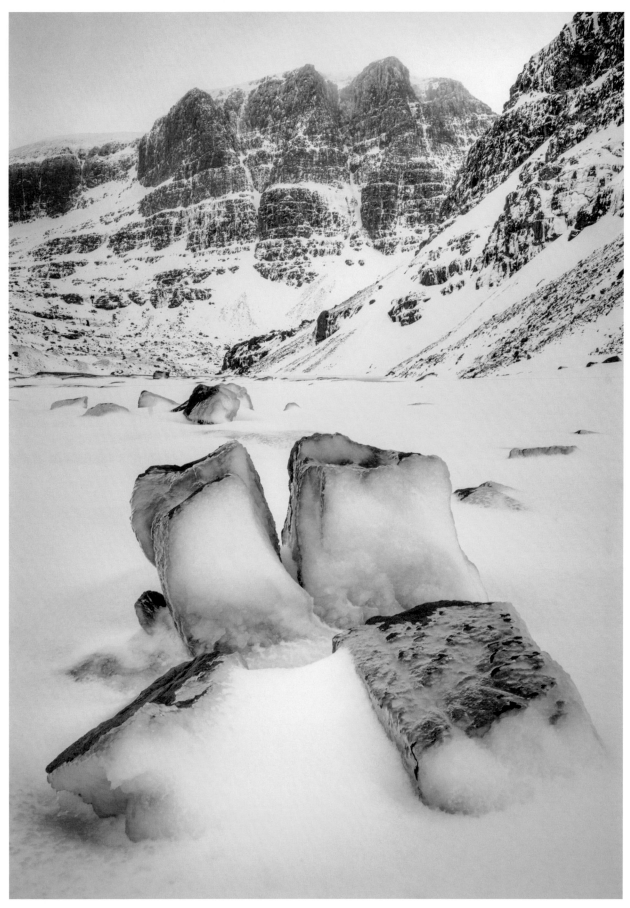

Triple buttress, Choire Mhic Fhearchair

59

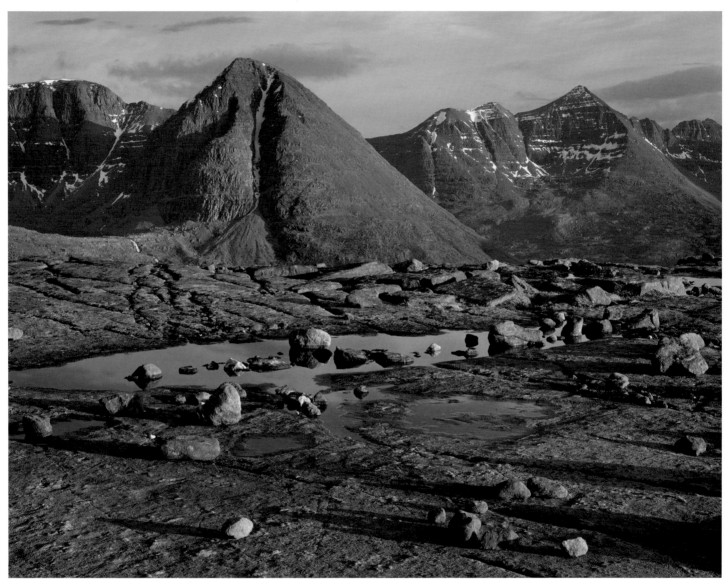

Sàil Mhór and Liathach from Beinn a' Chearcaill

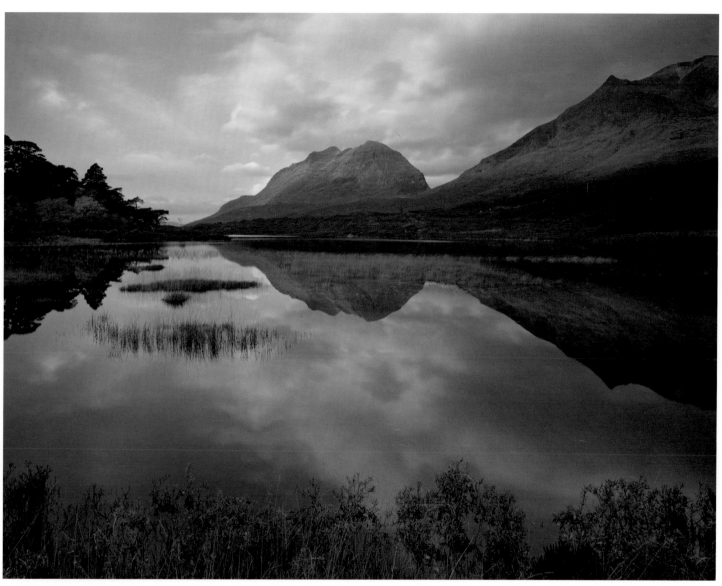

Liathach from Loch Clair

Reeds and reflections, Loch Clair

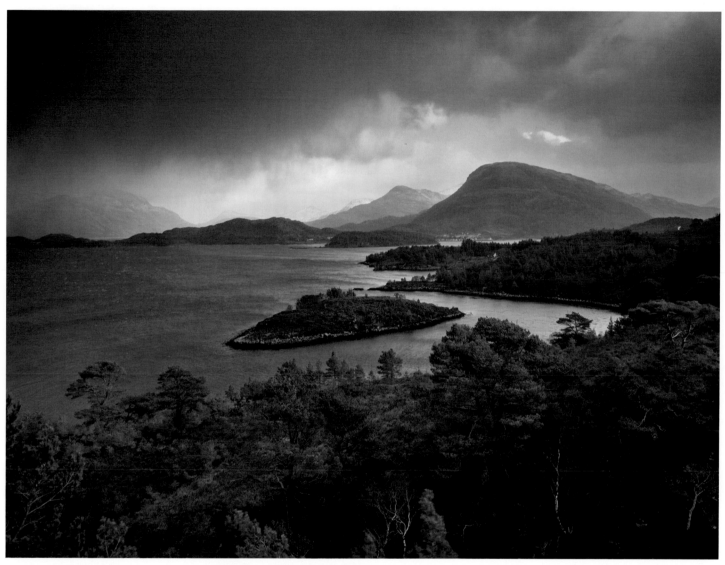

Upper Loch Torridon

SPANIARDS' BLOOD
Glen Shiel and Loch Duich, Highlands

The great Scottish mountaineering writer Bill Murray, writing in *Highland Landscape* (1962), his seminal survey for the National Trust for Scotland, was unequivocal: 'In Kintail, nothing lacks; all things culminate. It is the epitome of the West Highland scene.' Few would disagree with his assessment, which was eventually to lead to the designation of the 60-square-mile Kintail National Scenic Area in 1980.

The crowning glory of the Kintail NSA are the splendid hills which crowd around the mountainous head of Loch Duich on either side of the A87 as it runs through Glen Shiel. These include the elegant, steepled ridge of the Five Sisters and, across the glen, The Saddle and Sgurr na Sgine.

Three mountain ranges meet here: Beinn Fhada (the long mountain, 3,386ft/1,032m), the Five Sisters of Kintail (culminating in Sgurr Fhuaran, 3,501ft/1,067m) and the South Cluanie Ridge, which extends for 9 miles (14km) and includes seven Munros leading up to Aonach air Chrith (3,350ft/1,021m) and The Saddle (3,314ft/1,010m). These can all be reached by experienced hillwalkers via the formidable scramble known as the Forcan Ridge.

Much of the northern side of Glen Shiel, including the Five Sisters ridge and remote Beinn Fhada between Glen Lichd and Glen Choinneachan, is now in the hands of the Trust. Its Kintail estate extends north to the remote and spectacular Falls of Glomach, one of the highest waterfalls in Britain, where the waters of the Allt a'Ghlomaich burn tumble for 370 feet (113m), contained within the walls of a narrow, rowan-hung ravine. To reach the falls, it's a tough but rewarding, five-hour, 10-mile (16km) walk on the deer-stalkers' path from Morvich at the mouth of Loch Duich.

The glens radiating from either side of Loch Duich are uniformly steep-sided and narrow, and contain rushing burns which tumble through waterfalls and pools lined with birch, rowan and alder to eventually reach the still waters of the loch.

The junction where the loch turns west to meet the sea and Loch Alsh and Loch Long, is guarded by the romantic and much-photographed castle of Eilean Donan, a heavily restored structure on an ancient island site, linked to the mainland by a causeway. The originally thirteenth-century castle, which has become an icon of the Scottish Highlands, lay in ruins for two centuries after it was heavily bombarded by a British frigate during the Jacobite Rebellion in 1719.

Shortly after this a Jacobite force, which included a 300-strong contingent from Spain, were defeated at the Battle of Glen Shiel in the corrie beneath the northern slopes of the mountain which is still known as Sgurr nan Spainteach ('Peak of the Spaniards').

The Spanish apparently fought a brave rearguard action, and the peak and corrie were named in their honour by sympathetic local people. The ruby-red garnets, which can still sometimes be found splashed and encrusted in the silvery mica schist pebbles in the River Shiel are still known locally as 'Spaniards' blood'.

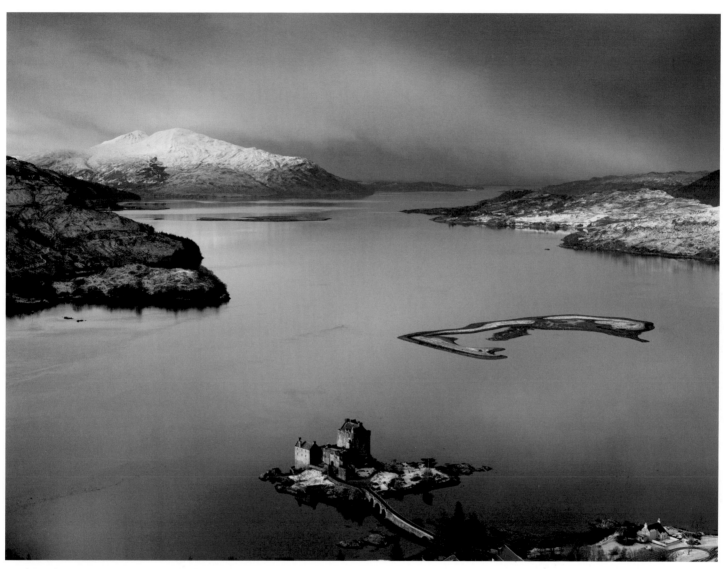

Loch Duich, winter

A LESSON LEARNED
Glencoe, Argyll

I'll never forget my first encounter with Buachaille Etive Mor, that rocky epitome of mountain grandeur which stands sentinel at the eastern entrance to Glencoe. It was fifty years ago, and I was in a party of four friends from our East Anglian village, on holiday to Scotland for the first time and all crammed into our 'sturdy and dependable', sit-up-and-beg, 1949 Ford Popular.

Driving north on the A82 from the sylvan shores of Loch Lomond, we'd reached Bridge of Orchy, from where 'the Sturdy' had protestingly chugged up onto the bleak moorland plateau of the Black Mount. Here we were faced by the beautiful desolation of Rannoch Moor: mile upon mile of bright purple moorland studded by countless sapphire-blue lochans dotted with small, rocky islands, which were graciously festooned with ancient birch, rowan and pine.

All around was the dramatic backdrop of the dark, forbidding mountains of the Black Mount: Stob a'Choire Odhar, Stob Ghabhar, Clach Leathad, Creise and Meall a'Bhuiridh. Brought up in the breadbasket flatlands of East Anglia, we'd never seen anything quite so wild and wonderful and, literally overwhelmed by the scene, we all fell silent.

Then as we approached Kingshouse, the Buachaille burst into view – a perfect cone of granite riven with dark gullies and soaring ridges which led to a temptingly pointed summit. It was just too much for us Essex boys, and we bundled out of the car and headed straight across the boggy moor bound for the hill, equipped with nothing more sophisticated than our Chelsea boot winklepickers and plastic macs.

I reckon we got about as far as the lowest reaches of Crowberry Gully before discretion thankfully became the better part of valour and, one by one, we turned back. Just as well, because it could easily have all ended in disaster, but it was a valuable lesson I never forgot.

Since then, of course, better equipped and with a lifetime's experience in the hills, I've explored Glencoe thoroughly: climbing the Devil's Staircase constructed by General Wade's troops to reach Kinlochleven; inching along the serrated cock's comb of the Aonach Eagach which forms the northern wall of the glen – surely the finest ridge scramble in Britain – and delving into the deepest recesses of the 'lost valley' of Coire Gabhail, between the first and second of the glen's famed Three Sisters, where the MacDonalds hid their rustled cattle far from the eyes of their sworn enemies, the hated Campbells.

Glencoe will always be associated with the massacre of about thirty-eight MacDonalds by members of the Earl of Argyll's Regiment of Foot under the command of Captain Robert Campbell in February 1692. Although the official excuse was that Alastair Maclain, Chief of Glencoe, had been late in pledging his allegiance to William and Mary, the reason the massacre still rankles was the fact that the troops, having first been billeted with the MacDonalds, had abused the time-honoured Highland tradition of hospitality. That's why a sign above reception in the eighteenth-century Clachaig Inn at the foot of Glencoe still reads 'No hawkers or Campbells'.

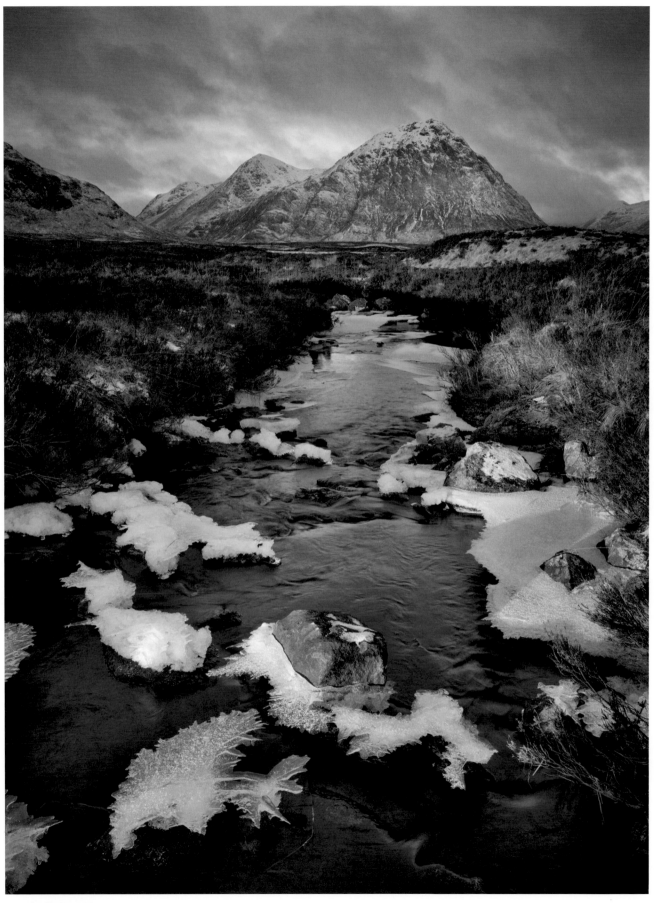

Buachaille Etive Mor

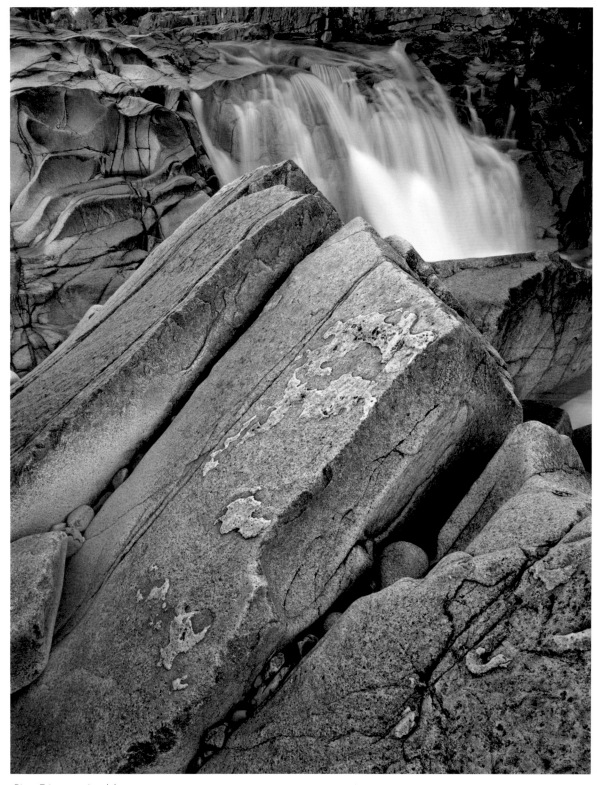

River Etive, granite slabs

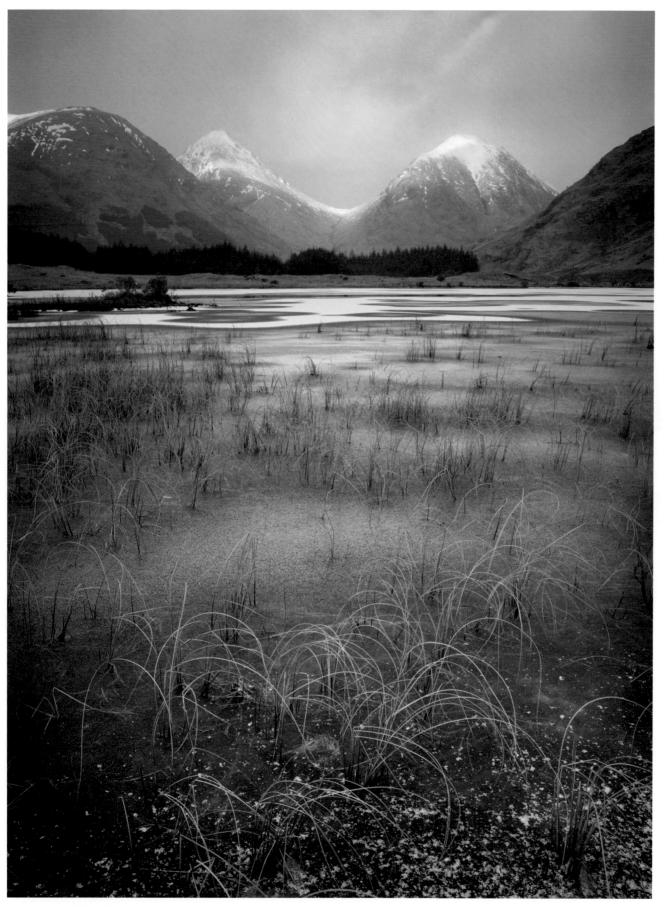

The two Buachailles from Lochan Urr

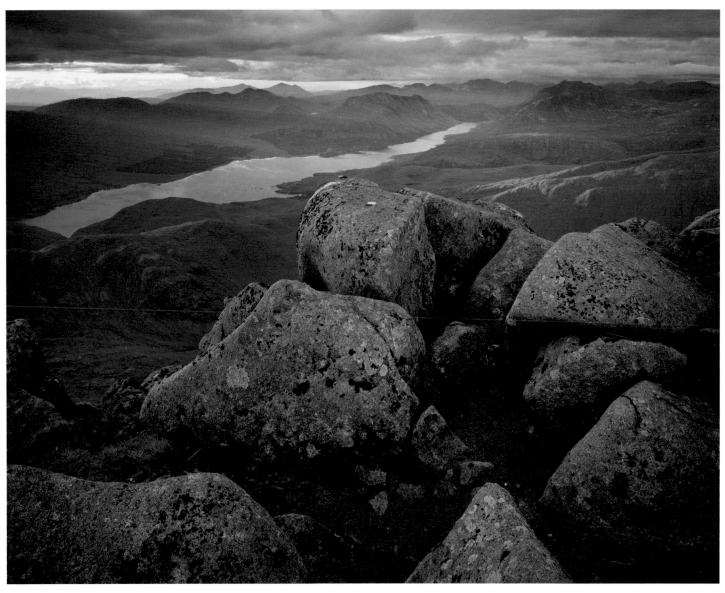

Loch Etive from Ben Cruachan summit

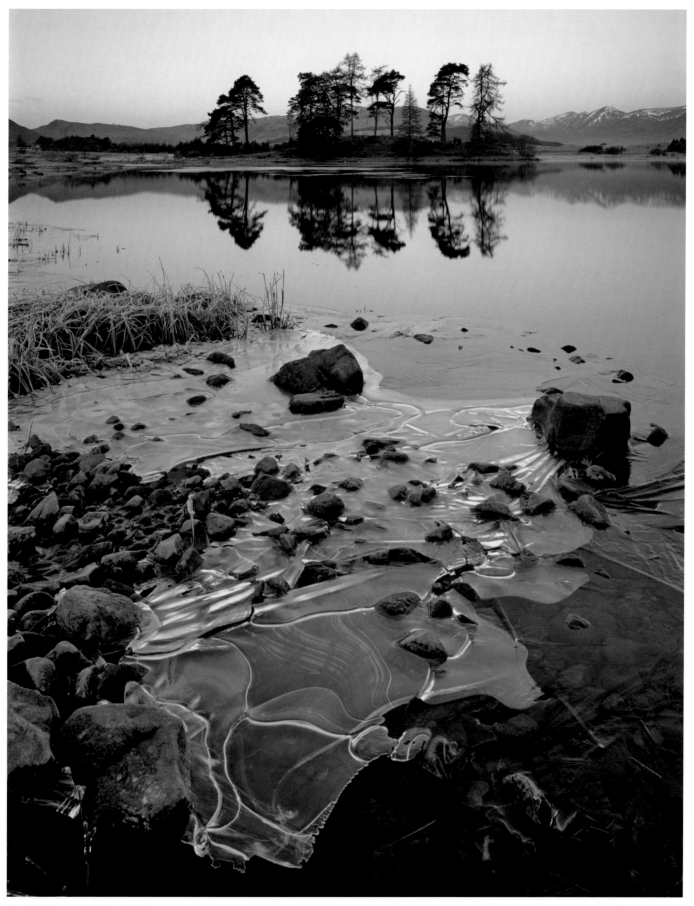

Loch Tulla, near Bridge of Orchy

THE FORTRESS BY THE LOCH
Slioch and Loch Maree, Highlands

Seen from the beautiful, pine-studded shores of Loch Maree, the largest loch north of the Great Glen, the buttressed granite walls of Slioch (3,218ft/981m) look like nothing less than a mighty, castellated fortress guarding its upper reaches. Its Gaelic name – meaning The Spear – adds to its military character. But it is a fortress relatively easily scaled via the open expanses of Gleann Bianasdail, which branches off to the north-east from the head of the loch, and then taking the steep path towards the mouth of Coire Tuill Bhàin (the white hollow) to reach the curving summit ridge.

According to mountain photographer Walter Poucher writing in the mid-1960s, the most romantic approach, avoiding the 5-mile (8km) slog up from Kinlochewe, was to arrange for a ghillie to row the climber across the loch from Rhu Noa, and to pick him up in the late afternoon'. Willing ghillies are somewhat harder to find these days.

You may wonder, as many have, why the hamlet of Kinlochewe (literally the Head of Loch Ewe) is so named, when the great sea loch of Loch Ewe lies at least 15 miles (24km) to the north-west. The answer is that it was once connected to Loch Maree in one great loch extending from The Minch inland to Glen Docherty. Over the centuries, it has become separated by sediments spreading across the low-lying ground around Londubh, Poolewe and Loch Kernsary and is now linked to it by the canalised, 2-mile (3km) River Ewe.

Loch Maree is said to take its beautiful name from the eighth-century St Maelrubha, whose grave lies overlooking the Inner Sound, Raasay and Skye at Applecross. He apparently lived in a lonely hermitage on the Eilean Maruighe, or the Isle Maree, a tiny, forested islet close to the Letterewe shore. Before Maelrubha's occupation, the island is said to have been sacred to the Druids, and W.H. Murray claims that pagan rites involving the sacrifice of a bull occurred here as late as the seventeenth century. It became a place of pilgrimage and the loch took its name, eventually to be Anglicised to Maree from the unpronounceable Maelrubha and Maruighe. Highland lover Queen Victoria visited the island in 1877.

Writing in *Highland Landscape* (1962), Murray also claimed that Loch Maree was 'one of the most excellent' of Scotland's big inland waters. Its only possible rival, he claimed, was Loch Lomond. 'Ben Lomond, however, has a less powerful presence than Slioch, and its loch is without the Caledonian pines and extent of heather that add variety so markedly to the shores of Loch Maree,' he added. 'Loch Maree exhibits the wilder and tougher forms of mountain beauty, Loch Lomond the gentler.'

Seen from the deep slit containing Lochan Fada to the north, at the head of Gleann Bianasdail, Slioch presents an entirely different and contrasting profile. From here it is a shapely pyramid of sandstone resting on Lewisian gneiss, reflected in the lochan and lording it over the great, heather-clad wilderness that is the Letterewe Forest.

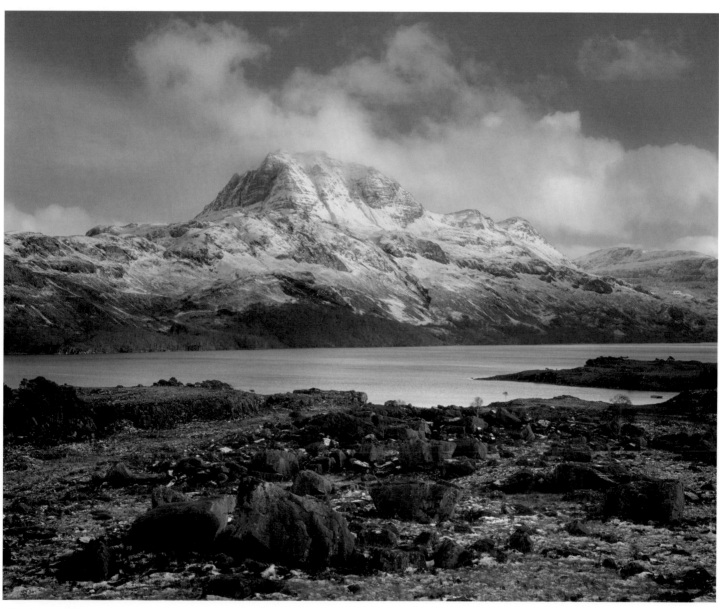

Slioch and Loch Maree

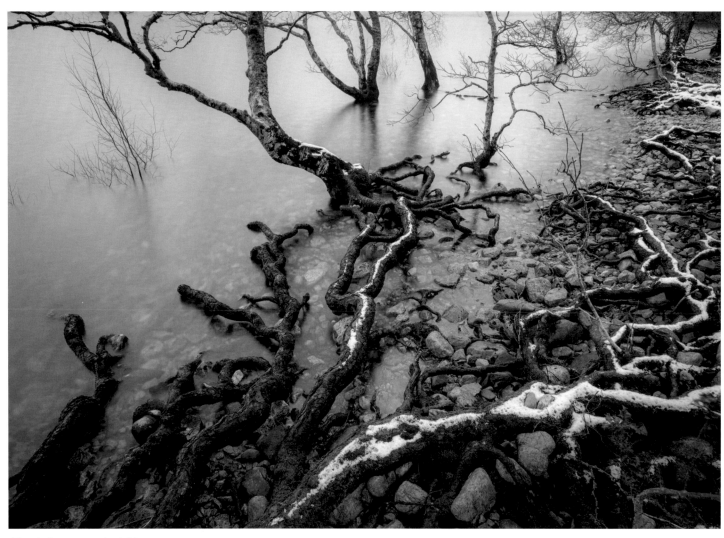

Flooded tree roots, Loch Maree

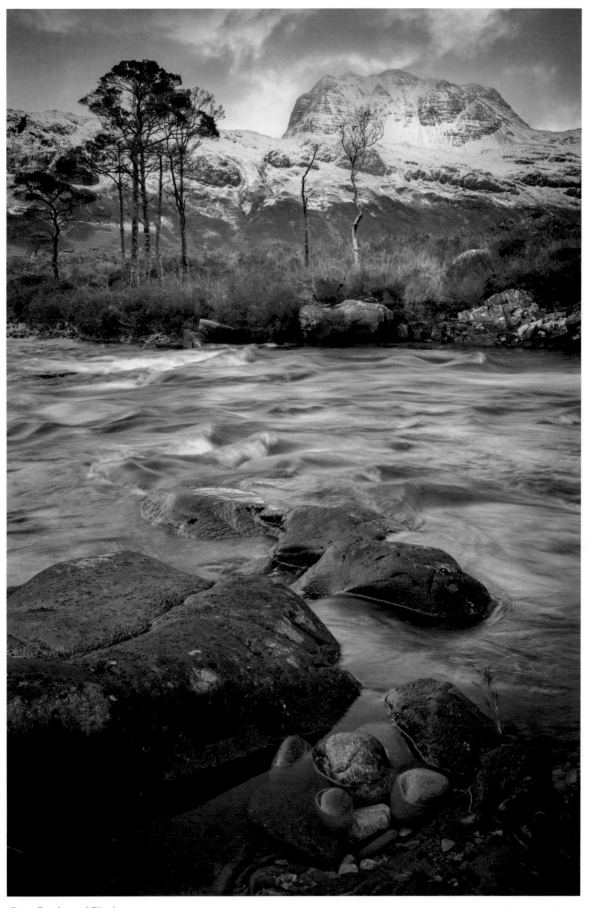

River Grudie and Slioch

'THE BEN' AND GLEN
Ben Nevis and Glen Nevis, Highlands

The wooded middle section of Glen Nevis, the spectacular gorge carved out by the Water of Nevis to the south of Ben Nevis, has often been compared to a Himalayan valley.

From the pastoral lower reaches, the glen climbs through glorious oak, alder, pine and birch woodlands on a narrow path above the boiling, rushing waters of the river, with glimpses of Carn Dearg, Meall Cumhann and the smoothly glaciated, southern shoulders of 'the Ben' on your left. No other part of Britain has greater relative relief. The glen runs south then east from the Georgian garrison town of Fort William, under the southern slopes of the Ben. It makes a beautiful, sylvan prelude to the highest ground in Britain.

The upper glen is a place of peaceful, Alpine meadows, where the ruins of Steall farmhouse are enhanced by the backdrop of the tremendous 350ft/106m leap of Steall Waterfall, as it crashes down the lower cliffs of Sgurr a' Mhaim in a lacy cataract. To reach the waterfall, you have to cross a nerve-testing, three-stranded wire bridge over the rushing Water of Nevis.

The northern side of Ben Nevis is dominated by Coire Leis, described by the distinguished mountaineer W.H. Murray as 'the most splendid of all Scottish corries'. Coire Leis is flanked by the knife-edge ridges of Carn Mor Dearg, Aonach Beag and the tremendous northern buttresses of Ben Nevis. Here stands the CIC Hut, a refuge for generations of climbers on the Ben, built in 1929 as a memorial to mountaineer Charles Inglis Clark, who died during the First World War. It is now maintained by the Scottish Mountaineering Council.

The normal 'tourist' route to the summit of Ben Nevis, from Achintee at the foot of Glen Nevis, is known as the Pony Track, and was constructed in 1883 in order to get building materials to the summit for Ben Nevis Observatory. A team of three meteorologists lived here for weeks on end in the tiny building, making regular observations of the rainfall, temperature, wind speed and sunlight for twenty years until the observatory closed, despite storms of protest, in 1904.

Those hardy meteorologists recorded annual averages of temperature of 31.4°F (–0.3°C); about two hours sunshine a day; nearly 158 inches (4m) of rain, and wind speeds which exceeded 150 miles an hour (240km/h) in winter. The maximum depth of snow, 141 inches (3.5m), was recorded in April 1883.

The Pony Track ascends gradually from Achintee up to the broad saddle that contains Lochan Meall an t-Suidhe, known as the Halfway Lochan. A steep and arduous series of zig-zags then takes you up the broad west face of the Ben, where you eventually reach the relatively flat but highly exposed summit and the remains of the observatory. The route is only about 5 miles (8km) in length, but involves 4,400 feet (1,340m) of relentless ascent. It usually takes between three and four hours, and as countless charity walkers have discovered, it is not to be underestimated and a serious undertaking. The weather on the Ben can change in an instant.

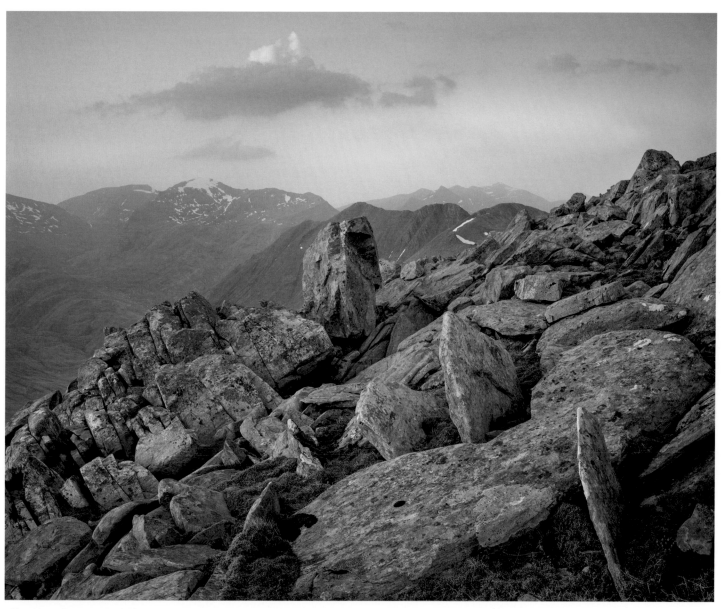

Glen Nevis from Am Bodach

Caledonian pine, Glen Nevis

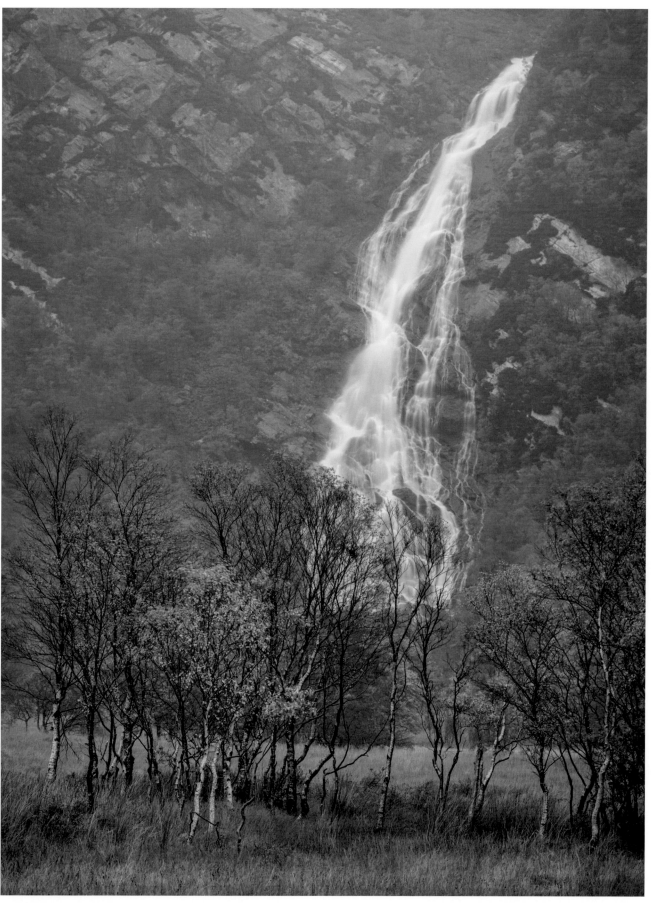

Steall Waterfall, Glen Nevis

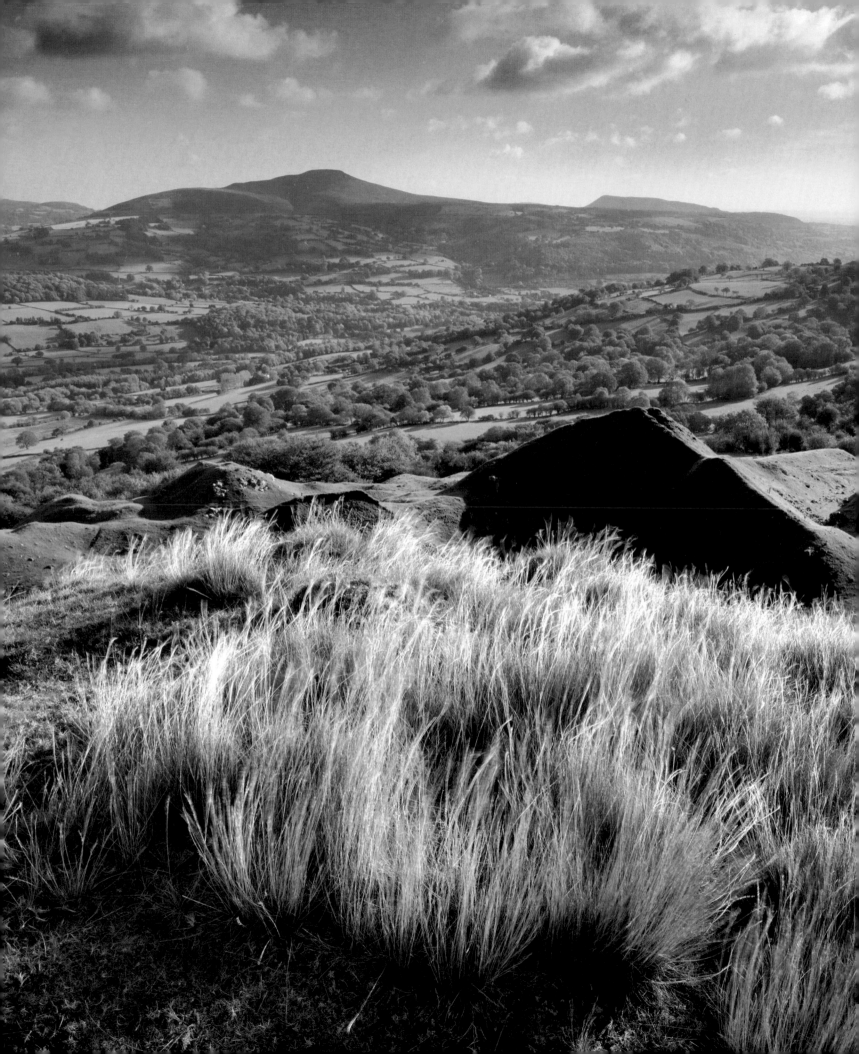

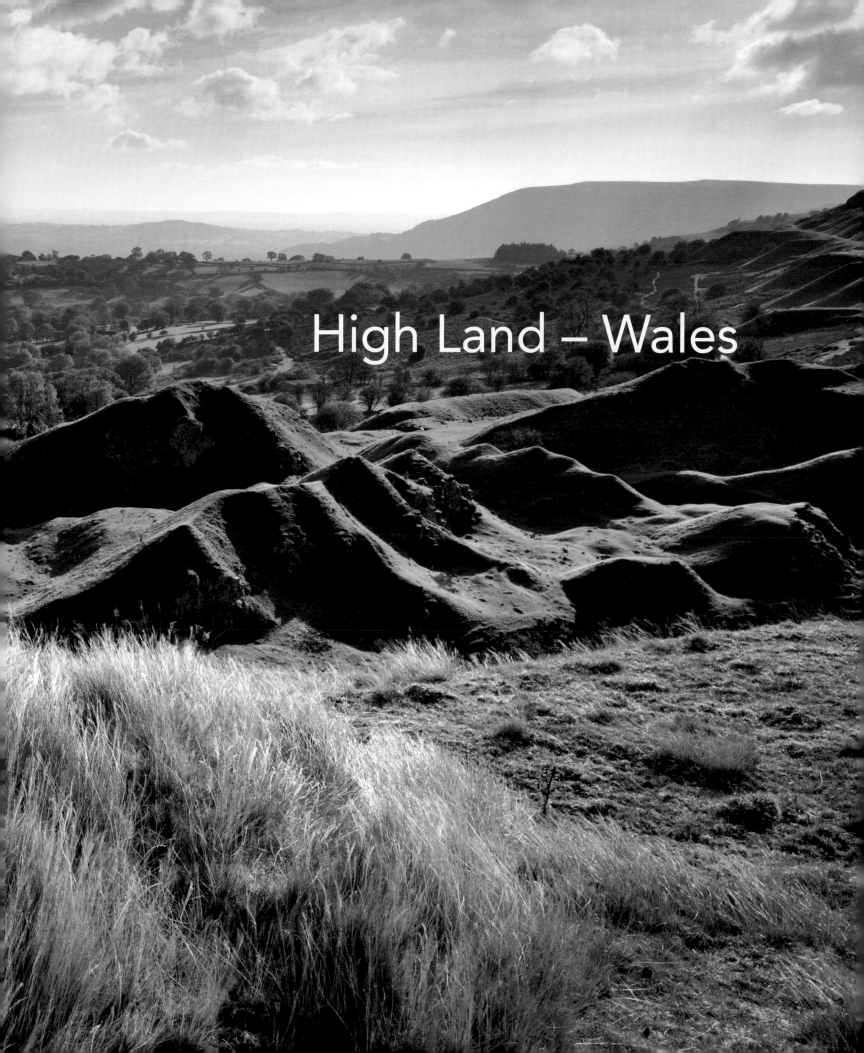

High Land – Wales

HIGH LAND – WALES

In his introduction to *Wild Wales* (1862), the

eccentric English author George Borrow wrote that he

considered Wales 'one of the most picturesque countries in

the world, a country in which Nature displays herself in her wildest,

boldest and occasionally loveliest forms'. Small wonder then that

Wales has no less than three National Parks, and in Snowdonia,

the highest ground in Britain south of the Scottish Highlands.

From the Ordovician slates of Yr Wyddfa on Snowdon in

the north to the striated Old Red Sandstones of the

Brecon Beacons in the south, Wales is a

mountain lover's delight.

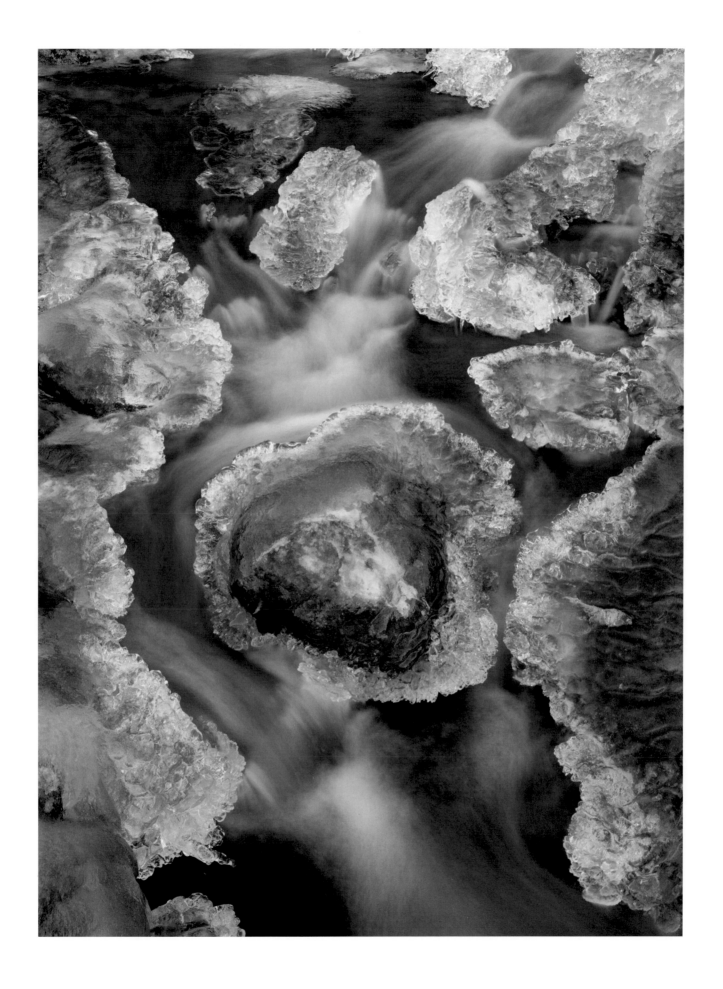

A LUCKY ESCAPE
Snowdon, Gwynedd

'Now be very careful,' I warned. 'It's always more dangerous going down than going up.' As one of the more experienced hillwalkers in an admittedly ill-equipped party of fellow Coventry journalists who had ventured down the A5 for a mid-winter ascent of Snowdon some forty years ago, I felt I had some kind of responsibility. The conditions were about as difficult as they could get. It was a grey January day as we set out from Pen-y-Pass to take the easy Miners' Track to the 3,560ft/1,086m summit. And as we ascended the Zig Zags above the shores of Glaslyn, we hit the snowline.

And it wasn't just snow as we emerged by the monolith at Bwlch Glas, on the col between Carnedd Ugain and the reigning summit of Yr Wyddfa. A freezing wind had turned the surface to ice, and lacking ice-axes and crampons, some people were donning socks over their boots to get some kind of purchase on the skid-pan surface.

We all made the summit – not that there was anything to see in the freezing fog and cloud – and set off back down the track to Bwlch Glas. My good friend Alan had lost his expensive sunglasses on the Zig Zags on the way up – although quite why he was carrying them on such a claggy day, I never found out. Just as we started down the Zig Zags and I had uttered my safety warning above, he saw them, sticking out of the snow just below the path.

'Don't worry,' I said confidently, 'I'll get them.' And stupidly, I set off down the near-vertical icy slope face-out, kicking my boot heels into the snow for footholds. In an instant, one foothold gave way swiftly followed by the other and before I knew it, I was falling uncontrolled on my bottom down what is easily the steepest face on the mountain.

Your whole life is supposed to flash in front of you in situations like this, but all I can remember was it like being on a helter-skelter, with rocks and small outcrops flashing past as I skidded down, vainly trying to dig my heels in to arrest my fall. The others, having seen me fall down the near-vertical face, had already set off to call the mountain rescue. But somehow, quite incredibly, the small avalanche of snow which had built up under my heels slowed and eventually stopped me. I lay there for a few minutes, gingerly feeling my limbs, but miraculously nothing appeared to be broken. I called to the others that I was OK, and then very, very carefully made the tricky traverse across the snow and ice-covered face to rejoin the path.

It remains the closest I have come to death in the hills, and later, much better equipped and in better conditions, I have enjoyed the Snowdon Horseshoe, the classic 8-mile (13km) scramble over the knife-edge of Crib Goch, Carnedd Ugain, Yr Wydffa and Y Lliwedd. But I can safely say that I learned a valuable lesson on that bitter January day. It's not the mountains that are dangerous; it's the way you treat them.

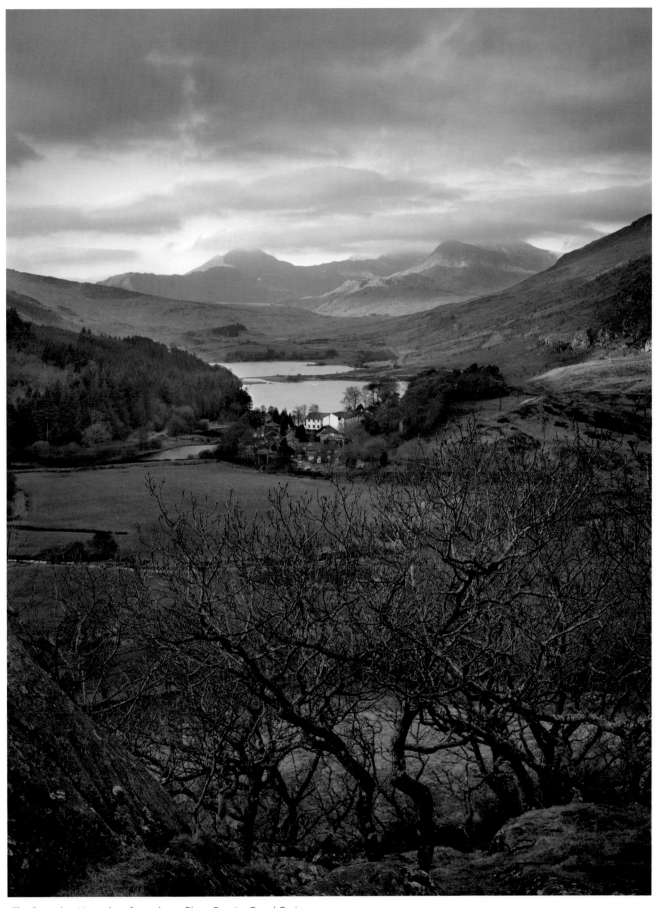

The Snowdon Horseshoe from above Plas y Brenin, Capel Curig

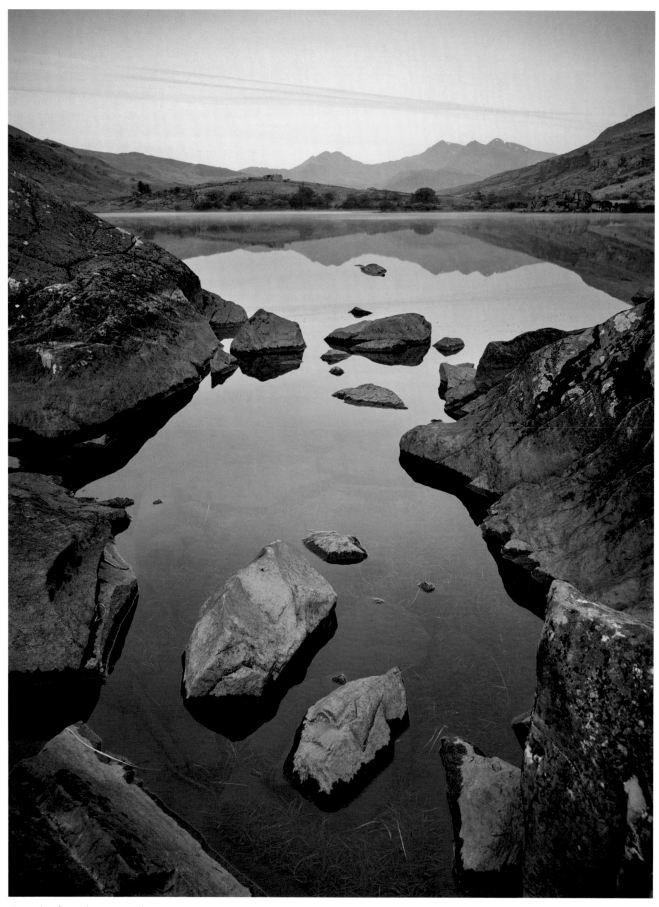

Snowdon from Llynnau Mymbyr

Slate sheep fences, Watkin Path, Snowdon

THE BECKONING BEACONS
Pen y Fan, Brecon Beacons

Tommy Jones, a tubby five-year-old from the mining town of Maerdy at the head of the Rhondda Valley, was visiting his grandparents in the isolated farm of Cwm-llwch below the Brecon Beacons with his father over the Bank Holiday weekend of August 1900.

They'd caught a late train and the light was fading fast as they walked from the station in Brecon up the lane up to the farmstead of Login, where they met some soldiers. Tommy's cousin, Willie John, came down to meet them, and the two boys set off for the farm together. But little Tommy was tired and started to cry, saying he wanted to go back to his father, so Willie carried on to tell the grandparents of the approaching visitors. Somehow in the gathering gloom, little Tommy must have became disorientated, and he never made it back to Login.

As soon as he was missed a massive search started which continued over several weeks, but no sign was found of Tommy. The story of the little lost boy hit the headlines, prompting the *Daily Mail* to offer the then sizable reward of £20 for any news of his whereabouts. It was a month before Tommy was found, when a gardener from Brecon came across his sailor-suited body on the exposed 2,250ft/685m ridge of Craig Cwm Llwch, below the summit of Pen y Fan. It seems that Tommy had become hopelessly lost in the darkness, continuing to climb up past his grandparents' farm and onto the bleak mountain ridge. The inquest on Tommy returned a verdict of death from exhaustion and exposure, and a simple, rugged obelisk was erected by public subscription on the exposed ridge the following year.

Tommy's tragic story serves as a chilling reminder that despite their modest height, the Beacons should be treated with respect. The fact that Royal Marine commandoes do their mountain training, with the occasional fatality, at nearby Sennybridge Camp, should serve as a warning to those who underestimate the beguiling Beacons.

The north faces of the central Beacons – Pen y Fan (the highest point at 2,907ft/886m), Corn Du and Cribyn – stand like a petrified wave of russet-red and green striated sandstones, frozen in the act of breaking over the lowlands of the Usk valley beneath. Another analogy would be of a neatly sliced layer-cake, consisting of alternate rust-coloured bands of Old Red Sandstone and green, vegetated Brownstones. Winter snows can add a sprinkling of icing sugar to the whole tempting confection.

The Beacons present a towering barrier to the south as the motorist travels along the A40 through the green valley of the River Usk between Abergavenny and Brecon. It is one of the finest valley-to-mountain prospects in Britain, and a reminder of the power of the Ice Age glaciers which carved the great scalloped cwms of Cwm Llwch, Cwm Sere, Cwm Cynwyn and Cwm Oergwm.

The 3-mile (4.8km) ascent of Pen y Fan from the Storey Arms on the A470 to the south-east is the easiest and most popular one, especially since the National Trust has now stepped and slabbed much of the route. But the ascent from Neuadd to the north via the ridge of Cefn Cwm-llwch and the traverse of the entire ridge from Corn Du via Pen y Fan, Cribin and Craig Cwm Cynwyn gives a far better feel of these fatally beckoning Beacons.

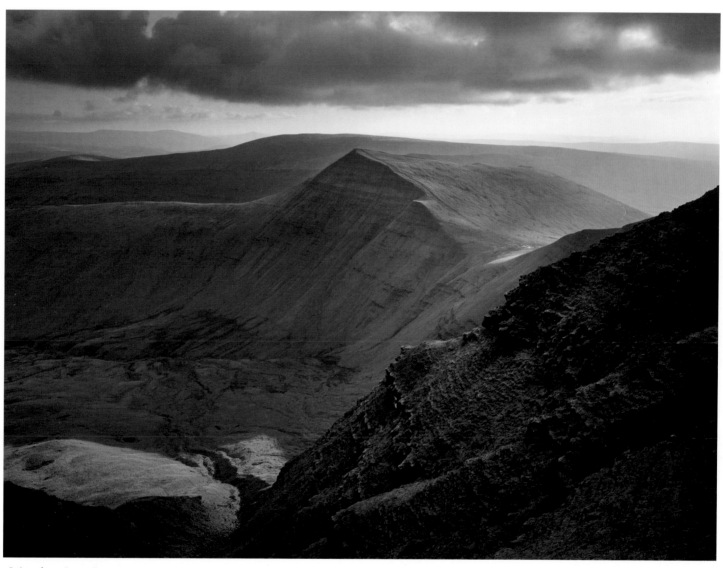

Cribyn from Pen y Fan

ARROW MOUNTAIN
The Rhinogs, Gwynedd

If you believe the guidebooks, the rocky, heather-covered Rhinogs in western Snowdonia offer some of the roughest and toughest walking in Britain. A gentle introduction to these knobbly and heather-covered hills, formed of 500 million-year-old Cambrian rock, is to start your exploration from the glorious tumbling sessile oakwoods which cloak the deep valley of Cwm Bychan, east of Llanbedr.

Cwm Bychan, filled by the shining waters of its eponymous *llyn*, is overshadowed by the rocky terraces of Carreg-y-Saeth (1,482ft/452m) – the rock of the arrows. This is a fine expedition on its own, and covers typical Rhinogydd country over trackless rocky steps and boulders and heather-filled canyons to reach its slabby summit.

The main path to Rhinog Fawr (2,362ft/720m) leads up from the lake over the triple streams of the clear waters of Afon Artro towards the slabs of the so-called Roman Steps. It's highly improbable that these were constructed by Imperial legionaries, but far more likely that they are an engineered route built for medieval cattle drovers making their way between Dolgellau and Harlech.

The path weaves through a series of rocky tors on either side, which close in as you eventually emerge at Bwlch Tyddiad, a grassy hollow overlooking the spruce woods of Coed y Brenin, with views of the featureless moors around Trawsfynydd. You now head south across some real ankle-twisting Rhinog rough country towards the desolate, crag-bound tarn of Llyn Du (Black Lake). The rocky north face of Rhinog Fawr lies straight ahead, and a quick scramble from its eastern shore up one of the scree-filled gulleys will take you to its bald and featureless summit.

The views from here extend over scores of tiny lakes, including Gloywlyn and sylvan Llyn Cwm Bychan to the north, and the partly hidden, steep scree-shored Llyn Hywel, which fills an improbable rocky shelf between the equally if not more impressive Rhinog Fach (2,335ft/712m) and the reigning summit of Y Llethr (2,480ft/756m). The mass of Y Llethr effectively blocks the view to the south.

You can return across more ankle-twisting Rhinog rough country via the long, narrow Lakeland-like tarn of Gloywlyn, which lies beneath the rocky crags of Rhinog Fawr. The landscape round here gives a fair impression of the desert canyonlands of Utah or Arizona, rather than what you might expect in Gwynedd. The difference, of course, is the Atlantic climate, which creates not a sun-scorched desert but often rain-soaked ranks of bushy heather punctuated by bright emerald oases of sheep-cropped grass. Eventually you emerge at a charming little packhorse bridge, to return through the songbird-filled oakwoods of Cwm Bychan.

The Rhinogs once formed the heartland of the Celtic kingdom of Ardudwy, which was renowned for the ferocity of its fighting men. It was an area that travellers feared to cross during medieval times because of its bands of renegade bandits and highwaymen. So maybe that comparison with the Wild West wasn't so fanciful after all.

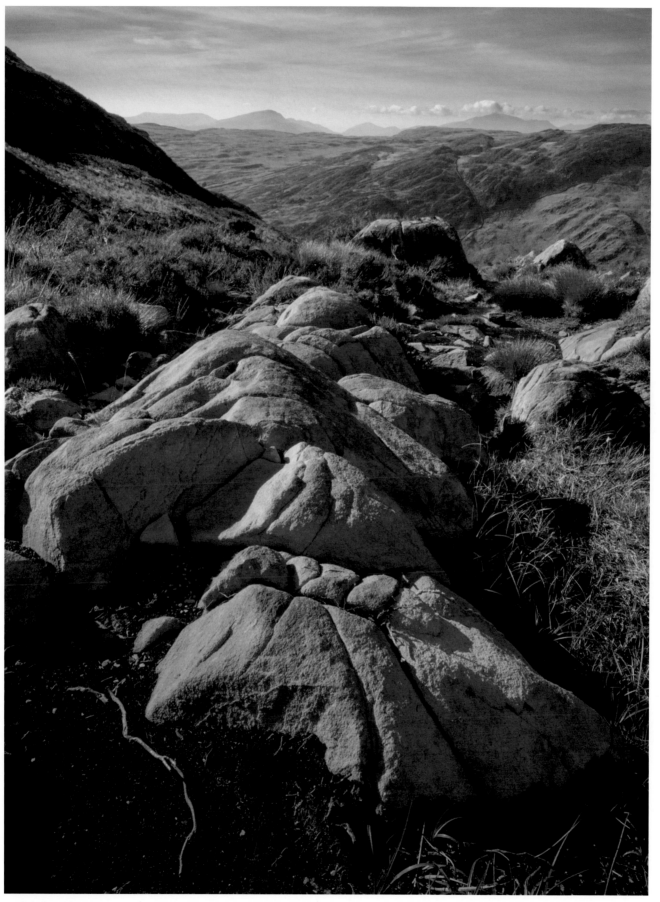

Path below Gloywlyn

Early summer in The Rhinogs

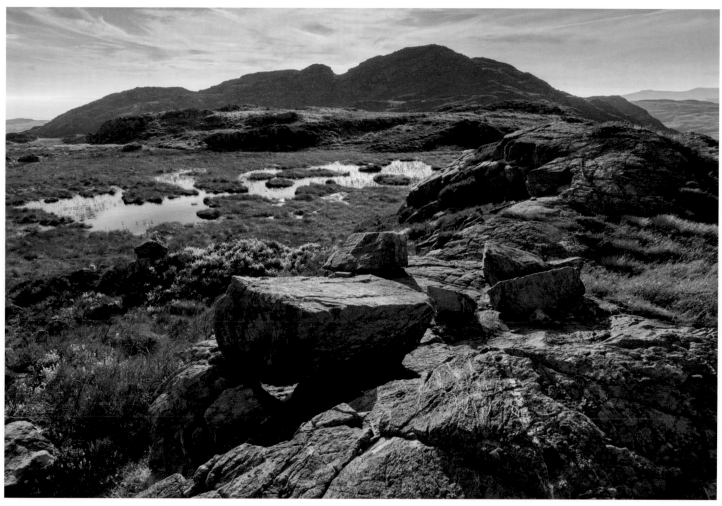

Carreg y Saeth

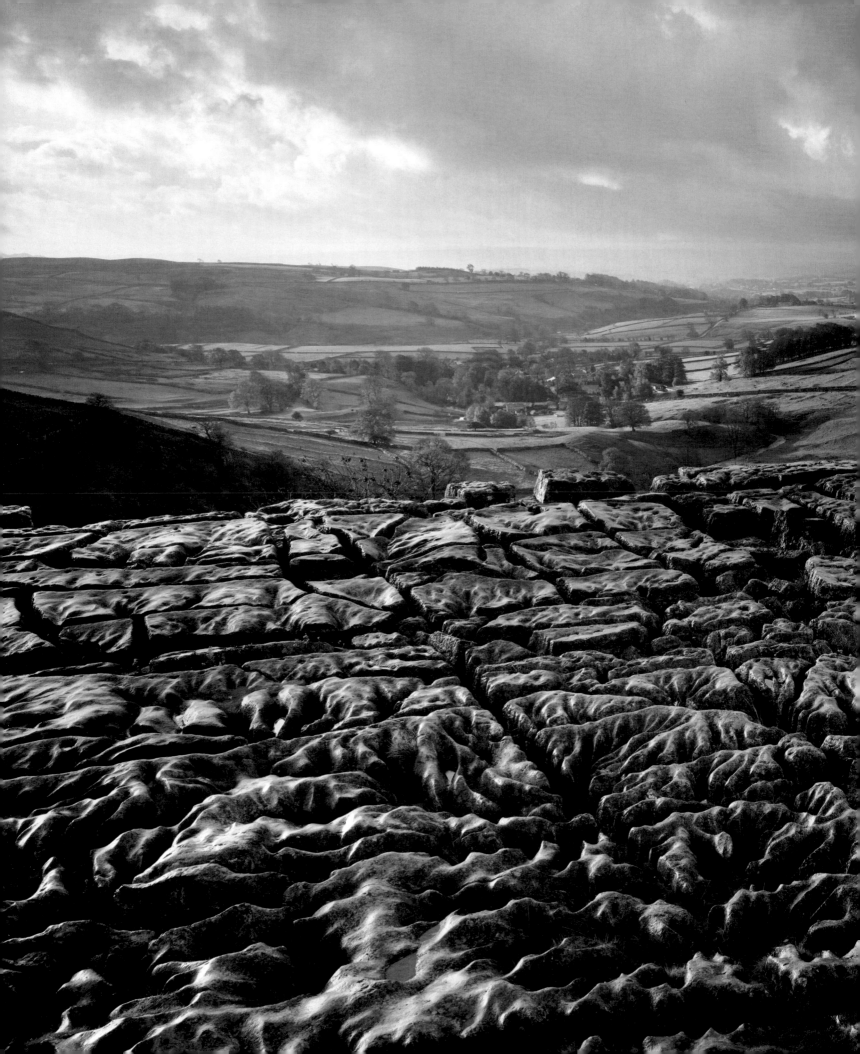

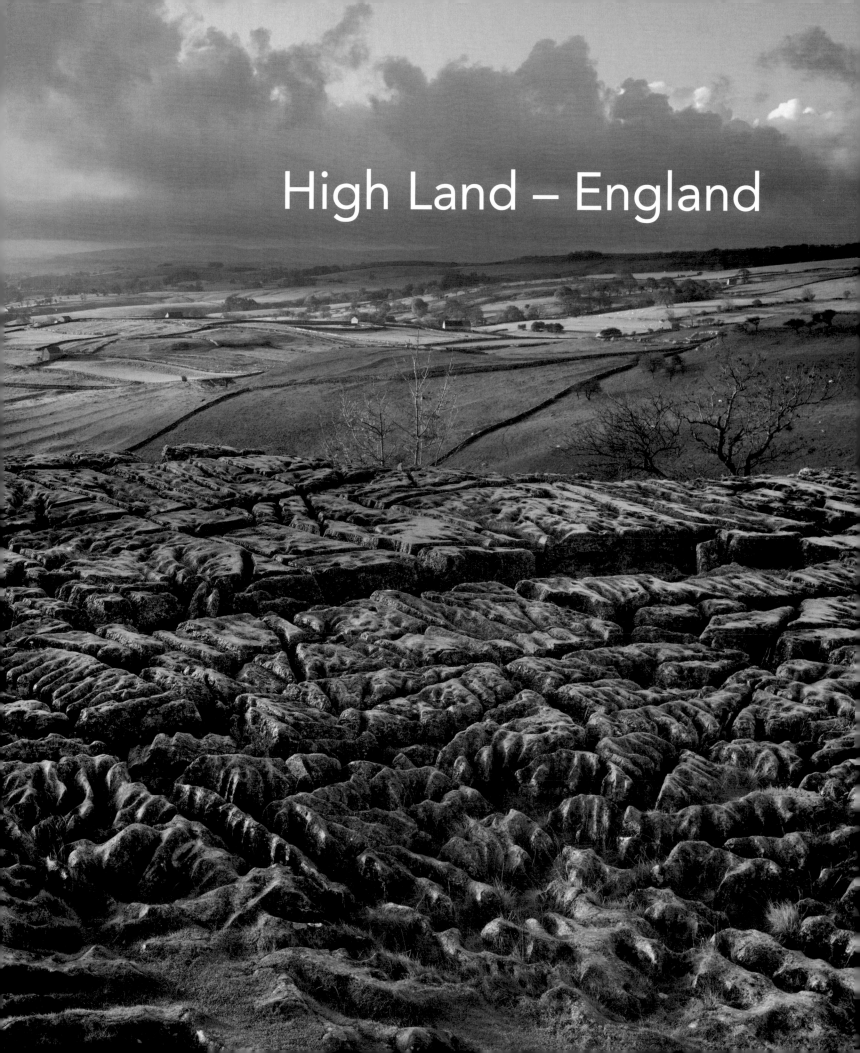

High Land – England

HIGH LAND – ENGLAND

For such a small country, the variety of England's

mountain scenery is astonishing. From the glorious fells, dales

and lakes of the Lake District, immortalised by William Wordsworth

and others, to the moors and 'edges' of the Pennines, the English

highlands are a constant cause of delight. The bleak, inhospitable

gritstone moors of the Pennines like Kinder Scout contrast sharply

with the sparkling limestone showpieces of the Yorkshire Dales,

such as Malham and Gordale. England's mountain mélange

is endlessly fascinating to the student of

upland topography.

GRAND CANYON OF THE PENNINES
Upper Teesdale and High Cup Nick, Cumbria

Nothing quite prepares the bog-trotting, head-down, rucksack-toting Pennine Wayfarer for the jaw-dropping moment as he or she reaches High Cup Nick.

Having trudged across the flat limestone outcrops, old mine shafts and swampy shake holes of High Cup Plain, you suddenly find yourself teetering on the edge of a yawning abyss, with a whole new world opening out at your feet. A vast amphitheatre drops vertiginously away, with the tiny silver thread of High Cup Gill winding hundreds of feet below, and the western views extending far out towards the misty Vale of Eden and the distant blue outline of the Lakeland hills. What a moment, and one that will make you forget those 150 thigh-aching, toe-blistering miles you have endured from Edale to reach this magical point.

High Cup Nick is surely the most dramatic moment on Tom Stephenson's 268-mile (431km) long-distance epic, and it has been called the most glorious landscape feature in the North of England, and even, if somewhat of an exaggeration, the Grand Canyon of the Pennines.

This huge bite out of the western scarp of the Pennines is result of the grinding power of Ice Age glaciers, and around the rim of the ravine, columns of steely-grey Whin Sill dolerite create a grandstand palisade. They include the hard-to-find rocky finger known as Nichol's Chair or Last, some 20 yards off the main path. It was named after a Dufton cobbler who had the nerve to climb to its crumbling summit – and, while sitting there, sole and heel a pair of boots.

To reach High Cup Nick, the Pennine Wayfarer has followed Maize Beck through the glorious Upper Teesdale

National Nature Reserve from High Force. Here, if you come in the right season, Ice Age relict species such as pink bird's eye primrose, the yellow stars of Alpine cinquefoil, golden globeflower and the electric blue of spring gentian will carpet the meadows of Widdybank and Cronkley Fells above the shattered crags of Falcon Clints.

The Whin Sill is also responsible for a couple of other Teesdale highlights passed on this section of the Way. The 600-foot (180m) waterfall of Cauldron Snout crashes and boils its way down from the vast Cow Green Reservoir above in a series of foaming cataracts. Since the construction of the ugly and ultimately unnecessary reservoir in 1971, Cauldron Snout is now tamed and regulated as an outflow from the artificial lake above.

Another great but long-forgotten landscape feature, which sadly disappeared under the bland, lapping waters of Cow Green, was the celebrated 'Wheel of the Tees' – a vast, deep, swinging meander in the riverbed once popular with local wild swimmers.

Further south is the glorious sight of not the highest but surely the most powerful of English waterfalls, High Force. The 70-foot (20m) cliff over which the peat-stained water thunders into its dramatic, wooded amphitheatre is yet another example of an intrusion of the ubiquitous Whin Sill.

As we see elsewhere in this book, this doleritic rock, formed as molten magma forced its way through the earth's crust around 295 million years ago, has had an enormous effect on the landscapes of northern England, from Lindisfarne in the east to Hadrian's Wall in the north.

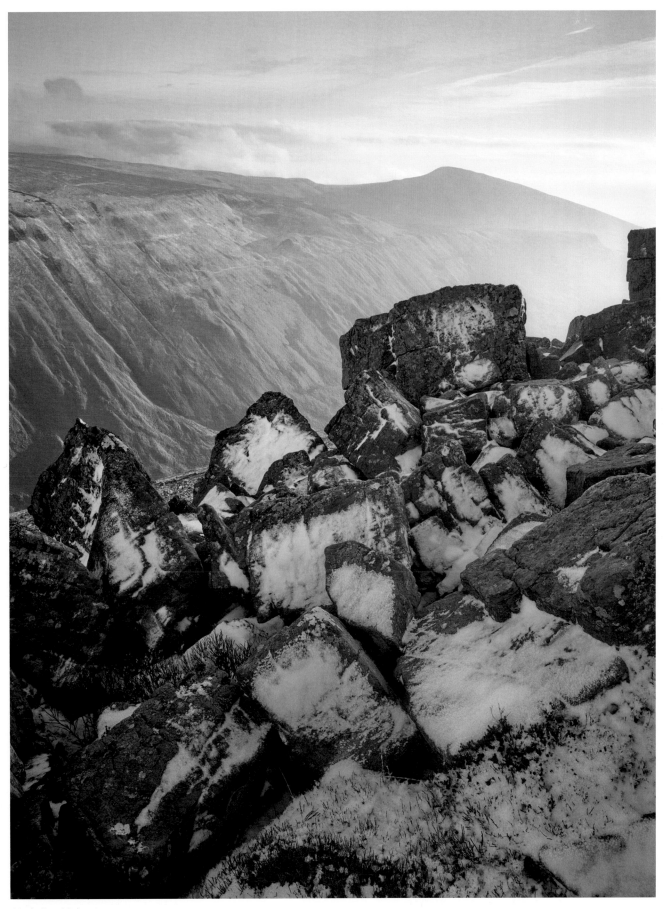

High Cup Nick, winter

KINDER SURPRISE
The Woolpacks and Downfall, Kinder Scout, Derbyshire

The sculptor Henry Moore, son of a coal miner, was born on the edge of the Pennines in Castleford, and always said that the millstone grit tors that ring the moors were the model and inspiration for many of his monumental works.

'Nature is inexhaustible,' he wrote. 'Not to look at and use nature in one's work is unnatural to me. It's been enough inspiration for two million years – how could it ever be exhausted?'

The collection of smoothly rounded gritstone tors known as The Woolpacks on the southern edge of Kinder Scout, at 2,088ft (636m) the highest point in the Peak, provide a perfect example of Moore's maxim. Moulded by aeons or wind, rain, frost and ice, this is a truly weird and wonderful place, unmatched, apart perhaps from Brimham Rocks in Nidderdale, by anywhere else in the Pennines.

When viewed in the not-infrequent mists that wreathe the Peak's highest summit, The Woolpacks can take on an almost organic, animalistic persona. That is how they earned their alternative names of Whipsnade or the Mushroom Garden. Each of these extraordinary natural yet abstract sculptures has earned its own name. There are several mushroom-shaped rocks perched on unlikely pedestals, as well as the Moat Stone (surrounded by a peaty pool of water), the Mitre, the Anvil, Pym Chair, Noe Stool and the Pagoda. Some people have seen a Boar's Head and a gigantic Snail in the rocks, but really the only limitation to what you see is your own imagination.

I remember taking a distinguished climbing photographer friend with experience of mountain ranges around the world, including Everest and the Himalaya, to the Woolpacks one misty October day. I'll never forget his reaction: 'Wow,' he exclaimed, swiftly setting up his tripod, 'I've never seen anything like this.'

The Woolpacks is just one of the highlights of Kinder Scout, probably the most walked-upon mountain in Britain, and one which has attained iconic status in the rambling world after the long-running and notorious battles to gain access to its peaty heights, culminating the celebrated Mass Trespass of April 1932.

The 100-foot (30m) Kinder Downfall, on its western scarp, is the highest and most notable waterfall in the Peak, famed for its trick of blowing back uphill in the face of the frequent westerly gales which funnel up the valley of the Kinder River from Hayfield. Directly below the notch created by the Downfall, a tiny, reed-fringed tarn is named the Mermaid's Pool, and legend has it that immortality awaits anyone who encounters her on Easter Eve.

Equally strange rock formations punctuate Kinder's other edges, with names like Boxing Glove Stones, Seal Stones, Druid's Stone, Ringing Roger and the jumble of flat-topped rocks on Crookstone Out Moor called, for reasons unknown, Madwoman's Stones.

In truth, Kinder Scout is as much a spirit as a mountain. Hillwalkers tend to either love the 14-square-mile (36km²) plateau of chocolate-brown peat hags and groughs, or they hate it. There's just no room for compromise on Kinder.

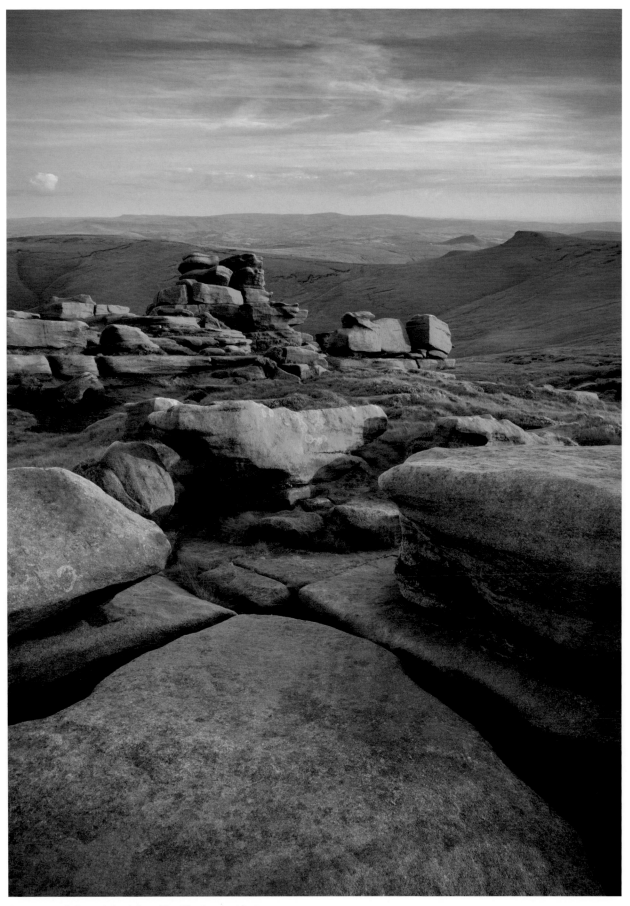

View towards Swine's Back from The Woolpacks, Kinder

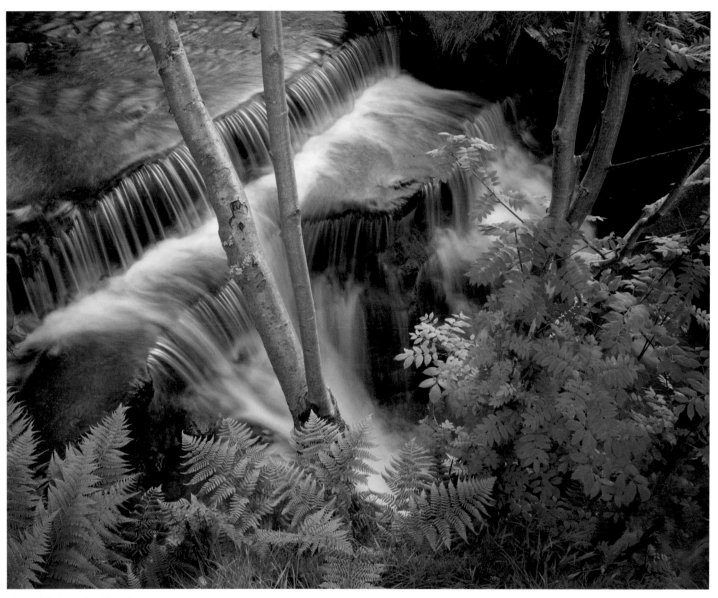

Waterfall, Crowden Clough

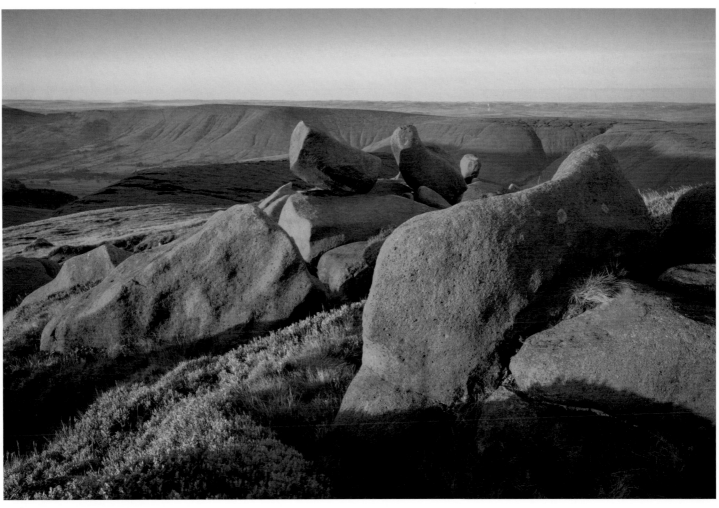

Lord's Seat from The Woolpacks

A CATHEDRAL TO KARST
Ingleborough and Gaping Ghyll, Yorkshire Dales

It was a Spring Bank Holiday Monday, and my daughter Claire and I had decided that having earlier climbed to the roof of Yorkshire via its most iconic mountain – Ingleborough – it was time we got to know its basement as well. We walked up from Clapham and emerged from the pine-topped confines of Trow Gill out onto the pothole-peppered limestone karst expanses of Clapham Bottoms, and joined the crowds of people congregating around the fern-draped, crater-like depression of Britain's largest open pothole – Gaping Ghyll.

It was one of the rare days when the Bradford Potholing Club traditionally sets up a bosun's chair to allow ordinary mortals such as us to descend into the 340-foot (104m) depths of the cavern. We paid the fee and joined the queue to descend into the awesome depths and experience the Yorkshire Dales' usually secret and hidden landscape. 'It's free to go down, lad,' quipped the potholer in a broad Bradford accent as he strapped me in, 'but it's £12 t'cum back oop.'

The descent into the ferny chasm created by the waters of Fell Beck was slow and easy, and although the stream had been dammed upstream, there was still a fair amount of water to pass through. It was only when I swung free into the roof of the main chamber that the sheer size of the cave became apparent. All the guidebooks say that you could fit York Minster into the void, and as I reached the boulder-strewn floor, I could well believe it. But this was surely a cathedral to karst not Christianity.

A thin veil of wispy water filled the air as our eyes gradually became accustomed to the darkness. Of course, we had no equipment to go further, but a kindly group of proper cavers allowed us to join the middle of their well equipped party, and we made the slippery passage with them to the aptly named Mud Hall.

Ingleborough, at 2,372ft/723m, is not the highest of Yorkshire's famous Three Peaks, but it's certainly the most imposing. It's said that every true-born Yorkshireman (or woman) should attain its broad, barren summit, where the Brigantian leader Venutius allegedly held out in his hillfort against the invading Romans, in a kind of gritty Yorkshire Masada.

Like all the Three Peaks, Ingleborough's millstone grit summit stands on a platform of Carboniferous limestone, laid down in a tropical sea some 350 million years ago. This is best seen at places such as Southerscales Scar, where an extensive area of fretted pavement, criss-crossed by a crazy paving of clints (smooth slabs) and grykes (fissures) creates a warm, moist mini-climate. This allows woodland plants such as delicate harts-tongue fern, the scarlet bloody cranesbill and the white bells of lily of the valley to thrive, safe from the wind and the nibbling teeth of the ubiquitous Swaledale sheep.

The highest of the Three Peaks – but also, it has to be said, the most boring – is whale-backed Whernside (2,414ft/736m), which lords it over the delicate filigree twenty-four-arch span of the Ribblehead Viaduct on the Settle–Carlisle line at Ribblehead.

Pen-y-Ghent (2,273ft/694m), on the Pennine Way above Horton-in-Ribblesdale, is the third and lowest of the Three Peaks. But it has that distinctive, lion couchant profile created by the Yoredale series of alternate beds of limestone, shale and grit, shared by each of the Three Peaks, which belie their modest height, and imparts such an air of heraldic nobility to them all.

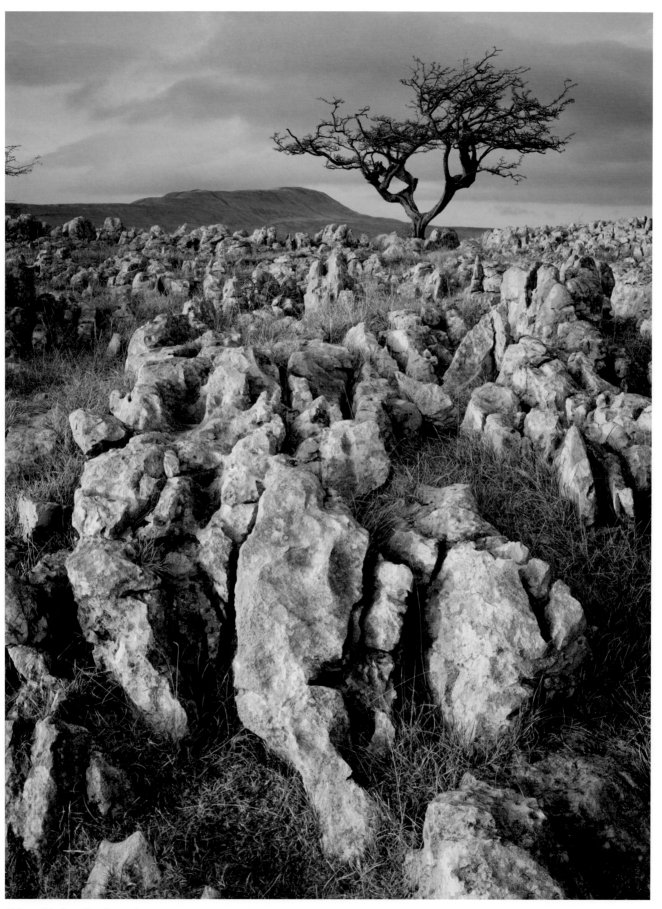

Whernside from Southerscales

TO THE GREEN CHAPEL
The Roaches and Lud's Church, Staffordshire

The Staffordshire Moorlands are the Wild West of the Peak District. This is a land of mists and legend, where myths haunt strange and spectacular rock formations and secret, secluded valleys lie under bleak, brooding moors.

As you drive north out of Leek on the A53 Buxton road, the skyline ahead is serrated by some of the most amazing rock formations in the Peak. These are The Roaches, Hen Cloud and Ramshaw Rocks, bristling upthrusts of pink-tinged gritstone towering over the Cheshire Plain, offering some wonderfully airy walking and some of the most severe gritstone climbing in the Peak.

Deep in the woodlands of Back Forest north-west of the Roaches is a deep and mysterious mossy chasm which used to be marked on OS maps as 'Lud's Church (cave)'. Actually, it is not a cave at all, but a huge natural landslip in the gritstone, which has created a winding fissure about 60 feet (18m) deep and only 20 feet (6m) wide at the top, largely hidden in the surrounding trees.

The name 'Lud' is alleged to come from the fact that it was used for illegal services by Walter de Ludank, a Lollard follower of the religious dissident and reformer John Wycliffe during the fourteenth century. The story goes that a service held in the secret natural chapel was raided by the King's troops, and Walter's daughter Alice was accidently shot dead. For many years, a white statue (actually a ship's figurehead), supposed to represent Alice, stood high on the walls of the chasm, and she is still said to haunt the place.

But the legends attached to Lud's Church go back much further than that. One of the earliest poems in the English language is *Sir Gawain and the Green Knight*, a fourteenth-century alliterative Arthurian composition, which sets the dénouement of that somewhat gory tale of ritual beheadings in a Green Chapel. This was identified as Lud's Church during the 1960s by a Keele University academic, based on the medieval poet's detailed description of the area, and perhaps most tellingly, the north Midland dialect in which it was written by the anonymous author.

The description of the Green Chapel in latest translation by poet Simon Armitage (2007) still seems a pretty fair description of Lud's Church:

> . . . its walls, matted with weeds and moss,
>> Enclosed a cavity, like a kind of old cave
>> Or crevice in the crag . . .

I'll always remember my first visit to Lud's Church in the 1970s. It was a misty, autumnal day, and my photographer friend Mike and I disturbed a red-necked wallaby – a wartime escapee from a private zoo – as we walked up through the naked beeches and birches of Back Forest.

In those days, Lud's Church was quite difficult to find – it was hidden among the trees and the entrance was blocked by a massive fallen rock. It may have been just that we were particularly receptive, our heads full of Arthurian legend, but as we climbed out of the chasm, we saw the unmistakeable sight of the lantern-jawed, Desperate Dan profile of the helmeted Green Knight naturally outlined in the rocks – a sight many others, including Joe, have observed since (see page 109).

Moss-booted birches, Back Forest

Back Forest

The Green Knight, Lud's Church

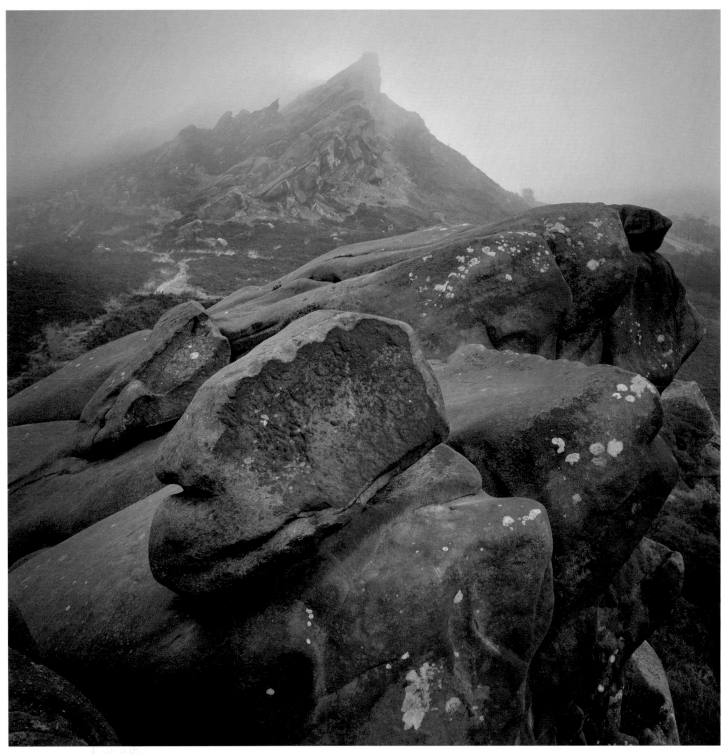

Ramshaw Rocks

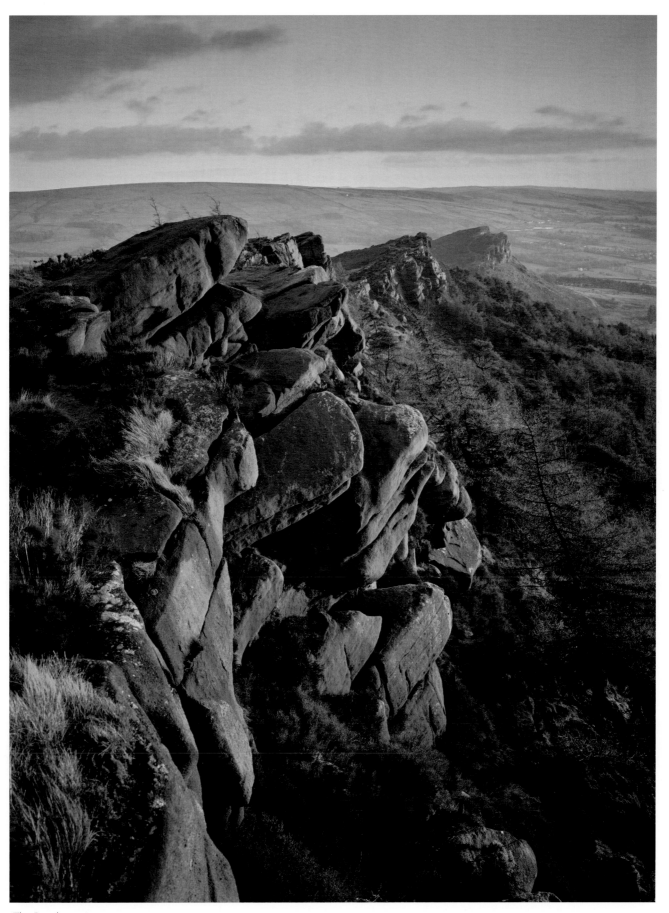

The Roaches, winter

LOVELIEST IN THE LAKES
Derwent Water and Borrowdale, Lake District

For once, Joe wholeheartedly agrees with that connoisseur of the Lake District fells, the usually curmudgeonly Alfred Wainwright. The square mile centred on Castle Crag, the sharp-toothed incisor in the Jaws of Borrowdale, is the loveliest in Lakeland. That's a pretty big claim, because few people would deny that the Lake District, tucked away in the north-west corner of England, is the nation's most beautiful combination of mountains, dales and lakes.

For Joe, then in his early twenties, photographing the National Trust's Borrowdale and Brandlehow estates was the first big job he ever had. 'I fell in in love with them then, with those spectacular views down Derwent Water and up to Skiddaw (see cover photograph), and I've been going back regularly ever since.

'I can just imagine falling asleep in the heather on Shepherd's Crag surrounded by the beauty of Borrowdale: it's the most comfortingly idyllic landscape I know.'

Generations of fellwanderers have followed in Joe's and Alfred's bootprints, and flocked to the southern end of Derwent Water, known as the Queen of the Lakes, to enter the tight little valley of Borrowdale. Indeed, for the young children of many fellwalking families, the easy, 1½-mile (2.4km) ascent of shapely Catbells (1,481ft/451m), the western portal of Borrowdale, is their introduction to the hills – and often marks the start of a life-long love affair.

The classic view of Catbells across the lake and south into the gaping Jaws of Borrowdale, framed by Castle Crag and King's How, is from Friar's Crag, on the eastern shore of Derwent Water on the outskirts of Keswick. There's a memorial here to another famous Lake District luminary, John Ruskin, who was first taken here as a baby and claimed the view between the statuesque Scot's pines was one of the most beautiful in Europe.

To New Zealand-born Hugh Walpole, author of *Rogue Herries* (1930), Borrowdale was the home of Francis Herries, the main character in the novel. There was, he wrote, 'no ground in the world more mysterious, no land at once so bare in its naked-ness and so rich in its luxury, so warm in the sun and so cold in the pitiless rain, so gentle and pastoral, so wild and lonely'.

Borrowdale – the Norse name means 'valley with a fort', a reference to the Iron Age hillfort that once girdled the quarry-scarred summit of Castle Crag – also gives its name to the Ordovician volcanic rocks which constitute the highest land in England. They spread across the district in an uncompromising, craggy, grey-green band from Keswick to Ambleside.

Borrowdale's river is the Derwent, which appropriately means the river of the oaks, because the predominant vegetation of the valley is the sturdy sessile oak. The river rises in splendid desolation at Sprinkling Tarn, in the shadow of the Lakeland giants of Great Gable, Scafell Pike and Glaramara.

Borrowdale is perhaps most famous to the outside world for the tiny, road-end hamlet of Seathwaite, which has the unenviable distinction of being the wettest inhabited place in England. It receives around 140 inches (3.5m) of rain a year, but as any Lake District aficionado will tell you, it's the rain that fills the lakes and makes the scenery.

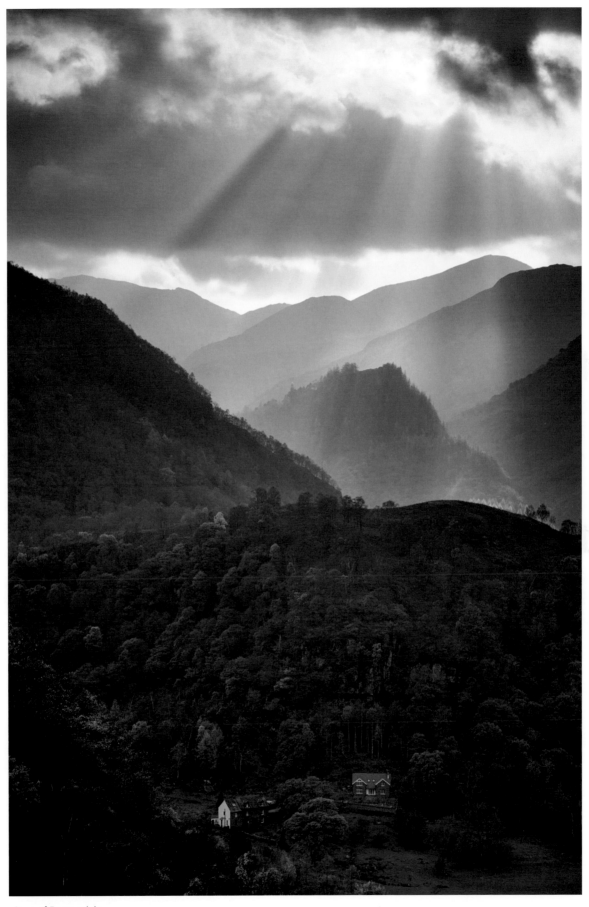

Jaws of Borrowdale

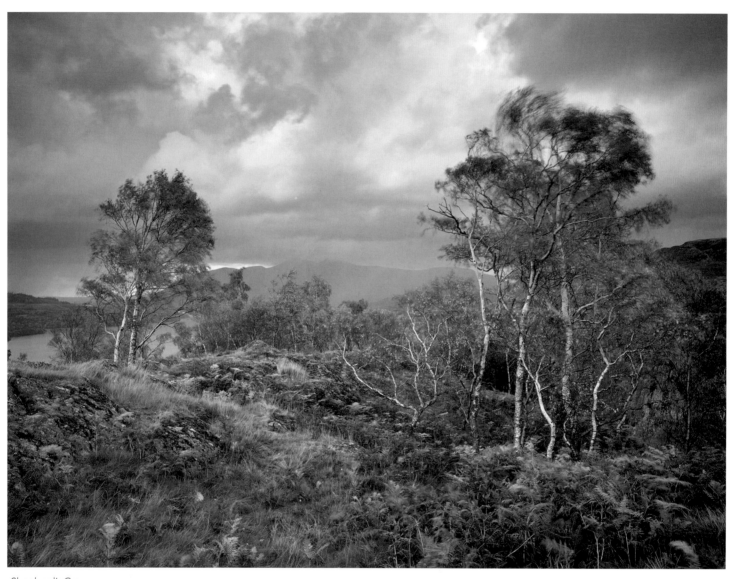

Shepherd's Crag

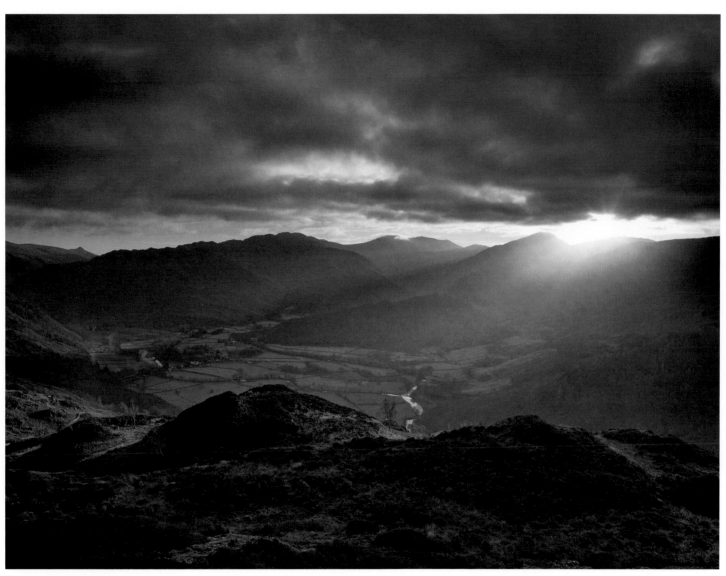

Borrowdale from King's How

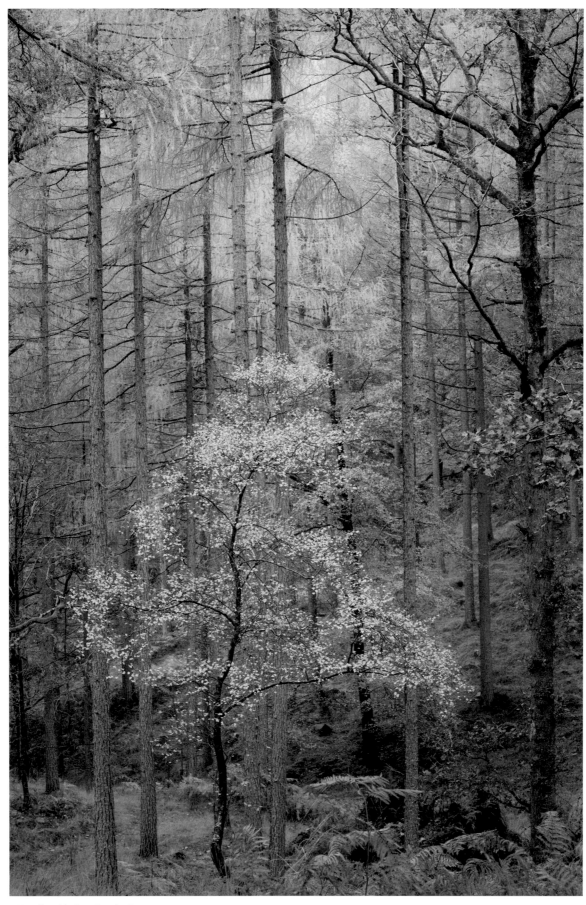

Woodland below Castle Crag

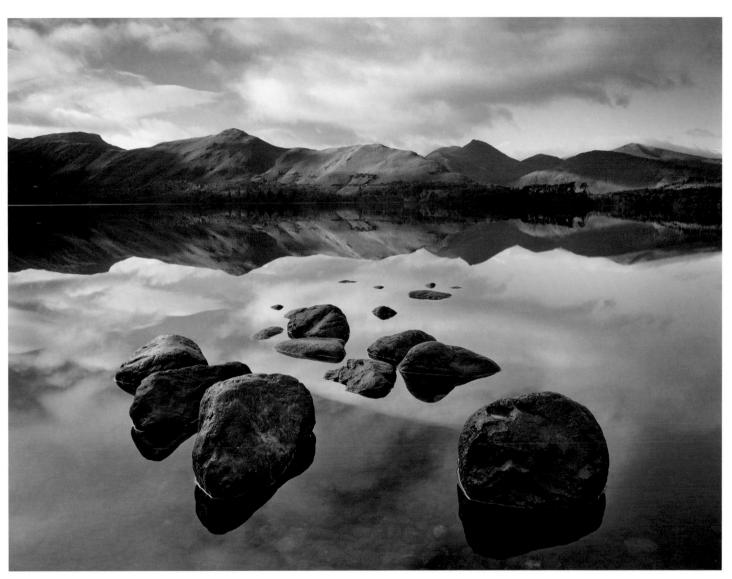

Calf Close Bay, Derwent Water

SUBLIME LIME
Malham Cove and Gordale Scar, Yorkshire Dales

James Ward's massive 1815 painting of Gordale Scar in London's Tate Gallery is considered by many to be a masterpiece of the philosophy of the sublime in English Romantic painting. Working in the last years of the Napoleonic Wars, Ward set out to depict a primordial national landscape, defended by 'John Bull' in the form of a muscular Chillingham White Park bull. He stands in the right foreground, overlooking his harem of docile cows, while a herd of native fallow deer graze in the middle distance. The threat of war is conveyed by the boiling clouds in the stormy skies above and the dark, impending walls of limestone, and the twin waterfalls at the centre of the gorge add a dramatic flash of light and movement. Ward deliberately emphasised the height and scale of the cliffs by subtly manipulating his perspective.

But there is really no need for the use of hyperbole as you approach Gordale Scar – described by Wordsworth as 'terrific as the lair where the young lions couch' – along the crystal-clear waters of the Gordale Beck. This is sublime limestone at its very best.

The 300-foot-high (100m) overhanging limestone crags gradually enclose the beck, and as you round a bend, the sudden sight and sound of the twin waterfalls burst into view, gushing clear from the rocks above. The path involves some mild scrambling over tufa at the lower waterfall before you emerge onto the ancient monastic highway of Mastiles Lane.

The gorge was formed by water from melting Ice Age glaciers, or possibly by the collapse of a cavern. On leaving the gorge, Gordale Beck flows over the charming, tree-embowered Janet's Foss waterfall before joining Malham Beck 2 miles (3.2km) downstream to form the River Aire. Janet, by the way, was the queen of the local fairies and lived behind the waterfall.

A mile to the west is another grand, melodramatic statement of the Carboniferous limestone. The distinctive arc of Malham Cove, Wordsworth's 'semicirque profound', is one of the great, iconic landmarks of the North – a sweeping, 1,000-foot-wide (300m), 260-foot-high (80m), natural amphitheatre, with an extensive area of fretted limestone pavement above.

It's hard to believe, but originally a waterfall higher than Niagara flowed over the cove, as the Ice Age glacier above shed its icy meltwaters. The stream which once fell over the cove now flows out of the placid lake of Malham Tarn, on the moors a mile to the north, only to disappear underground at the aptly named 'Water Sinks'.

Malham Tarn – a rarity of a natural lake in this generally porous limestone country – lies mainly on a bed of Silurian slate covered with marl deposits. At 1,237ft/377m, it is the highest lake in England, and one of few upland alkaline lakes in Europe.

It was while visiting Malham Tarn House in 1858 that Charles Kingsley was inspired to write the Victorian childrens' novel *The Water-Babies: A Fairy Tale for a Land Baby*, first published in 1863. Malham Cove is believed to be his inspiration for Lewthwaite Crag, which Tom, the fugitive chimney sweep, descends 'by stock and stone, sedge and ledge, bush and rush'. He 'dirties everything terribly' leaving 'a great black smudge all down the crag'. Kingsley may have got the idea for this from the dark patches of lichen which decorate the pearly-grey limestone of the cove, to which rock climbers now cling like human flies.

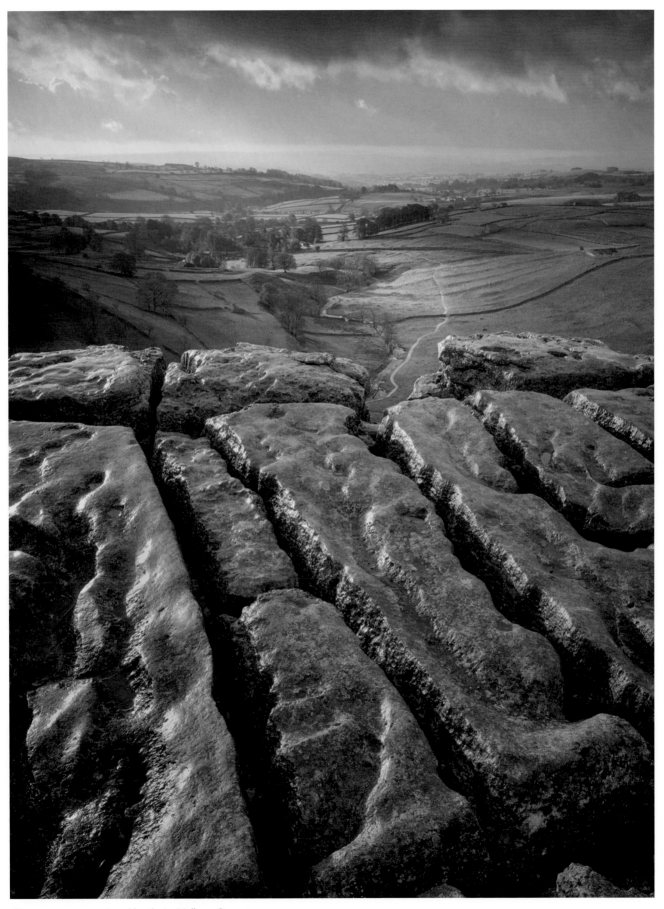

Limestone pavement and lynchets, Malham Cove

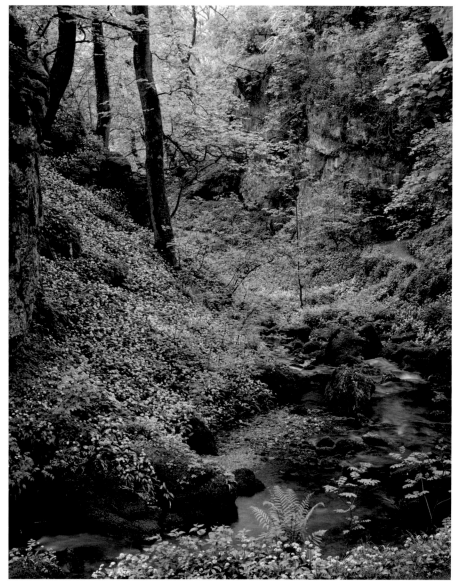

Below Janet's Foss

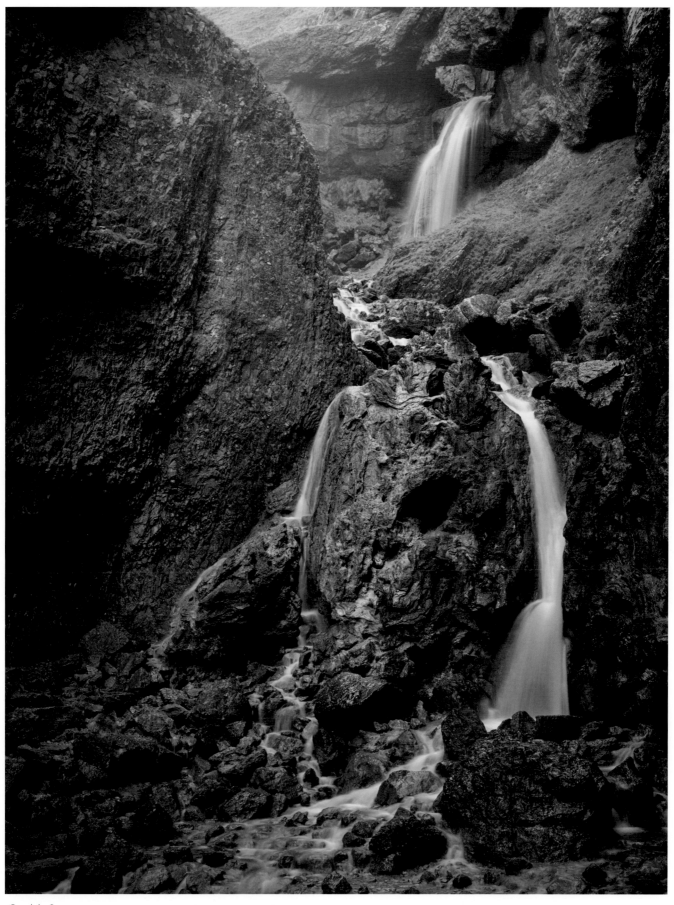

Gordale Scar

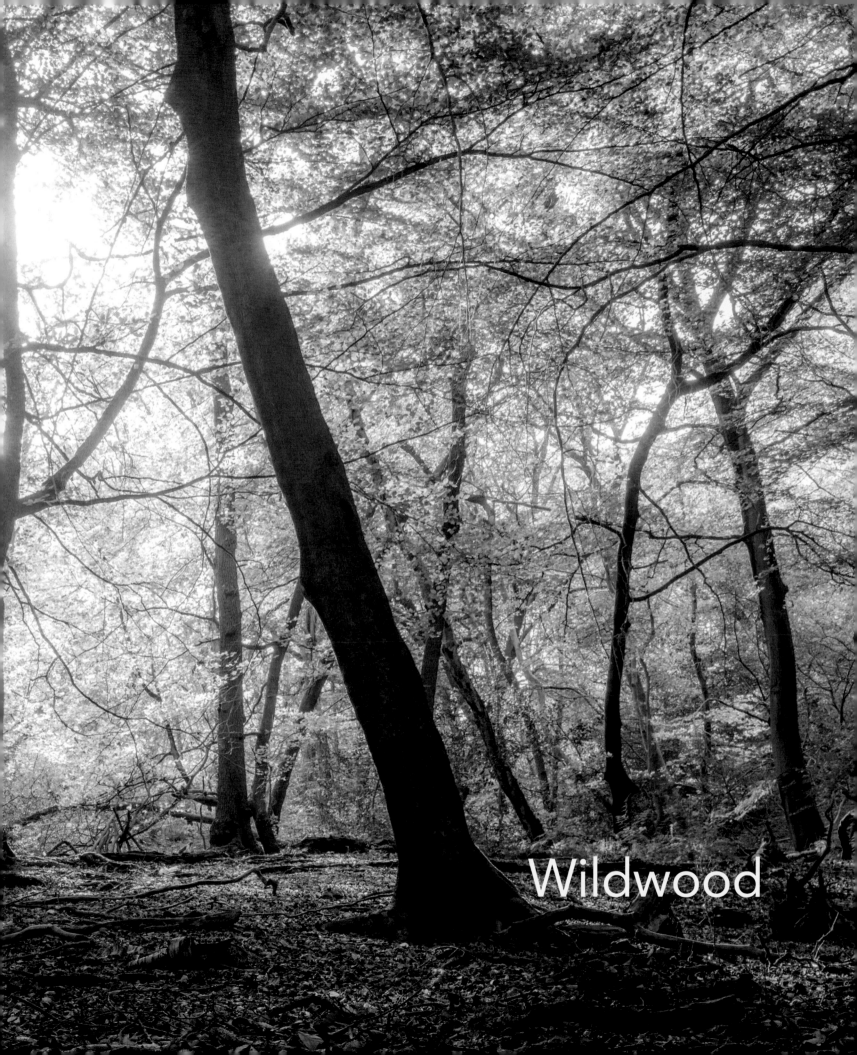

Wildwood

Wildwood

The natural, or climax, vegetation of the

British Isles is woodland. Without the constant

nibbling of the ubiquitous sheep, everywhere but the

highest summits and steepest crags would soon revert to

rowan, birch, ash and finally oak and yew woodland.

So it's rare to come across examples of the original

native tree cover – dubbed 'the wildwood' by woodland

historian Oliver Rackham – today. The closest we can come to

it is in places like the fairytale Wistman's Wood on Dartmoor,

and the magical yew forest of Kingley Bottom in

a fold of the Sussex Downs.

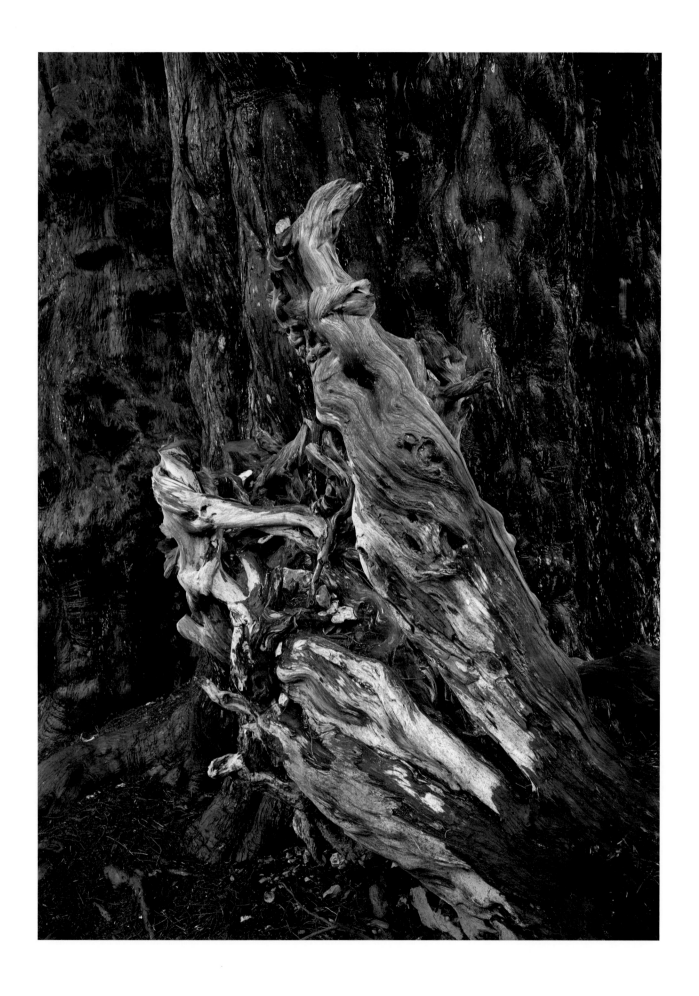

BEAUTIFUL BEECH
Burnham Beeches, Buckinghamshire

Beech trees are beautiful at any time of the year. In winter, their skeletal pale-grey boles and branches take on an architectural quality. It's like walking through the pillars and nave of some great cathedral on a crunchy carpet of mast and copper-bronze fallen leaves. Then in spring, the shining, bright lime-green of their new leaves emerging from those needle-sharp buds is made translucent by the strengthening rays of the sun. In summertime they bring a welcome cool, green shade to the hottest August day, and the bosky, fully leaved trees ring with a symphony of birdsong and the yaffle of green woodpeckers. Finally, autumn burnishes the leaves with a vivid splash of copper, and they shine like well-polished brass in the fast-fading light.

Although the beech is a native tree – it was certainly here over 5,000 years ago – none of our present beechwoods can truly be called natural. Many were planted on the chalky, lime-rich downs of southern England or the limestone of the north as windbreaks, cover for game, or for timber or furniture production.

Perhaps the most famous beech woods in England are at Burnham Beeches, near Farnham Common in Buckinghamshire, which cover an area of 540 acres (220ha). The close proximity to London and the Pinewood and Shepperton film studios have made Burnham Beeches a popular backdrop to films, most recently the Harry Potter series. It has also often doubled as Sherwood Forest in film and TV productions from *The Story of Robin Hood and His Merrie Men* (1952) to *Robin Hood: Prince of Thieves* (1991), despite the fact that the Midland forest consists mainly of oak and birch.

Burnham Beeches, a National Nature Reserve managed by the City of London, is one of the best examples of ancient woodland in Britain. Famed for its beech and oak pollards – many of which are more than four centuries old – it is also home to a rich variety of fungi, plants and animals, with pockets of lowland heath and sphagnum bog.

Pollarding is a kind of ancient pruning system in which the upper, younger branches of a tree are removed at about head height, promoting a dense head of new leafy branches. Trees were traditionally pollarded either for fodder for livestock, or for the young straight branches that sprang up, which were favoured for fence rails and posts as well as for boat or furniture construction. Wood pollards, like those at Burnham, were usually cut at intervals of between eight to fifteen years.

Apart from the pollards, if you know where to look, human influence can be seen in many places among the beeches of Burnham. Hartley Court Moat, formerly known as Hardicanutes or Harlequins, north of McAuliffe Drive, is the remains of a moated medieval farmstead, and on rising ground close to the Lord Mayor's Drive there are the faint outlines of an Iron Age hillfort.

The wooded hill above Halse Drive is named Mendelsohn's Slope because this is where German composer Felix Mendelssohn, a regular visitor here in the 1840s, is thought to have had the inspiration for his incidental music, including his famous *Wedding March*, for Shakespeare's *A Midsummer Night's Dream*. So if you hear the familiar nuptial strains as you wander through Burnham Beeches, you'll know where they are coming from.

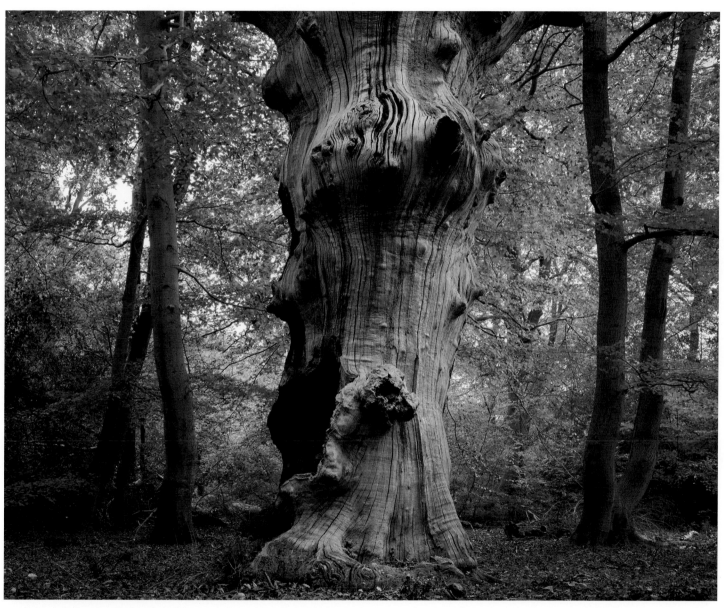

Bole of an ancient beech, Burnham

UNFORGETTABLE YEW
Kingley Bottom, Sussex

They call them 'snotty gogs' down here in Sussex; the bright, coral-red berries of the yew, which, when seen against a blue sky, were described by nature writer Geoffrey Grigson as 'one of the most tropical of English sights'.

The mistle thrush busily gorging himself on the gem-like berries (correctly known as 'arils') in Kingley Bottom did not appear to be unduly concerned by the fact that the yew is perhaps the most poisonous of British trees. It had no need to worry, because the deadly seed passes straight through its digestive system to maybe start a new yew tree elsewhere.

Grigson's 'black-tufted density' of Kingley Bottom's secret, dark and brooding forest of yews is said to be the largest and finest in Europe, and offers a truly magical walk. Kingley Vale, as Natural England prefers to call it, was one of the first National Nature Reserves to be established in Britain in 1952, so it has recently celebrated its sixtieth birthday. But the reserve designation is a mere stripling compared with the venerable yew trees for which it is famous. Many have probably already celebrated their 500th birthday, and some may be a millennium old.

Kingley Bottom is tucked away in a chalky fold of Stoke Down and Bow Hill, near the village of West Stoke about 3 miles (4.8km) north-west of Chichester. A walk through these incredibly ancient trees transports you through a magical, fairytale, Arthur Rackham landscape of tortured, twisted trunks and dark, cave-like clearings, where you half expect to see Rackham's sweet-winged fairies or wizened gnomes peeping out. The oldest yews at Kingley are found to the right of the nature trail. There are about twenty of these twisted and contorted veterans, each one seeming to fix the walker with a timeless gaze. Some of these rich red, writhing trunks seem to take on animal forms, while others just astound with their majestic presence and sheer bulk. It's a little like walking through the hushed nave of a natural cathedral.

A local legend claims that the original grove of yews was planted here to commemorate a ninth century battle fought in Kingley Bottom by local Saxons against marauding Vikings. The Bronze Age burial mounds on the downs at the head of the vale were allegedly where the slain Viking kings were buried – hence the name. Evidence has also been found here of Stone Age flint 'mines', where flint nodules were excavated for manufacture into tools and weapons at the very dawn of human civilisation.

As you approach the top of the coombe, the views to the south extend to the elegant spire of Chichester Cathedral and the snaking inlets of Chichester Harbour, with the silvery glint of the English Channel and the blue outline of the Isle of Wight beyond.

On the brow of the hill is a simple sarsen stone marking the memorial of Sir Arthur Tansley, first chairman of the Nature Conservancy. Tansley loved this place and it was his favourite viewpoint in the whole of Britain. Few would argue with his choice.

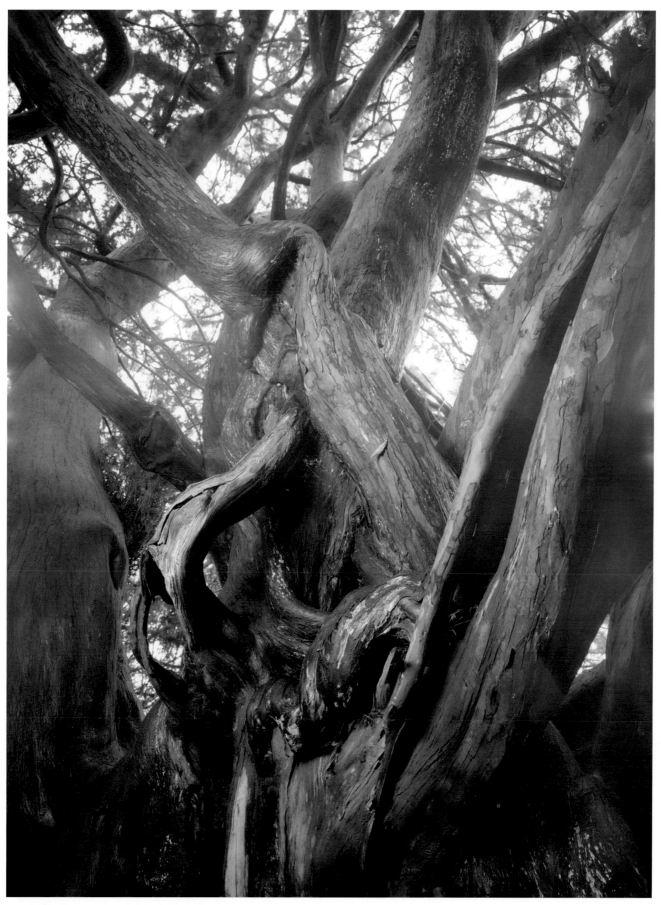

Contorted yew branches, Kingley Bottom

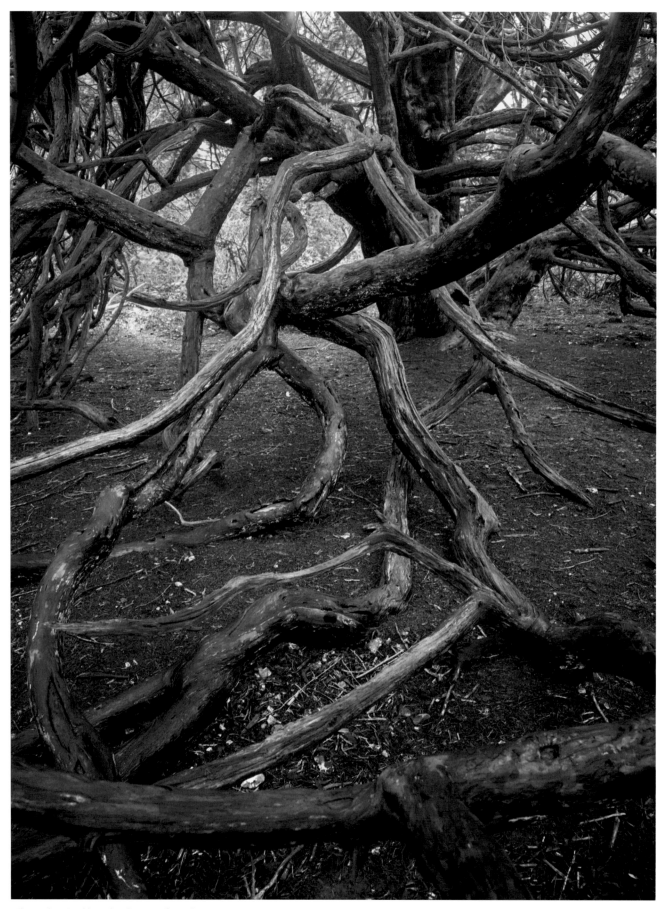

The Arthur Rackham landscape of Kingley Bottom

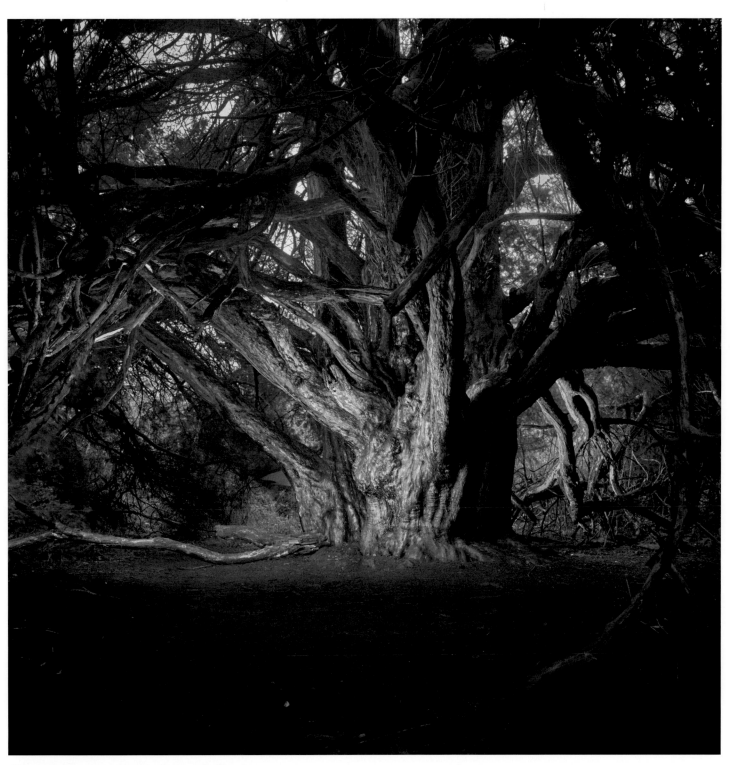

This venerable yew may be into its second millennium

ACORN ANTIQUES
Wistman's Wood, Dartmoor

It may sound strange but for me the essence of Dartmoor, usually labelled with the well-worn cliché 'the last great wilderness of Southern Britain', is not to be found on the open, tor-topped moors.

I believe it is more convincingly found in the fairytale, lichen-encrusted oaks of Wistman's Wood, hidden away in an eastern fold of the desolate valley of the West Dart River north of Two Bridges. The name Wistman is thought to come from the old West Country word *wisht*, which means sad or uncanny; so 'Wisht-man' may refer to a local woodland spirit. And as you peep into the stunted, twisted branches and trunks of Wistman's Wood, which spring straight from a boulder field of moss-covered granite, you can easily find yourself believing in those teashop souvenirs featuring the celebrated Dartmoor pixies. If they were to exist anywhere, then surely it would be here.

Perhaps the most remarkable feature of Wistman's Wood is its luxurious mantle of mosses, ferns, liverworts and lichens. They drip from the weirdly contorted branches like the epiphytes and bromeliads of an Amazonian rain forest, and in fact, represent a habitat which is every bit as rare and threatened. It covers about 8½ acres (4ha), and its amazing survival is thought to be due to the fact that the pedunculate oaks have grown, and continue to grow, in the shelter of the rocky crevices of the 'clitter', the onomatopoeic local name

for scree such as this. These create a favourable micro-climate, protecting the trees from winter gales and frost and above all, from the nibbling teeth of the local sheep.

Wistman's Wood is a National Nature Reserve managed by Natural England under agreement with the owners, the Duchy of Cornwall, and access is strictly by written permission. However, a public footpath runs conveniently past the wood, and you can peep into it after an easy, 3-mile (4.8km) stroll from Two Bridges.

Of course, Dartmoor itself remains one of the most important and complete prehistoric landscapes in north-west Europe, and the Ordnance Survey map is littered with sites in the Gothic lettering the OS reserves for ancient monuments. One such site lies just to the east of the elephant-hide wrinkled granite mass of Hound Tor, near Manaton. A complete medieval village consisting of eight houses, a shed and three corn-drying barns were discovered here in the 1960s, and archaeologists found that a sequence of seventh- or eighth-century turf-walled buildings underlaid the stone ones. And a smaller site closer to the tor – known rather prosaically as Houndtor 2 – was built directly within a prehistoric enclosure, and re-used the foundations of two prehistoric houses.

That incredible continuity of history makes Dartmoor a unique palimpsest of the past, where stories have constantly been written and re-written over the lay of the land.

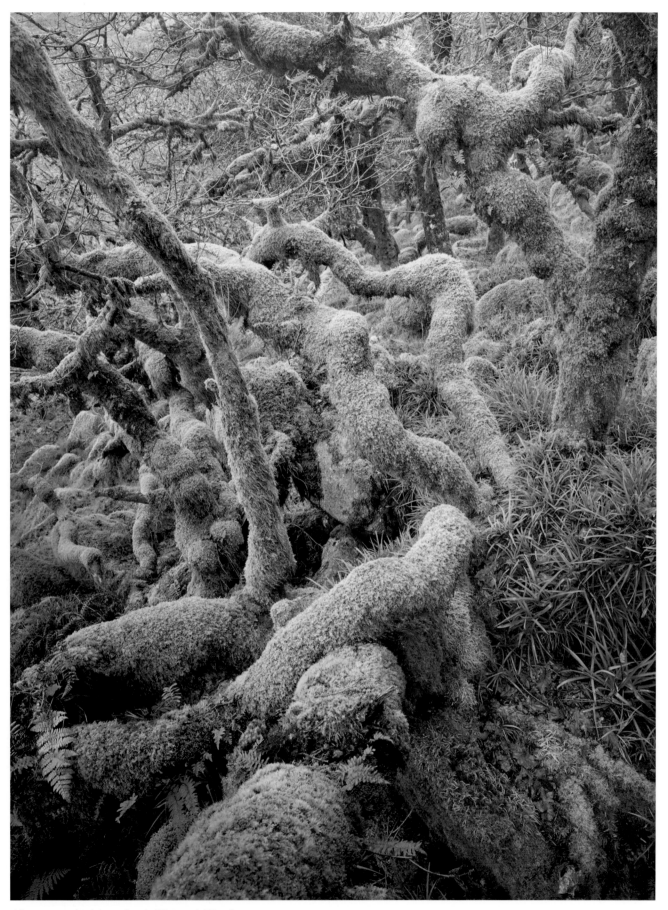

Moss covered oak branches in Wistman's Wood

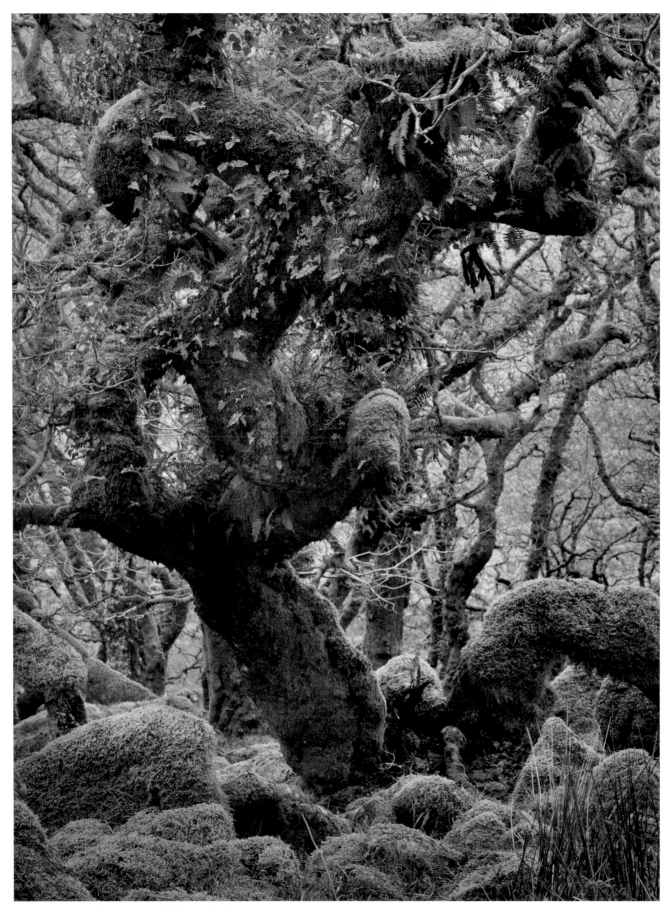

Mosses, ferns and lichens wreath Wistman's oaks

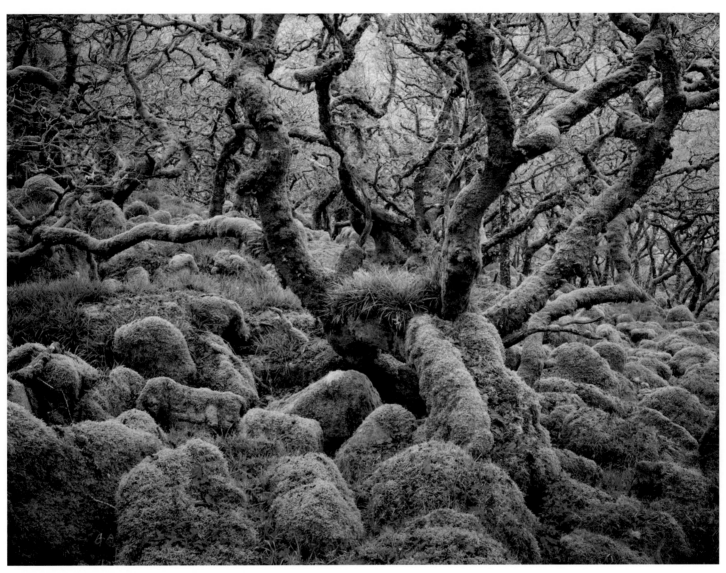

Wistman's Wood

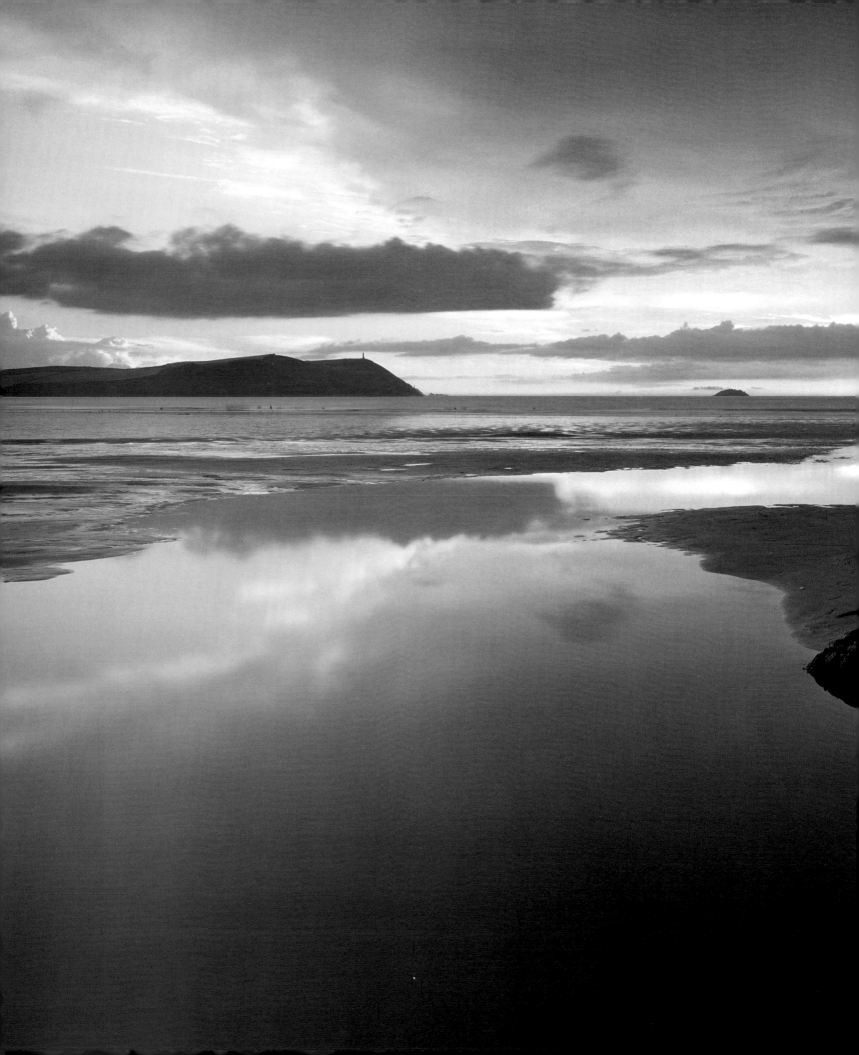

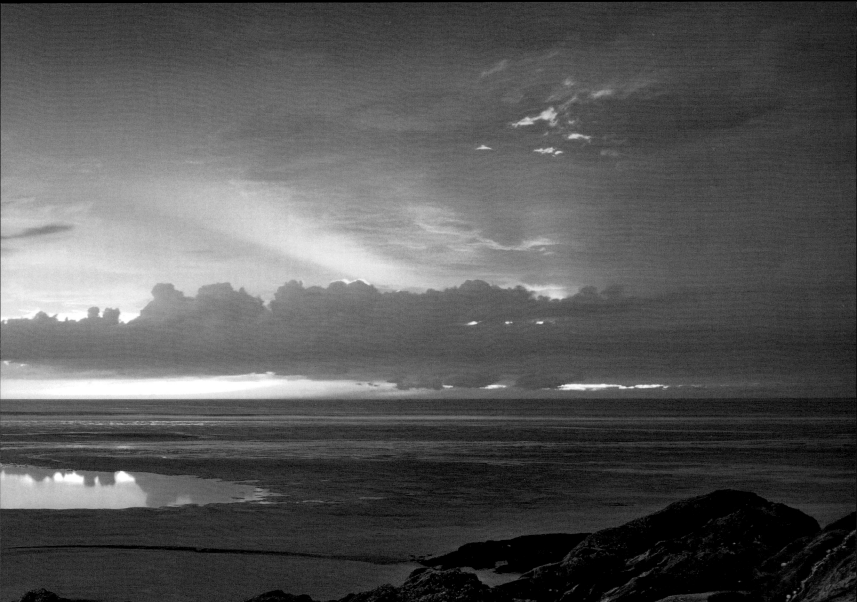

The Edge

Nowhere in Britain is more than

70 miles from the sea, and the total length of the

British coastline, excluding islands, is 10,800 miles (17,380km).

And it's surely true to say that nowhere in the world has such a

variety of coastal scenery. From the tortured limestone strata of

the World Heritage Site Jurassic Coast of Dorset to the granite

cliffs and sea stacks of Wales and Cornwall and the chalk

White Cliffs of Dover and Sussex, the range of scenery

on these 'edges of land' is unsurpassed.

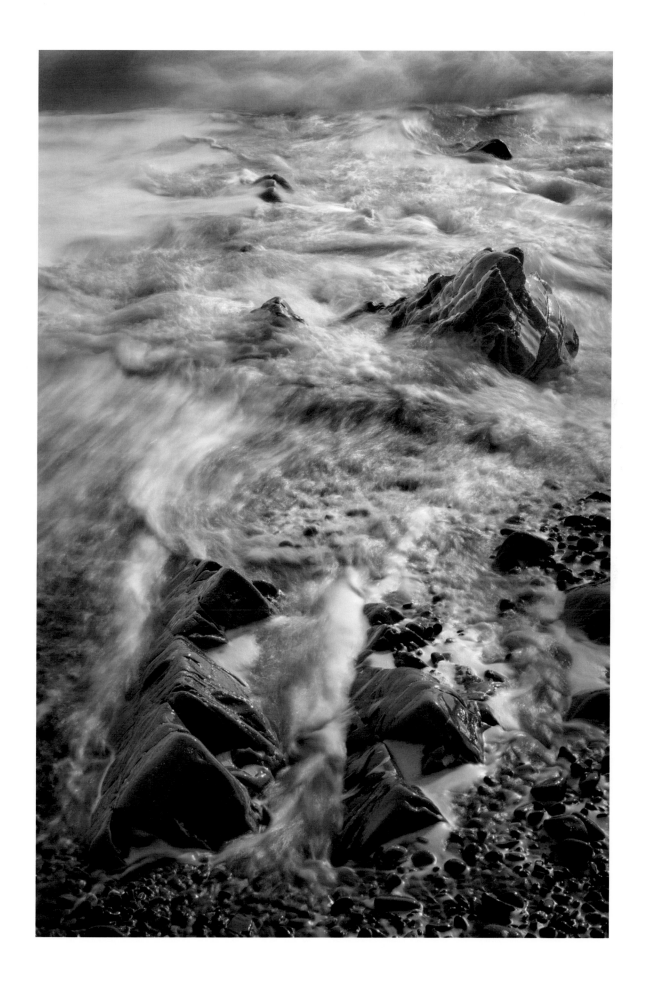

LANDSCAPE OF MEMORY
Pentire Head and Rumps Point, Cornwall

Family holidays spent on the anvil-shaped headland of The Rumps and Pentire Head on the north Cornish coast are among Joe's earliest memories. And he admits: 'The landscape here was the first that really captured my imagination.

'Our parents amused themselves by scaring us with the impression that the serrated skyline of The Rumps looked like a dragon sleeping in the ocean. Thirty-odd years later, when we took our own children there for the first time, it had become a stegosaurus – which perhaps suggests the cultural shift that has happened in the world of children's story-telling. It's still a place that inspires me.'

The best approach to the headland is from New Polzeath beach. Follow the South West Coast Path to the 259-foot (79m) viewpoint of Pentire Point and then head east along the clifftops to reach the twin-headed promontory of The Rumps, which is defended by triple steep banks and ditches spanning the narrowest part.

The Rumps is a classic late Iron Age promontory hillfort constructed in the slate and pillow lava bedrock, which was excavated by the Cornwall Archaeological Society in the 1960s. Six apparent hut platforms were partially excavated in the interior, and the dig discovered that the people who lived in the 6-acre (2.4ha) fort some 2,000 years ago were virtually self-sufficient, weaving cloth and cultivating crops of grain.

Whether they ever had to defend their airy citadel in time of war we shall never know. But it's much more likely that Sevensouls Rock and Cove on the northern cliffs record the victims of a shipwreck, unfortunately quite common on these inhospitable coasts, rather than an Iron Age conflict.

A simple stone plaque erected on the cliffs between the headlands marks the spot where the poet Laurence Binyon wrote his famous ode of remembrance, 'For the Fallen', first published in *The Times* shortly after the horrendous Battle of the Marne in September 1914. Binyon's timeless words, repeated faithfully at town and village war memorials every Remembrance Sunday since, are engraved on the plaque:

> They shall grow not old, as we that are left grow old:
> Age shall not weary them, nor the years condemn.
> At the going down of the sun and in the morning,
> We will remember them.

Perhaps it was the outstanding views from the storm-dashed promontories that inspired Binyon to pen this tribute to the war dead, who now, as he so movingly wrote, 'sleep beyond England's foam'.

These rugged yet often flower-decked headlands are the very epitome of peaceful Cornish coastal scenery. Views extend north as far as the legendary Arthurian capital of Tintagel Head across Port Quin and Port Isaac bays, and south across Padstow Bay and the Camel Estuary to Stepper Point, with the flashing beacon of the Trevose Head lighthouse beyond.

The rocky skerries of The Mouls and Newland are nearer to hand, and if you are really lucky you could spot seals, dolphins, porpoises, basking sharks and sunfish in the boiling sea below, as Pentire Point and The Rumps offer some of the best sea-watching on the north Cornish coast. They provide a great viewing platform for seabirds, including gannet, fulmar, cormorant, shag, kittiwake, razorbill, guillemot and the occasional puffin. Terns and auks can also often be seen feeding on sand eels where tidal currents meet at the mouth of the Camel estuary, where a dangerous silt and sand bank is somewhat prophetically known as the Doom Bar.

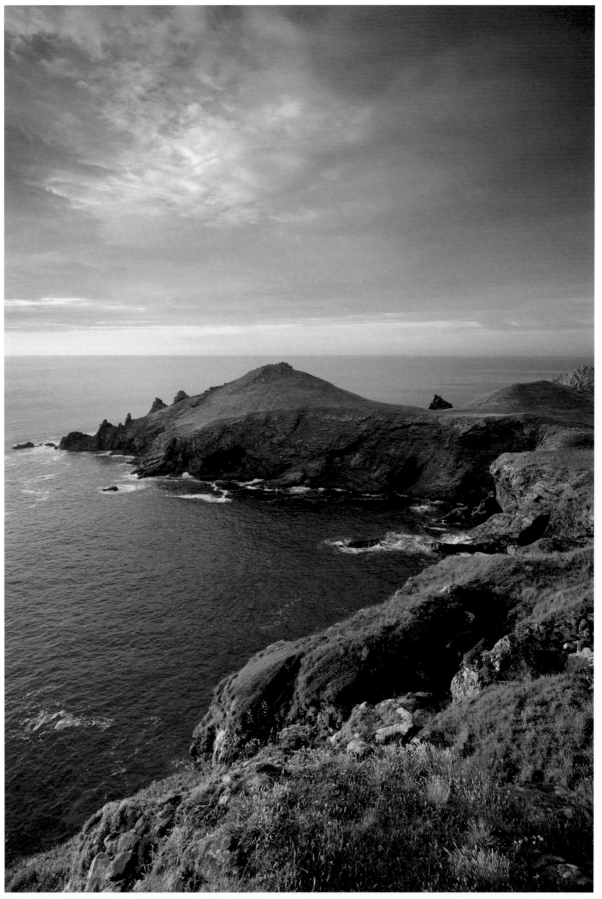

The Rumps

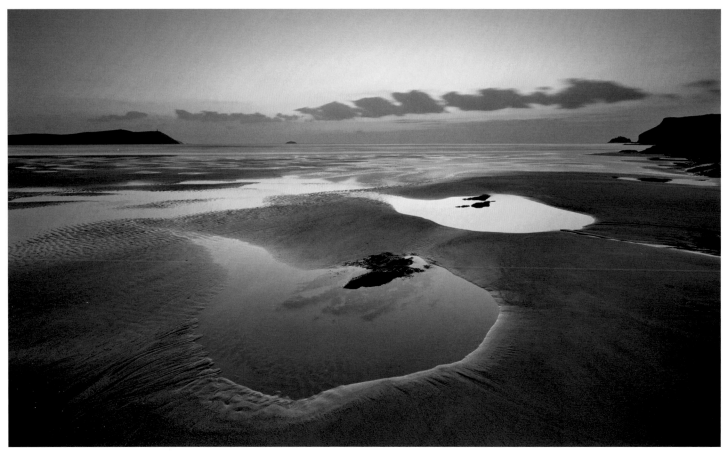

Polzeath beach

Tidal pool abstract, Greenaway undercliff

TO THE DRAGON'S HEAD
The Gower, Swansea

Worm's Head, the rocky causeway marking the westernmost extremity of the Gower peninsula in South Wales, creeps out to sea like a gigantic sea-serpent. Not surprisingly, it has attracted a wealth of folklore. Its name comes from the Old Norse *wurm,* meaning a dragon, and during the right conditions, a blowhole on the Head emits impressive booming and hissing sounds. A local saying is: 'The old Worm's a'blowing; time for a boat to be going.'

The causeway is only accessible for about 2½ hours immediately before and after low tide, so you should always check the tide times before you set out on the slippery scramble to Outer Head. Many people, including the poet Dylan Thomas, have been stranded on 'the great rock' of the Worm.

The Gower Peninsula, a lovely landscape of limestone cliffs and sandstone heaths, is the last unspoilt outpost of natural beauty in industrial South Wales. Perhaps because of this, it had the distinction of being the first Area of Outstanding Natural Beauty (AONB) to be designated in Britain, in December 1956. Its classic coastline has also been recognised by the fact that the whole of it lying within the AONB – a total of 36 miles (58km) – has also been designated a Heritage Coast. The landscape ranges from the marshes and dunes of the north coast, to the superb Carboniferous limestone cliff scenery of Worm's Head, Port-Eynon, Oxwich Bay and Mumbles Head on the rugged south coast, which faces the full force of the Atlantic storms.

Rhossili Bay curves in an elegant arc running north from the village of the same name, which gets its name from *rhos –*

the Welsh word for moorland. The beautiful sandy beach, known locally as Llangennith Sands, is 3 miles long (5km) and backed by extensive sand dunes. Behind the beach north of the village is the eponymous Rhossili Down, which is scattered with a wealth of prehistoric remains.

The Gower is an unrivalled microcosm of the historic heritage of Wales, and there are over eighty scheduled ancient monuments within the AONB, representing all periods in history from the Upper Palaeolithic through to eighteenth-century parkland and industrial monuments.

Perhaps the most famous ancient resident of Gower was the so-called 'Red Lady of Paviland', found by the antiquarian Revd William Buckland in Goat's Hole Cave, a difficult scramble up the cliffs between Port Eynon and Rhossili, in 1823. But the Red Lady was not what she seemed. The virtually complete skeleton dyed by red ochre and dating from the Upper Paleolithic era is thought to be the oldest anatomically modern human found in the UK, and the earliest known ceremonial burial in Western Europe. Because of the decoration and delicacy of the bones, Buckland believed the remains to be those of a female, possibly a prostitute or witch, dating from Roman times. However, more recent analysis has shown them to have been of a young male, and radiocarbon dating has shown the skeleton to date from an astonishing 33,000 years ago. The 'Red Lad of Paviland' – as he should surely now be known – now resides in the Oxford Museum of Natural History.

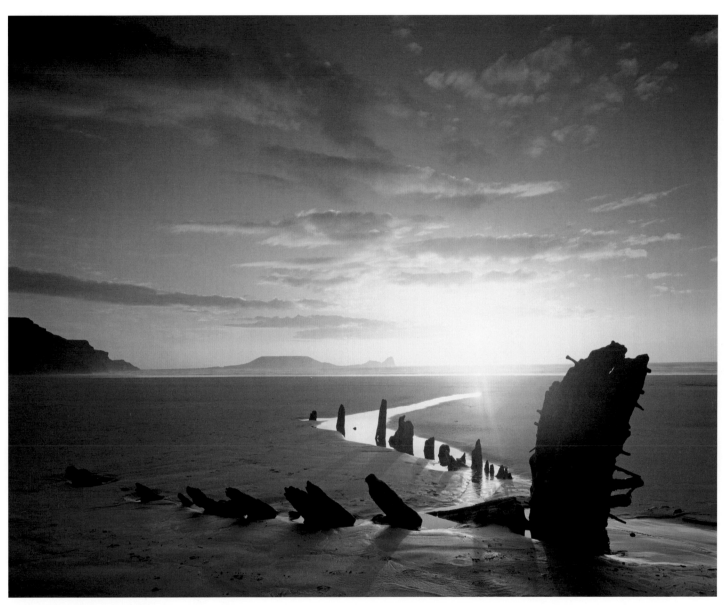

Worm's Head from Rhossili Bay

DIGGING FOR DINOSAURS
Jurassic Coast, Dorset

Unlike the unfortunate family in Steven Spielberg's 1993 blockbuster *Jurassic Park*, we weren't attacked by velociraptors as we walked along Dorset's spectacular Jurassic Coast. But by diligent searching, we found a fossilised bone of one of their cousins. With just a smattering of geological knowledge, you can be transported back through 180 million years to the days of the dinosaurs along the 95 miles (155km) of this World Heritage coastline.

The rocks were laid down in the Mesozoic era, which is made up of the Triassic, the Jurassic and the Cretaceous periods, all of which are represented here. The World Heritage designation – the first natural WHS to be recognised in Britain – was made in 2001 to recognise the unique and virtually continuous exposures of these Mesozoic rocks.

The highlights of the Dorset coast lie to the west of the perfect scallop-shell bay of Lulworth Cove, where once, right on cue, I once spotted an eponymous, tiny, toffee-brown Lulworth skipper butterfly. Walking west towards Lulworth along the coast path, the first stunning feature you come across is the astonishing natural flying buttress known as Durdle Door. This limestone spur has been created by erosion and wave action, but the soaring arch still stands as a classic, storm-defying example of natural architecture.

The other reason for the UNESCO designation was the internationally important fossil deposits which are found here. One of the earliest prospectors was Mary Anning, the daughter of a Lyme Regis dissenter who was recently described by the Natural History Museum as 'the greatest fossil hunter ever known'. Today Lyme Regis is full of curio and fossil shops attracting tourists by the coachload. But you can still go fossil hunting, as I did recently with my granddaughters, and rediscover the thrill that Anning must have enjoyed. The coast here is eroding rapidly, resulting in thousands of fossils – such as the beautiful ram's-horn spirals of ammonites and the tapering pencil-points of belemnites – being left on the beaches from landslides from the surrounding cliffs, especially after winter storms. And if you are really lucky, as we were, you might even find a fragment of dinosaur bone.

Just to the east of Lyme Regis stands the bold headland of Golden Cap, at 616 feet (188m) the highest point on the south coast. This beautiful National Trust property gets its name from the cap of golden sandstone which tops the cliff face, best seen in the low light of a setting sun.

Bracketing the eastern end of Lyme Bay is Chesil Beach, one of the best examples of a barrier beach in the world. The pebbles which form the shingle beach are graded in size from west to east by the action of the wind and waves by a phenomenon known as longshore drift. Chesil Beach has stood up to the full force of Channel gales for thousands of years, providing a constant breakwater and protection for the wildfowl-haunted Fleet, the largest tidal lagoon in Britain, which lies behind it.

Nothing much changes, because as we now know, birds are the closest living things we have to those Jurassic dinosaurs.

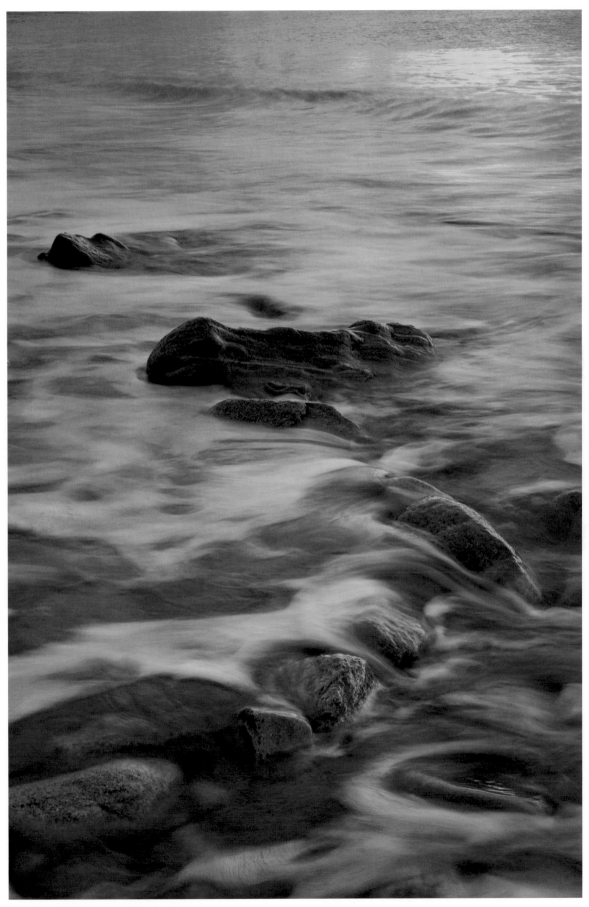

Gold and blue, Jurassic Coast

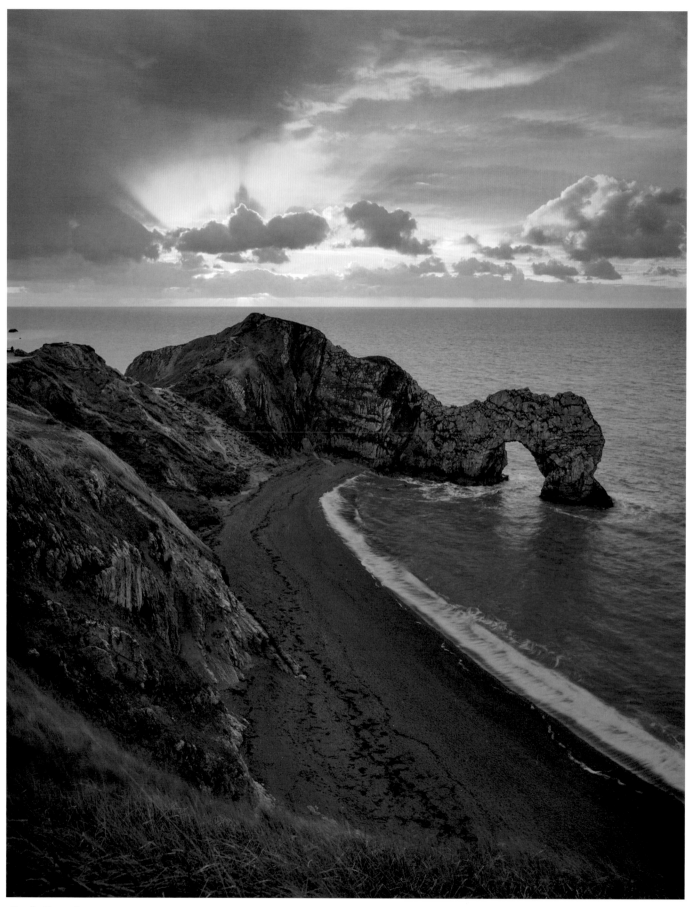

Durdle Door, dawn

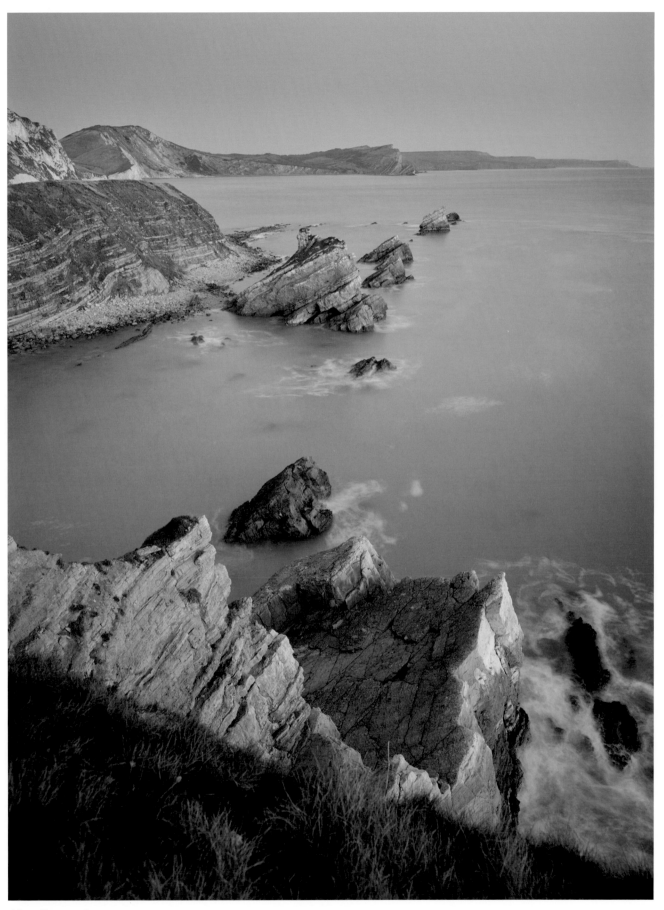

Mupe Bay, evening

ONIONS AND AMMONITES
Robin Hood's Bay, Staithes and Whitby, North Yorkshire

I've never been happier to see a village sign than when that for Ravenscar on Robin Hood's Bay finally appeared at the end of the Lyke Wake Walk. That gruelling, 40-mile (64km) bog-trot across the top of the North York Moors remains the furthest I've ever walked in a day – and the furthest I ever want to.

But why did Robin, whoever he was, stray as far from Sherwood as this bay on the North Yorkshire coast? The guidebooks claim it gets its name from a sea battle between the outlaw and a pirate with the unlikely name of Damon the Monk, who had been raiding along the Yorkshire coast. Robin is supposed to have won the battle, then hanged Damon and his crew from their own yard-arm, before beaching the ship in the bay which bears his name.

The truth is there's no real historical evidence that Robin Hood, let alone Damon the Monk, ever existed. To the downtrodden people of England, he fulfilled the role of a medieval superhero, in much the same way that King Arthur had done during the Dark Ages. And judging from his constant film and TV re-creations, and even the recent suggestion for a 'Robin Hood tax' on the greedy rich, he still does.

The Bay, as it is known locally, is a great place to peel back the geology of the North York Moors. If you stand on Old Peak (or South Cheek) at Ravenscar in the south, or Ness Point (or North Cheek) to the north of the village, at low tide, the exposed concentric crescents of Jurassic Lower Lias limestones look as if someone has taken a slice through a half-submerged onion.

As the remorseless North Sea has gradually eaten away at the coastline, successive layers of what was once a dome have been exposed, leaving the wave-cut platforms, or scars, extending seawards for 600 yards (550m) from the base of the enclosing cliffs, which consist of more resistant Upper Lias strata.

The charming fishing ports of Whitby and Staithes further up the coast are both natural harbours where the River Esk and Easington Beck, which rise on the heather moorland above, respectively enter the North Sea.

Whitby's fine north-facing harbour takes advantage of a geological fault first recognised by the Revd George Young, the nineteenth-century pastor of Cliff Lane Presbyterian Chapel and biographer of the town's most famous son, explorer Captain James Cook. Plainly visible as you enter the harbour, the Lias limestones of the East Cliff, on which the parish church of St Mary and the dramatic ruins of the eleventh-century Benedictine abbey stand, has slipped down to sea level and below on the West Cliff opposite. The jet (fossilised remains of prehistoric monkey puzzle trees) for which Whitby is famous come from the Upper Lias shales mostly along the east beach, where curled ammonites and beds of alum can also be found.

Staithes is a picture-postcard village of red pantiled cottages which tumble down in glorious confusion to the tiny harbour at the mouth of the Easington Beck. You have to leave the car behind and walk down the steep hill to reach the cobbled streets of old Staithes, an appropriate Old English name which literally means 'a landing place'.

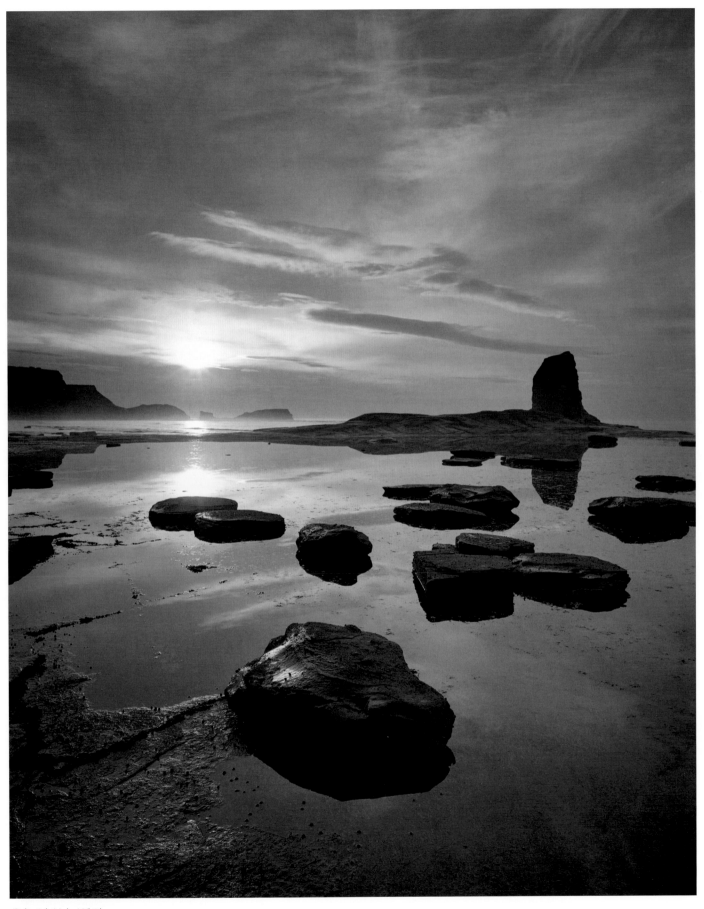

Saltwick Nab, Whitby

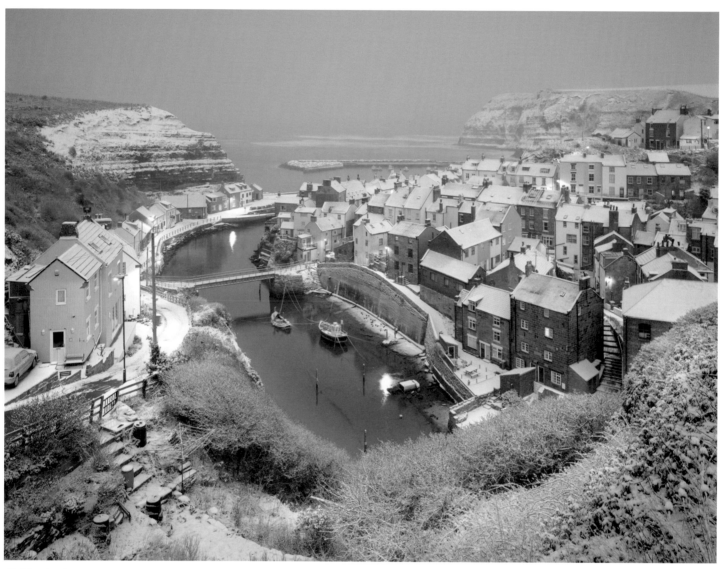

Staithes in winter

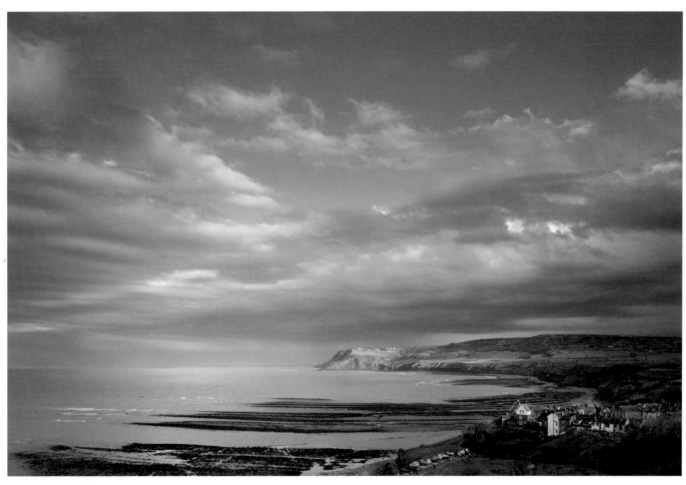

Robin Hood's Bay

THE GOLD COAST
Heritage Coast, Glamorgan

The Glamorgan Heritage Coast is an unsung, hidden gem of British coastal scenery, treasured by the populations of Cardiff, Barry, Bridgend and Port Talbot, but by-passed by the M4 and thus little known outside South Wales. The 14-mile (22.5km) stretch of coast between Aberthaw and Porthcawl features dramatic striated cliffs, secluded scalloped coves and beaches, and spectacular wave-cut platforms of smooth rock. And at its western end, it is backed with some of the most extensive sand dunes in Europe.

The golden-grey cliffs of the coast are a mixture of Jurassic limestones and shales and Carboniferous sandstones and limestones. They were formed 200 million years ago when this part of Wales lay beneath a warm, shallow, equatorial sea at the dawn of the Jurassic age. The crumbling cliffs in places like Nash Point, Dunraven and Monknash still contain the remains of Jurassic sea creatures, such as ram's-horn-curled ammonites.

As the coast faces the wild Atlantic, it bears the full force of ferocious south-westerly winds, which makes it ideal for surfers but a real test for the crews of ships sailing up the Bristol Channel into Cardiff or Bristol. Trinity House's Chief Engineer James Walker designed the startlingly white Nash Point lighthouse to protect these vessels in 1832, and it was the last manned lighthouse in Wales before it was automated in 1998.

Among the other striking topographical features of the Gold Coast of Glamorgan are the dramatic shark's fin of Nash Point, near Marcross, the extensive wave-cut platforms of Dunraven, and the scalloped cliffs and boulder fields of Monknash.

By far the best way to explore the coast, especially its more remote parts, is to take the Heritage Coast Path. At the western end of the path at Ogmore Castle – a twelfth-century Norman construction – stepping stones over the River Ewenny lead you into one of the most fascinating landscapes in Britain: the Merthyr Mawr Warren sand dunes.

The dunes are the closest thing Wales has to a desert, and quite unlike anywhere else in the Principality. Indeed, they doubled as Wadi Rum for some sequences in David Lean's classic film *Lawrence of Arabia*, which were filmed here in the early 1960s. The dunes spread over 800 acres (323ha), with some rising to 200 feet (60m) – making them the second highest sand dunes in Europe. The most impressive is the biggest of the lot, the so-called Big Dipper. The Welsh rugby team and Olympic athletes such as Steve Ovett and Iwan Thomas have used the thigh-bursting ascent of the Big Dipper in their training. The dunes were once joined to the Kenfig dunes, forming part of a huge sandy tombolo, which stretched from the Ogmore river to the Gower peninsula. Kenfig Pool, the largest freshwater lake in south Wales, lies at the heart of the Kenfig reserve, and is particularly valuable as a staging post for migrating birds.

Inland, a string of castles such as those at Ogmore, St Donat's and Coity guard the southern route into Wales, and the old town centre of Llantwit Major is an intricate maze of narrow lanes, ancient inns and historic buildings. But the Glamorgan coast remains one of Wales's best-kept secrets – except, that is, to the people of Morgannwg.

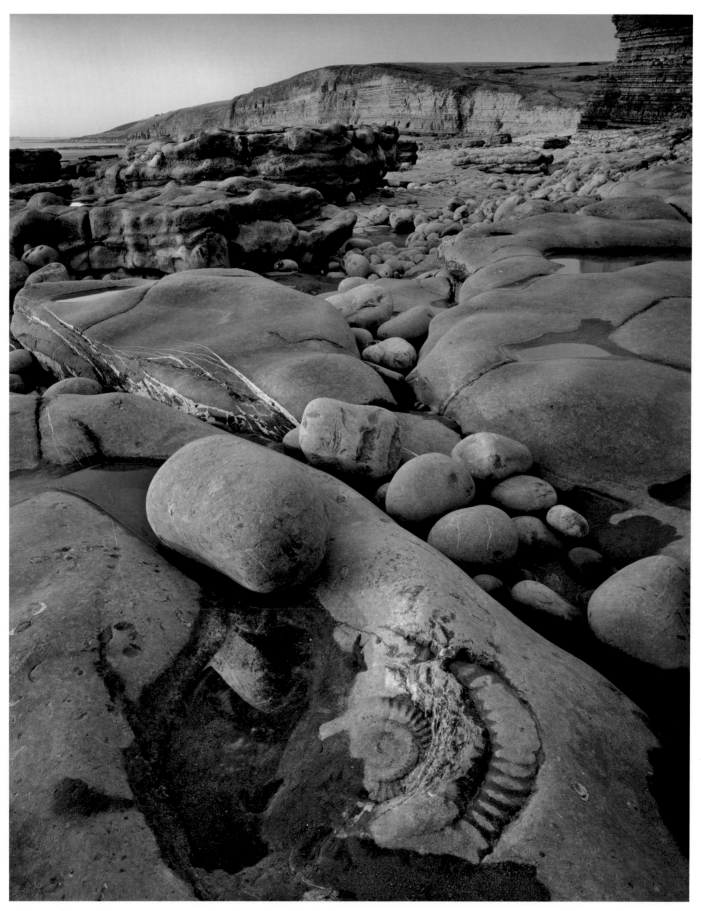

Dunraven Bay, ammonite

CHALK AND CHEESE
Dover, Beachy Head and Seven Sisters, South Downs

When Vera Lynn sang about bluebirds over the White Cliffs of Dover in her 1942 wartime hit, the only bluebirds were the marauding Heinkels and Dorniers of the Luftwaffe. Equally, in this optimistic and, it has to be said, rather cheesy song written by Walter Kent and Nat Burton, she could be referring to the old country name for swallows, which do have an iridescent blue sheen to their plumage.

These migrants cross the English Channel from the Continent in spring and leave again in autumn, and they are traditionally believed to be portents of improving weather and harbingers of good fortune. So the song was the perfect metaphor for the slowly turning tide of the Second World War in 1942, and it became one of the most popular of the entire conflict.

The White Cliffs of Dover – always a bold symbol of England for those returning from the Continent – are themselves a national icon, voted the third greatest natural wonder of Britain by *Radio Times* readers in 2005. They, and the equally impressive cliffs of Beachy Head and the Seven Sisters, further west along the coast in Sussex where the South Downs meet the sea, consist of soft, fine-grained Cretaceous chalk. This is made up of planktonic algae whose skeletal remains sank to the bottom of the primeval ocean between 140 and 65 million years ago. Seams of jet-black flint, thought to be the silicified remains of sea creatures such as sponges, also line the chalk.

Shakespeare Cliff, just to the west of Dover, takes its name from the supposed place where the cruelly blinded Earl of Gloucester in *King Lear* was led to the cliff edge by his son Edgar. This is Gloucester's cliff, 'whose high and bending head looks fearfully in the confined deep'.

The deranged and suicidal Gloucester might equally have chosen the towering headland of Beachy Head, near Eastbourne, which is one of the most notorious suicide spots in Britain, with about twenty attempts each year. At 531 feet (162m), it is the highest chalk cliff in Britain, with views extending east to the shingle spit of Dungeness (see page 224), to Selsey Bill in the west.

The barber's-pole Beachy Head lighthouse in the sea below was built in 1902 to replace the 1834 Belle Tout lighthouse on the next headland west. Because of rampant coastal erosion, the lighthouse was moved bodily back 56 feet (17m) from the cliff edge in 1999, and is now an airy guesthouse.

West from Belle Tout is one of the longest stretches of undeveloped coastline on the entire south coast, with over 500 acres (200ha) of ancient chalk downland, alive with butterflies, wildflowers – and maybe even a few returning 'bluebirds' – in summer.

The cliffs eventually drop down to Birling Gap, where the Cuckmere River meets the sea, and beyond that to the iconic Seven Sisters. These are the truncated or hanging remnants of dry valleys in the South Downs, which are being eroded by the sea in places at the rate of up to a metre a year. It's also well worth exploring the beach below, where Shakespeare's 'murmuring surge, that on the unnumbered idle pebbles chafes', is perfect for beachcombing and rock pooling.

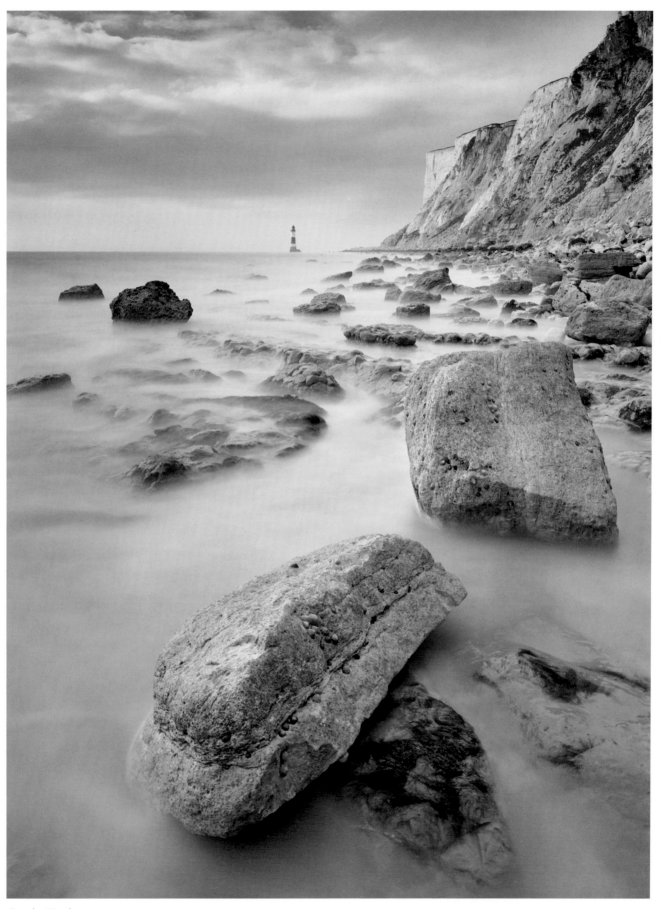

Beachy Head

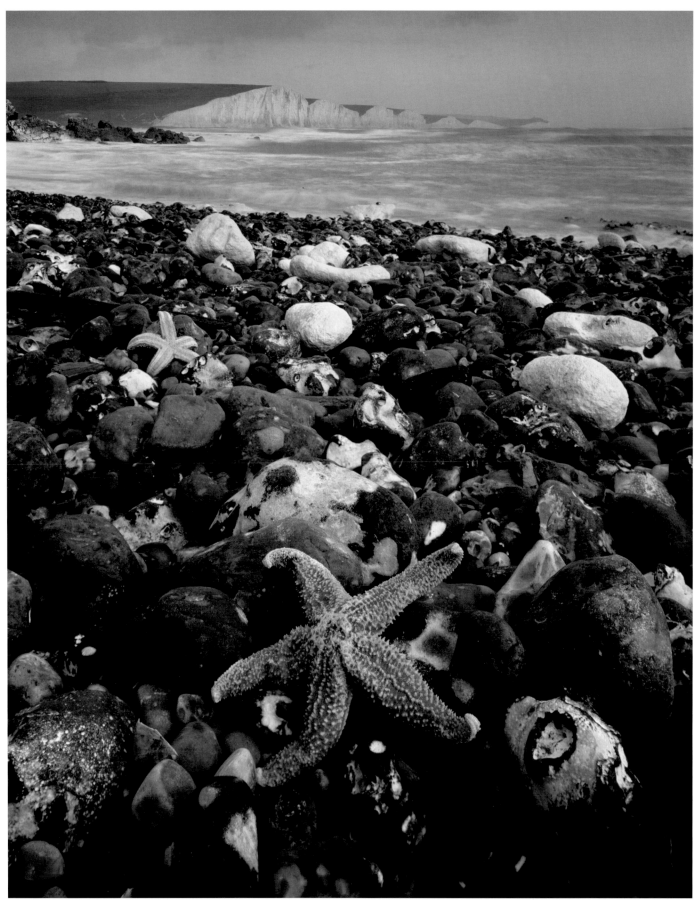

Seven Sisters and starfish, from below Seaford Head

Barnacle detail

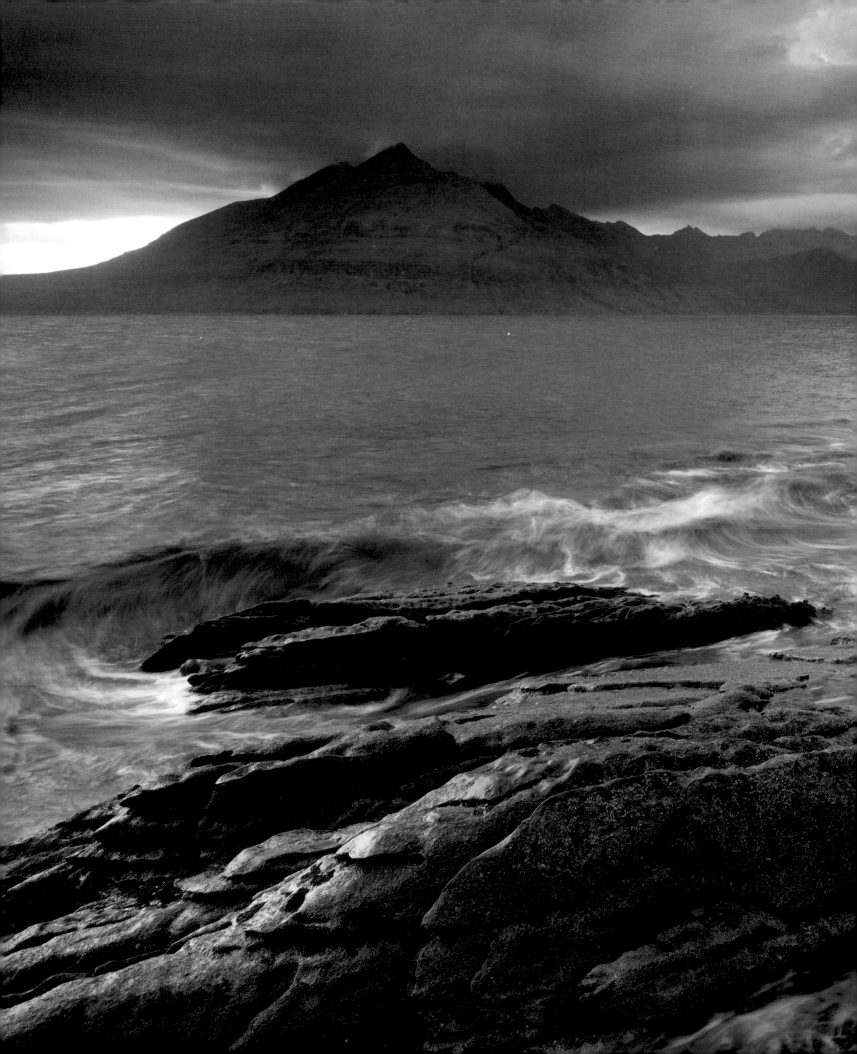

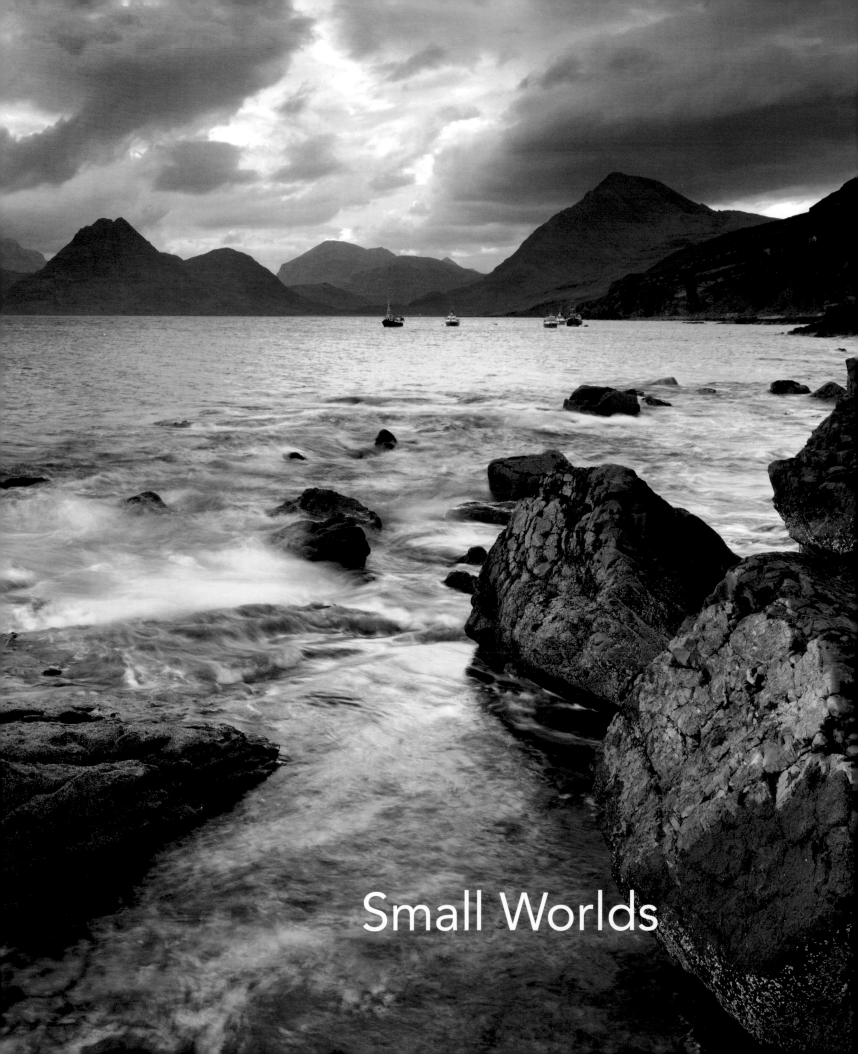

Small Worlds

Small Worlds

We are, when all's said and done, an island

nation. Unlike many other countries, the sea is our only

neighbour. There are reckoned to be around 6,000 of these 'small

worlds' around Britain, many of them uninhabited rocks or skerries.

Many have fascinating human histories and create, as in the case of

Arran off the south-west coast of Scotland, a microcosm of the

mainland. Others have an almost tangible, deep spiritual or

religious charisma, such as Lindisfarne and Iona, while

on the wild cliffs of Shetland or Orkney, you can

really feel that you are standing on the

very edge of the world.

SMALL ISLES, BIG HILLS
Rum, Eigg and the Small Isles, Inner Hebrides

Each of the Small Isles – the group of Inner Hebridian islands comprising Rum, Eigg, Muck and Canna off the south-western shores of Skye – has its own quite different character, but all have that distinctive Hebridean charisma.

The once-forbidden mountainous island of Rum contains every element of Hebridean scenery, from the stepped country of Torridonian sandstones in the north around Kilmory Glen to the grassy terraces and basaltic cliffs below the peak of Orval (1,874ft/571m) in the west and the knife-edged gabbro ridges of the Rum Cuillins – the twin peaks of Askival (2,663ft/811m) and Ainshval (2,552ft/778m) – in the south.

The distinctive Rum peaks were almost certainly named by Viking raiders as they sailed through the Hebrides, as most of their names are of Norse origin. Askival means 'the hill of the spear' and Ainshval 'the rocky ridge hill'. The only settlement of any size on Rum is the little township of Kinloch at the head of Loch Scresort on the east coast, where the crenellated red sandstone Kinloch Castle, with its walled garden, pasture and extensive areas of woodland, dominates Kinloch Glen.

The small population of Rum crofters were evicted (mainly ending up in Canada) in 1826 when the laird, Alexander Maclean, cleared the island for sheep. But the sheep were not as profitable as Maclean had hoped, and by 1845 the island had been turned into a shooting estate by the Marquis of Salisbury, who introduced Rum's famous herd of red deer.

The island was bought by Lancashire textile tycoon John Bullough in 1887, and continued as a deer stalking estate, with the public firmly excluded. John's son George inherited the island in 1897 and built Kinloch Castle from red Arran sandstone, which still stands as a decaying monument to Edwardian elegance. George Bullough also built the somewhat pretentious, classical Greek temple-style mausoleum for the family graves in lonely Glen Harris.

The whole island was designated a National Nature Reserve when it was sold to the Nature Conservancy Council (now Scottish Natural Heritage) in 1957. Apart from its magnificent herd of red deer, it is perhaps most famous for being the site of the re-introduction of white-tailed sea eagles from Norway in 1975. After a slow start, these magnificent birds have now spread to other parts of the Hebrides, and they share the Rum skies with a good population of native golden eagles.

The Sound of Rum separates Rum from Eigg, which is formed mainly from volcanic basalts and is therefore much more fertile than its larger neighbour. A steep-sided ridge of Jurassic sandstone forms impressive cliffs in the north of the island, while the southern end is dominated by the imposing prow of the Sgurr of Eigg (1,292ft/394m), a block of volcanic pitchstone lava which forms a long, undulating ridge of bare grey rock.

The low-lying island of Muck, off the south-western coast of Eigg, is formed of Tertiary basalt, which again gives it that familiar stepped profile, and the rock has been worn into a series of cliffs and caves around the coast.

The northern extremity of the Small Isles archipelago is Canna, another basaltic island but with inland cliffs above its grassy slopes and a spectacular northern coastline of caves, arches and stacks.

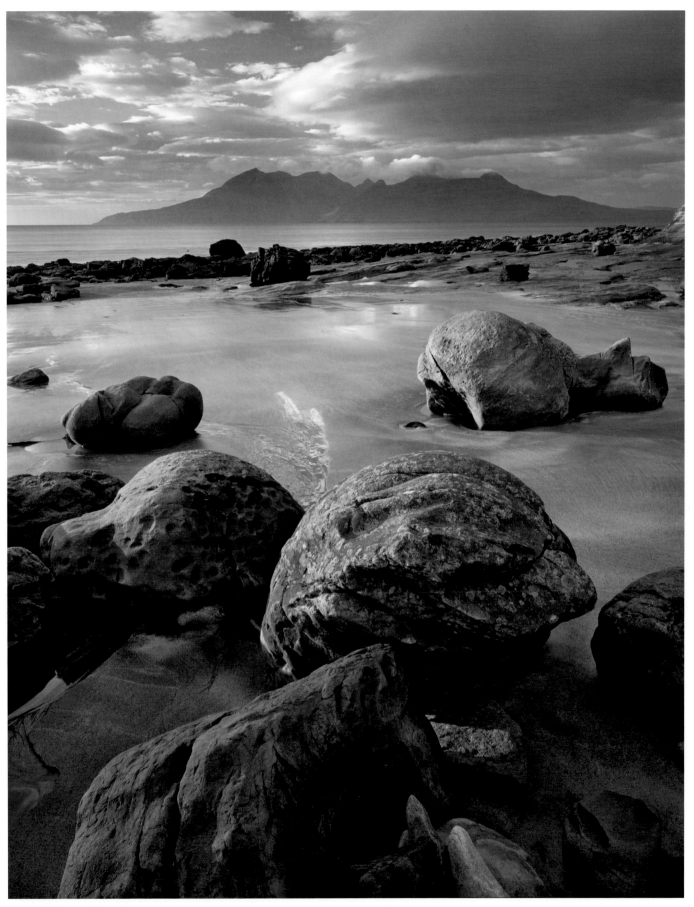

Rum from Bay of Laig, Eigg

STACKED AGAINST THE ODDS
The Old Man of Hoy and Rackwick Bay, Orkney Islands

See Hoy's Old Man! whose summit bare
Pierces the dark blue fields of air;
Based in the sea, his fearful form
Glooms like the spirit of the storm;

Malcolm (nineteenth-century Orcadian poet)

Nothing quite prepares you for the first sight of the Old Man of Hoy, lauded by our best-known mountaineer, Sir Chris Bonington, with the double plaudit of being not only Britain's finest sea stack, but also its most inaccessible summit.

The 2-mile (3.2km) trek across the featureless moorland of Moor Fea from the tiny hamlet of Rackwick is made hazardous by dive-bombing great skuas, or 'bonxies' as they are known in these parts, and leads to the cliff top opposite the famous 450-foot-high (137m) sea stack. In late summer, the moor is ablaze with the regal pink and purple of bell and ling heather and cross-leaved heath, as well as the occasional orchid. But it's only when you get to the edge of the cliff, with nothing between you and America, 3,000 miles (4,800km) away across the storm-tossed Atlantic, that you truly appreciate its spectacular position.

The tottering, ruby-red Orcadian sandstone tower, linked to the mainland at low tide by a narrow, boulder-choked causeway, is layered like the remains of a half-eaten chocolate cake, precariously overhanging its wave-dashed base on three sides. To the non-climber it simply looks impossible, yet the legendary climber and Ullapool G.P. Tom Patey, accompanied by Bonington and Rhodesian climber Rusty Baillie, first achieved the sloping, thyme-dotted summit

after an epic three-day assault on the east face in 1966.

The Old Man first really registered in the nation's consciousness the following summer, when 15 million people watched a BBC TV outside broadcast spectacular, as the sea stack was climbed by three teams using two separate routes. Viewers thrilled at Bonington and Patey's acrobatics on a Tyrolean traverse across the void between stack and mainland, and shivered at the thought of the uncomfortable bivouac which was spent halfway up the face.

The Old Man of Hoy is an outstanding example of a sea stack caused by coastal erosion. It was once linked to the mainland by a sandstone arch, which long since was battered into oblivion by the ceaseless, pounding waves of the Atlantic. Perhaps the only reason that the stack is still standing is because it rests on a plinth of more resistant granite. One thing is absolutely certain: one day it will tumble and crash into the sea, just like its former link to the Hoy mainland.

A less direct but more interesting approach to the Old Man is to stroll along the beautiful beach of Rackwick Bay from the Rackwick Bay Hostel, down the coast to the south. Hemmed in by teetering sandstone cliffs, Rackwick's dusky pink sands are backed by beautiful, pastel-contoured boulders and a string of heather-thatched crofts. Inquisitive grey seals bob their heads in the breakers and seabirds scream from the enclosing cliffs as you leave the beach and head up across the moor towards the Old Man, with the bulk of Hoy's reigning summit of Ward Hill (1,513ft /461m) looming ahead.

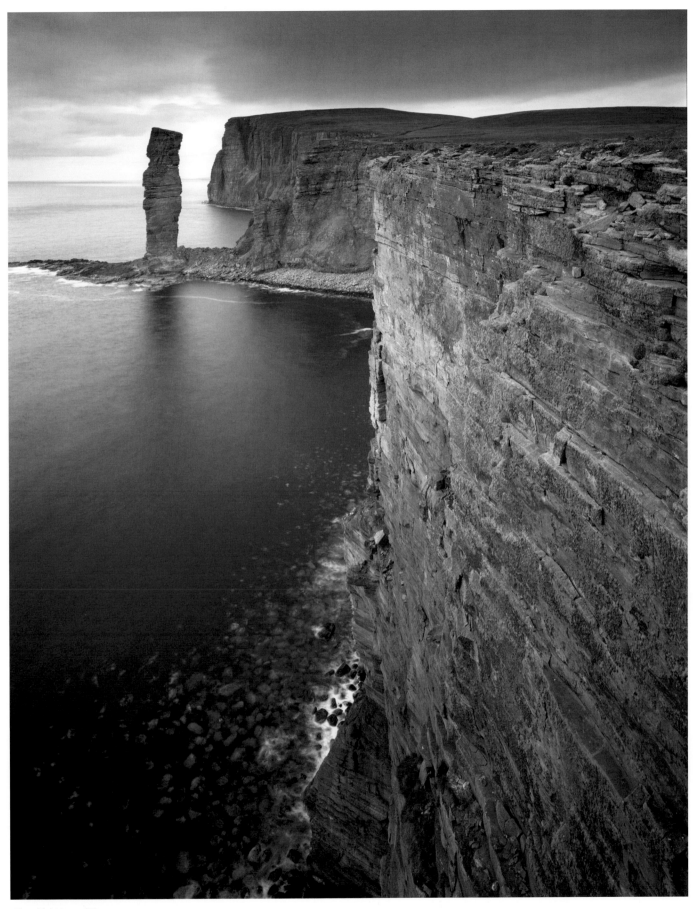

The Old Man of Hoy

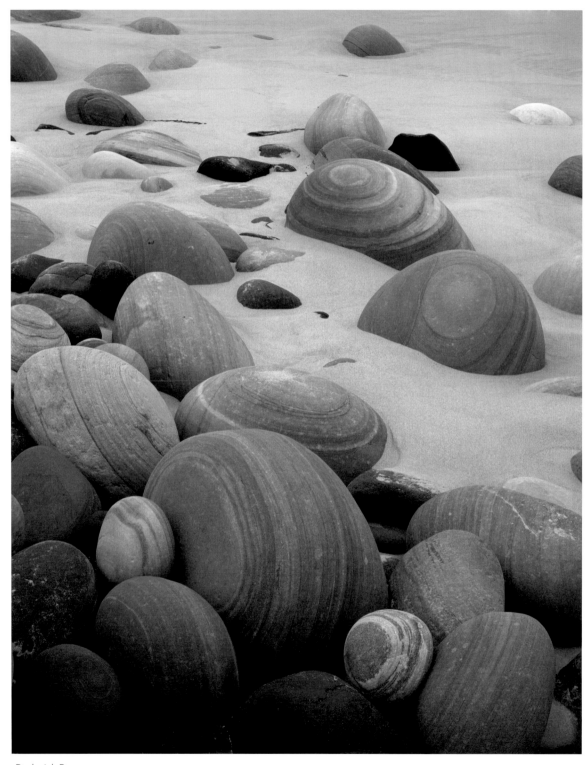

Rackwick Bay

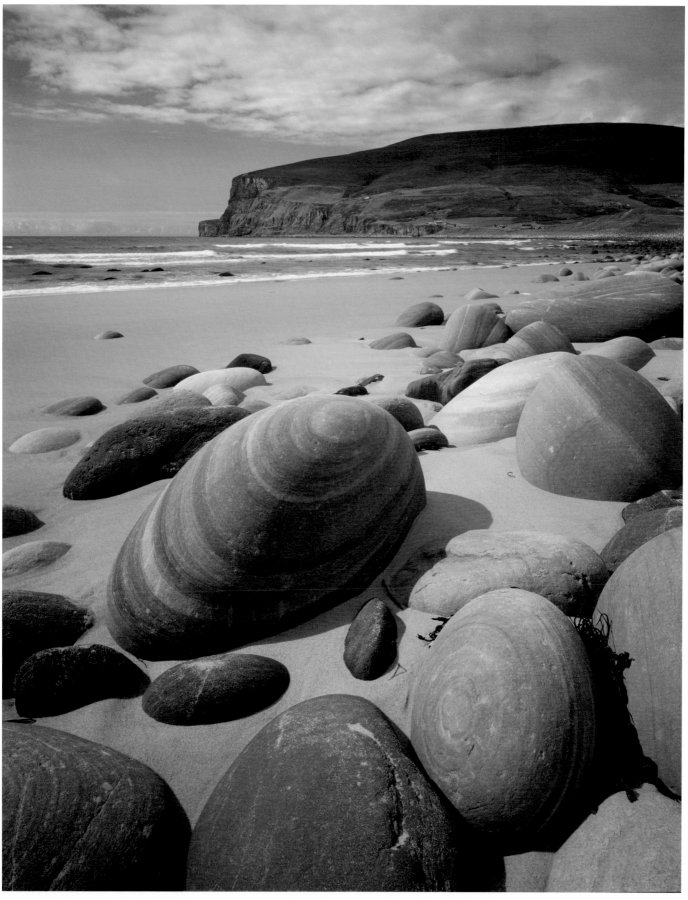

Rackwick Bay

MENDELSSOHN'S INSPIRATION
Iona and Staffa, Inner Hebrides

The enormous Atlantic swell crashed into the gaping mouth of Fingal's Cave, filling the air with plumes of salty spray and making it boom like a sonorous drum. Dramatic, certainly, but frustrating for us in our attempt to land on the tiny island of Staffa, west of Mull in the Inner Hebrides.

As our tiny boat bucked and heaved in the boisterous waves, I sympathised with the German composer Felix Mendelssohn, who apparently had a similar experience when he landed here one August day in 1829. Travelling on the newly introduced paddle steamer sailing round Mull and calling at Iona and Staffa, Mendelssohn and the rest of his fellow passengers were very, very seasick.

That didn't stop the composer from immortalising the scene in his *Hebrides* overture, usually known as *Fingal's Cave*, which was published the following year. Those gentle, tide-like cadences gradually swell into a glorious, rumbustious representation of the full power of the Atlantic breakers surging into the echoing, pillared cave. Whenever I hear them, without fail they take me back there in my imagination.

Actually, that constant heaving swell meant it took me three attempts over several years to actually land on Staffa. But when I finally did, I took the advice of boatman David Kirkpatrick and headed north from the landing at Clamshell Cave, in the opposite direction to the rest of the group, who were bent on seeing Fingal's Cave. The grassy walk north along the cliffs to Meall nam Faoileann gave me an intimate introduction to Staffa's most charming residents, the comical, clown-like puffins, whose burrows pepper the thyme-scented cliff tops.

The name Staffa appropriately comes from the Old Norse word for the vertical staves used for the walls of their wooden buildings. The cave, one of several around the island, takes its name from Fingal, the father of Ossian, the legendary bard of the Gaels.

I returned to Fingal's Cave after the crowds had departed, and had it all to myself. I entered the cathedral-like cavern with its regular hexagonal columns of basalt springing up into the fretted roof from the heaving, breathing sea-floor, with a feeling of reverential awe.

We'd taken David's boat from St Columba's sacred island of Iona, 10 miles (16km) away to the south. Most visitors to Iona arrive by the regular ferry from Fionnphort on Mull, dash up to the abbey, and then rush back to catch the next ferry back.

If you can, it is much better to stay on Iona to explore it more thoroughly, especially the southern end and St Columba's Bay, or Port a' Churaich (the bay of the coracle), where the saint was supposed to have landed in exile from Ireland around AD 563.

The beach at Port a' Churaich is covered with smooth, wave-worn pebbles of every imaginable colour, from the delicate lime green known as Iona marble (and locally as 'Columba's tears'), through to pastel reds, mauves and purples. My bookshelves are now full of them.

On the west coast of the island, the dazzling white beaches of Camus Cul an t-Saimth are speckled with delicate, ground-hugging wildflowers in one of the best examples of machair (fertile, shell-based meadows) in the Hebrides. And it's here that you may be lucky enough, as I was, to hear the harsh, mechanical call of one of Britain's rarest birds, the shy, skulking corncrake, whose onomatopoeic call almost exactly replicates its Latin name of *Crex crex*.

White Strand of the Monks, Iona

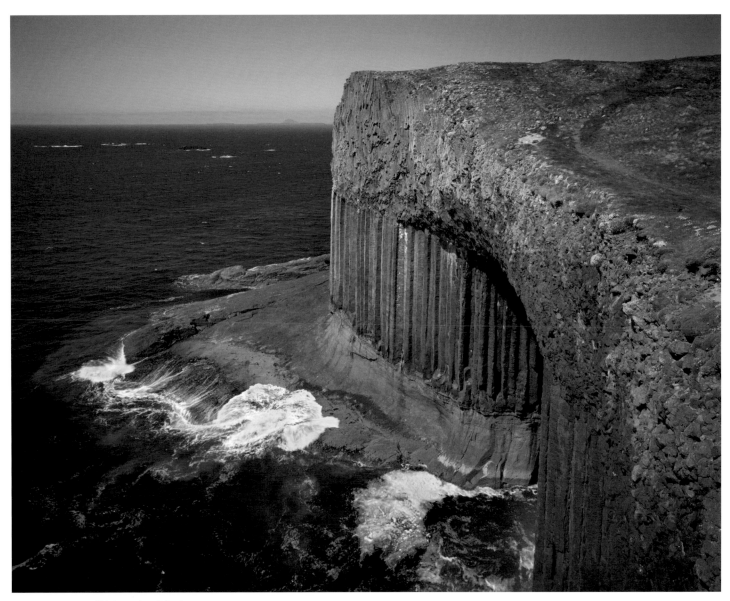

Fingal's Cave, Staffa, from the cliffs above

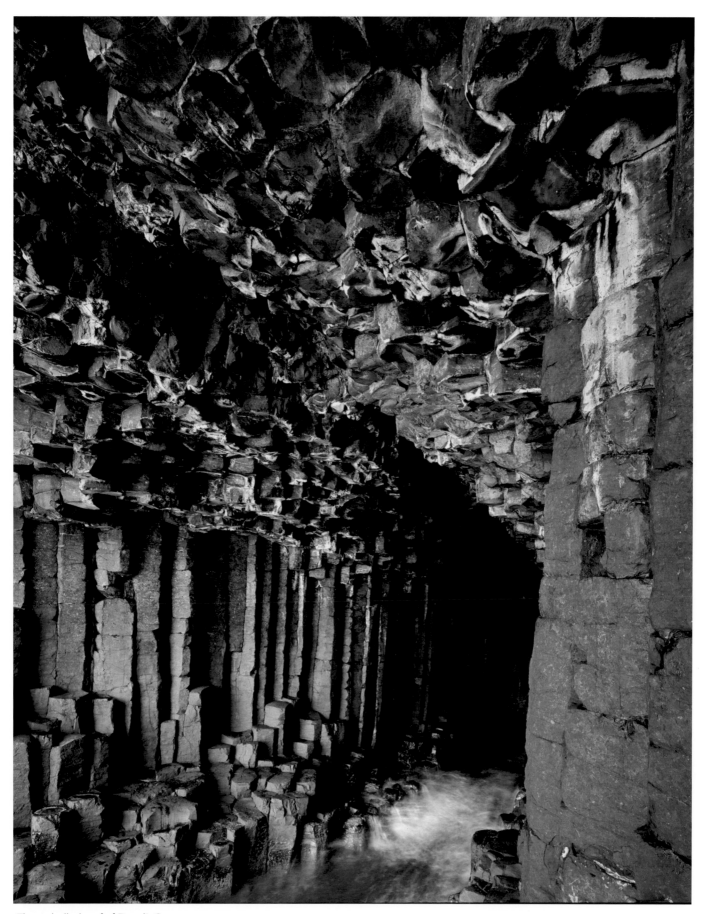

The corbelled roof of Fingal's Cave

THE VIKINGS ARE COMING
Lindisfarne and the Farne Islands, Northumberland

. . . never before has such terror appeared in
Britain as we have now suffered . . . Behold,
the church of St Cuthbert spattered with the
blood of the priests of God, despoiled of all
its ornaments; a place more venerable than
all in Britain is given as prey to pagan peoples.

Letter from York scholar Alcuin to King Aethelred, AD 793

The shock which resounded around the Christian world at the first recorded attack by Viking raiders on the Holy Island of Lindisfarne off the Northumberland coast on 8 June 793 is clearly evident from Alcuin's breathless account. Even the *Anglo-Saxon Chronicle*, written a century later, echoed the sense of devastation felt at the time: 'the harrying of the heathen miserably destroyed God's church on Lindisfarne by rapine and slaughter'.

Although the reputation of the Vikings purely as agents of rape and plunder has undergone something of a rehabilitation in recent years, there can be no doubt that the 793 raid on Lindisfarne marked the start of nearly three centuries of Viking incursions into Britain.

Their legacy is still with us today, in place names, especially in the northern and eastern parts of Britain; in the Scandinavian loan words, which have found their way into our language, and in the invisible yet persistent traces of their DNA in our chromosomes.

There's little evidence of that ferocious Viking raid 1,200 years ago on the peaceful island of Lindisfarne today. The landscape is dominated by Edwin Lutyens' fairytale early-twentieth-century castle, built on an outcropping plug of the Great Whin Sill, and the romantic sandstone ruins of Lindisfarne Priory. This twelfth-century foundation was probably built on the site of Cuthbert's church, and

was suppressed not by raiding Vikings but on the orders of Henry VIII during his ruthless Dissolution of the Monasteries in 1537.

Lindisfarne is reached by a 3-mile (4.8km) causeway from the mainland, which is cut off at high tide for about five hours every day, so visitors must keep an eye on the tide tables. But there's a kind of self-indulgent pleasure in seeing the tide coming in to isolate you, or seeing the last ferry leave for the mainland, when you know you are staying overnight on an island like Lindisfarne. At last, you think, you've got it all to yourself. Both Joe and I have enjoyed that rather selfish pleasure, and I have fond memories of a few days spent on Lindisfarne, which allowed me to explore the island thoroughly, from The Snook to Castle Point.

Lindisfarne is a National Nature Reserve, designated for its tidal mudflats, saltmarshes and dunes, which combine to make a perfect habitat for wildfowl and waders, including overwintering rarities such as pale-bellied Brent geese from Svalbard, pink-footed and greylag geese, wigeon, Arctic terns, grey plovers and bar-tailed godwits. But perhaps Lindisfarne's most famous avian residents are the elegant black-and-white eider ducks – known here as 'St Cuddy's (or Cuthbert's) ducks'.

You are most likely to see them if you take the boat trip from Seahouses to the rocky Farne Islands, south of Lindisfarne, where their Frankie-Howerd-like 'oo-oos' and 'ah-oos' will alert you to their presence. St Cuthbert had a special affection for these charming birds, the largest ducks in Europe. It is claimed he introduced the world's first bird protection laws in about 676 to protect the eiders and other sea birds nesting on the islands, after he discovered that local people liked to eat the eiders and their eggs, not to mention using their soft and cosy insulating feathers for bedding, as some people still do.

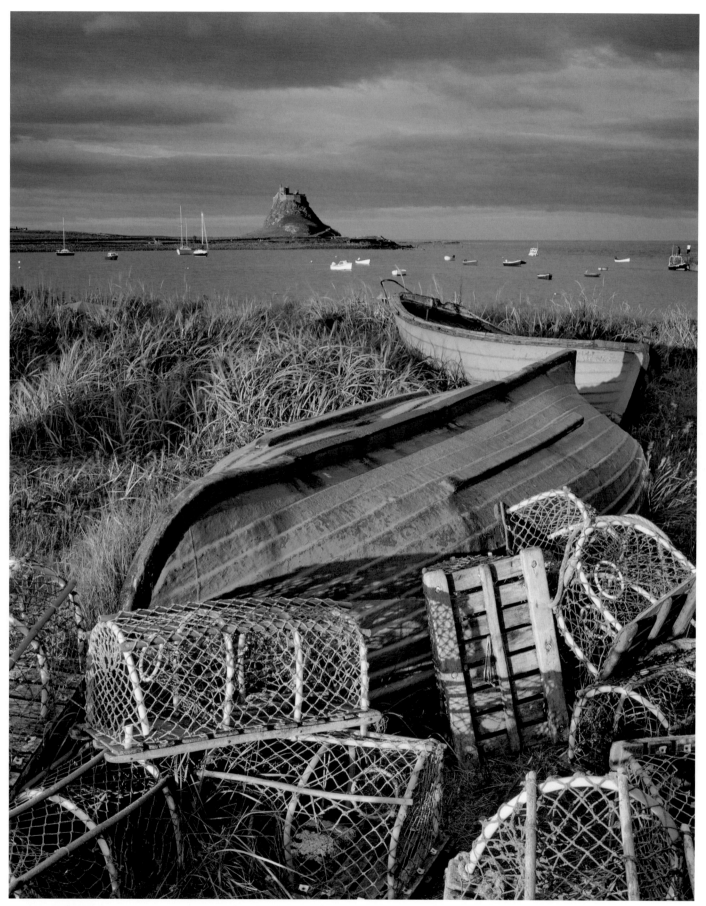

Still life, Lindisfarne

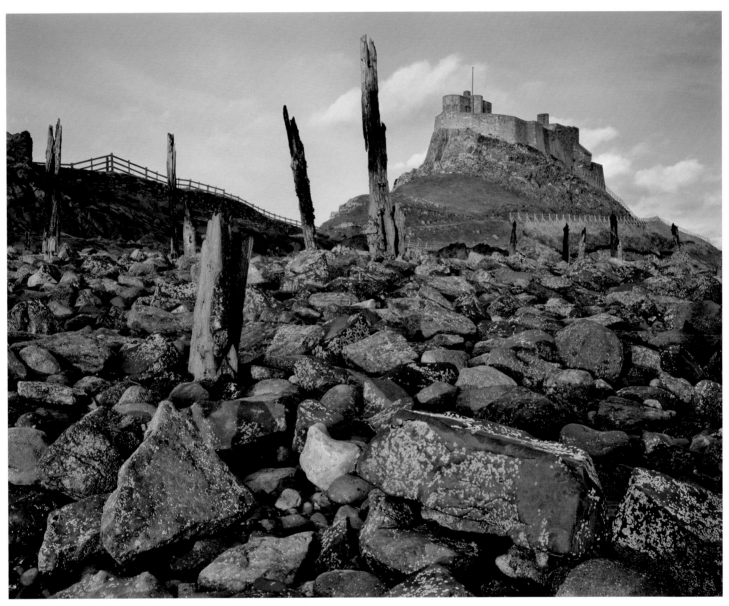

Pier remnants, Lindisfarne Castle

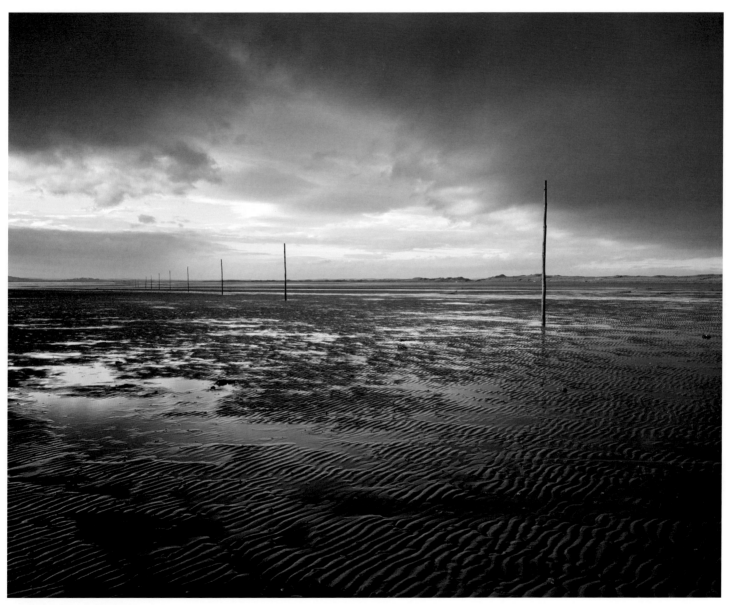

The Pilgrim's Way, Lindisfarne

HIGHLANDS IN MINIATURE
Goat Fell, Arran

Guidebooks often describe the Isle of Arran in the Firth of Clyde as 'the Highlands in miniature'. And although it is only an hour's boat trip across the Firth of Clyde from Ardrossan on the mainland, the more mountainous northern half of the island certainly exhibits some of the rugged character of the Western Highlands.

Northern Arran is dominated by serrated granite peaks culminating in Goat Fell, at 2,867ft/874m the highest point on the island. Ancient Highland rocks form the granite dome that is the basis of the spectacular scenery, and I had long been tempted by mountain photographer W.A. Poucher's description and photographs to explore its 'Cyclopean buttresses', as he called them.

Bad weather, driving rain and blanket clouds meant it took me three attempts to reach the summit of Goat Fell, the great rock fang of Cir Mhor (2,618ft/798m), and the equally challenging summits of the ridge, including Caisteal Abhail (2,818ft/859m) and Beinn Tarsuinn (2,707ft/825m). But it was well worth the wait. Deeply dissected by craggy glens like Glen Rosa and Glen Sannox, these rugged peaks are a serious proposition to even the most experienced hillwalker. But if they are successful, as I eventually was, on a good day you are rewarded with outstanding views across to Bute, Cowal and the mainland of Kintyre. These magnificent Arran hills are also the haunt of herds of red deer, and golden eagles and hen harriers can often be seen soaring on their broad, fingered wings across the glens.

The narrow coastal plain has typically Hebredian raised beaches, on which tiny 'clachan' (hamlet) settlements have developed, many now in sad ruins after the infamous Highland Clearances of the nineteenth century. The only large settlements are the ferry port of Brodick beneath Goat Fell on Brodick Bay, and Lochranza in the north, where there are the romantic grey-stoned ruins of a fourteenth-century tower house and a youth hostel.

One road (the A841) encircles the island, sticking closely to the coastline, while the B880 so-called String Road threads the glen of the Machrie Water across the centre of the island, between Brodick and Machrie Bay. Here there is plenty of evidence of prehistoric activity in the form of stone circles and standing stones.

The mild southern climate, warmed by the waters of the Gulf Stream, permits the growth of luxuriant vegetation in the more sheltered glens. This is shown to dramatic effect in the famous rhododendron gardens of Brodick Castle, the Scottish baronial-style former seat of the Dukes of Hamilton, now in the hands of the National Trust for Scotland and the centrepiece of a popular country park. I have seldom seen as many mounted antlers as I have in Brodick's Great Hall.

Lamlash Bay, on the sheltered east coast, is dominated by the rocky bastion of Holy Island, which has as a long spiritual history stretching back to the sixth century, when a hermit monk, St Molaise, took refuge there in a cave. Since 1995, the converted lighthouse cottages at the south end of the island have been used as a closed Buddhist retreat.

I never got to Holy Island, as I was told at Lamlash that the ferry, always dependent on weather and tide conditions, had recently sunk.

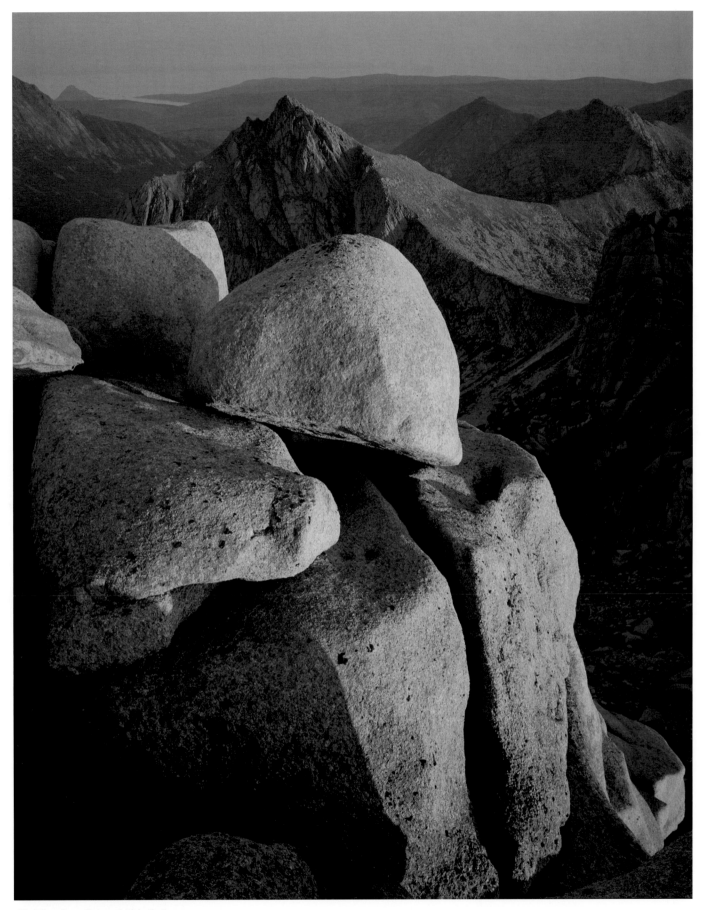

Cir Mhor from Caisteal Abhail, Arran

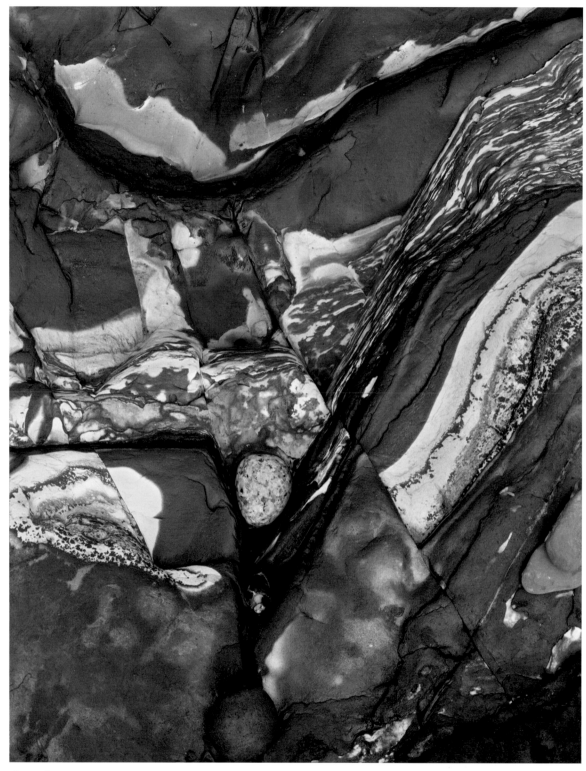

Arran abstract

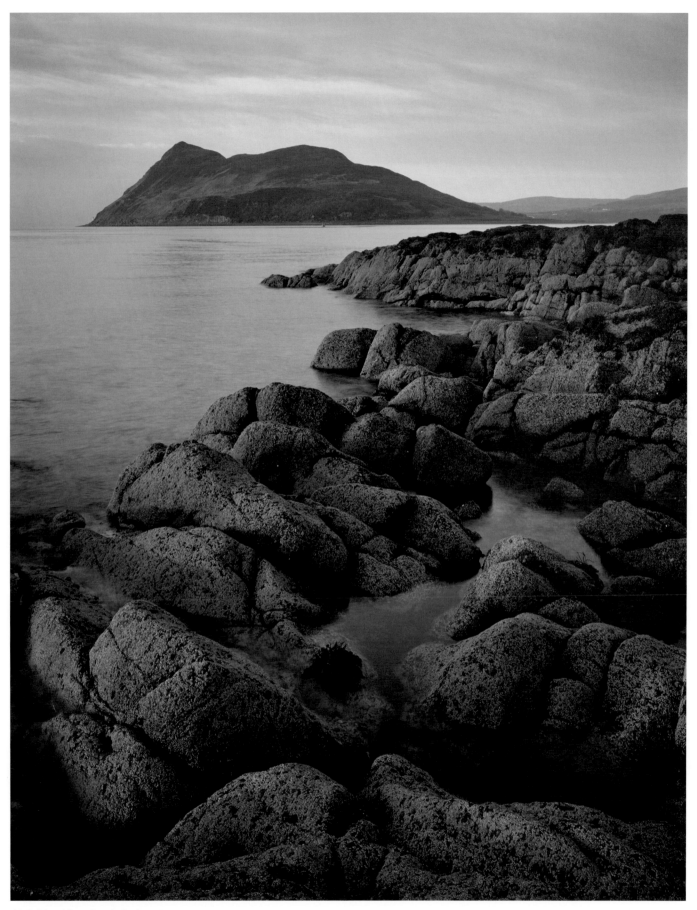

Holy Island from Lamlash, Arran

OVER THE SEA TO SKYE
The Cuillin and Trotternish, Skye, Inner Hebrides

For rarely human eye has known
A scene so stern as that dread lake,
With its dark ledge of barren stone.
Seems that primeval earthquake's sway
Have rent a strange and shatter'd way
Through the rude bosom of the hill;

<div align="right">Sir Walter Scott, The Lord of the Isles (1815)</div>

The remote and beautiful Loch Coruisk, cupped beneath the jagged, sawtooth ridge of the Cuillins of Skye and so vividly described by Walter Scott after his visit in 1814, is surely one of the wildest places in Britain.

Usually approached by boat from Elgol, Loch Coruisk is a glittering gem set in the beating heart of the Cuillin which, especially after a dusting of snow, are the nearest thing that Britain gets to the Alps. Walkers make their way to Coruisk by Glen Brittle and Camasunary, but I've always approached it along the coastline of Loch Scavaig from the crofting settlement of Elgol. This way you have the bristling skyline of the Cuillin ridge constantly beckoning you on until you reach the infamous 'Bad Step', where the path involves an awkward traverse across the steep slabs of Sgurr na Stri, which sweep straight down to the icy waters of Loch Scavaig.

On our first visit we were accompanied by a friendly Labrador, which had followed us from our corrugated iron-roofed B&B in Elgol, while out in the loch, an equally friendly breaching porpoise accurately forecast a week of fine weather – a real rarity on Skye.

Rising straight from the sea, the Black Cuillin presents the finest mountain profile in Britain, famous throughout the world both for the severity of their climbing and the magnificence of their views. Seen from the hamlet of Sligachan, the range is dominated by the shapely cone of Sgurr nan Gillean (3,167ft/965m). At 3,046ft/928m, Bla Bheinn (or Blaven) is another magnificent Cuillin Munro, consisting of slabs of naked grey rock isolated from the main ridge by Glen Sligachan, and best seen across Loch Slapin from the tiny, whitewashed walled hamlet of Torrin.

There are fourteen 'Munros' (mountains over 3,000 feet) in The Cuillin, and the difficulty of the traverse of the 7-mile-long (11km) Cuillin Ridge is reflected by the fact it was not accomplished in the summer until 1911, and not in winter until 1965, by a party led by the redoubtable Tom Patey.

Another more easily attainable wonder of Skye is the 20-mile-long (32km) northern peninsular of Trotternish, where the tottering basalt pinnacles of The Old Man of Storr and The Quiraing provide some of the weirdest volcanic landscapes in Britain, facing out across the blue waters of the Sound of Raasay and the mainland peaks.

Here a succession of flat-topped plateaux ends in beetling basalt cliffs, showing where landslips have created a landscape which geologists know as 'trap'. The teetering, undercut obelisk of The Old Man of Storr is a constant landmark on the road north of Portree, while The Quiraing hides its innermost secret behind a formidable stockade of needle-sharp pinnacles and crumbling towers. The Table, an emerald-grassed, football-pitch-sized plateau, is completely hidden from view until you scramble up to reach it.

Was this where the Skye MacDonalds hid their stolen cattle, as in Glencoe's Lost Valley? I like to think so.

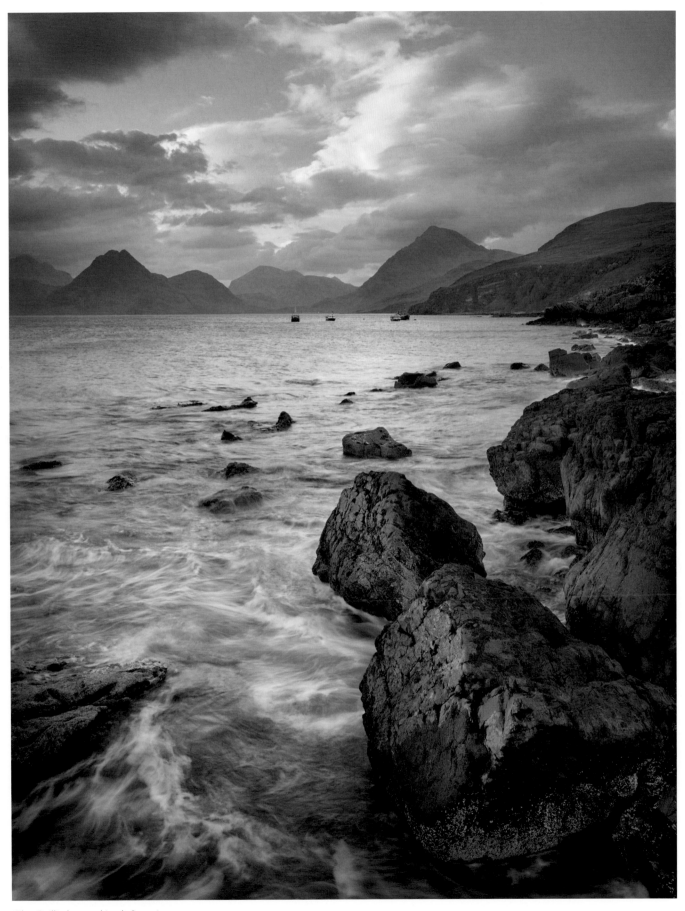

The Cuillin beyond Loch Scavaig

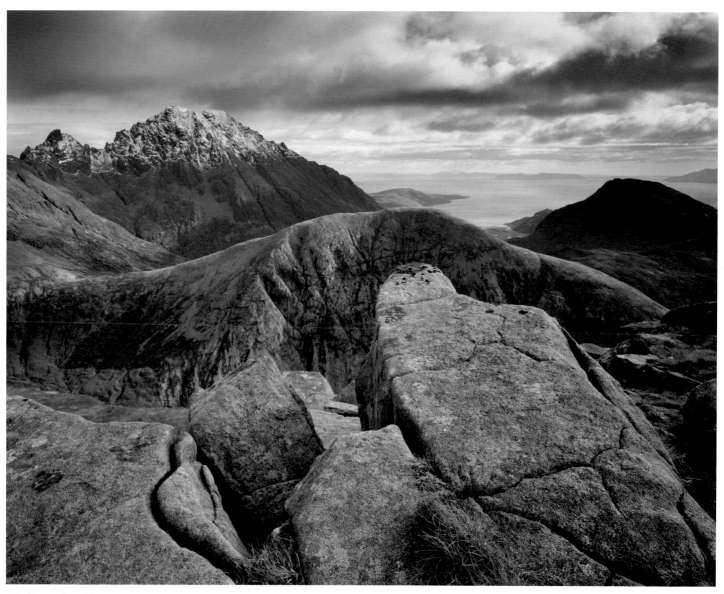

Bla Bheinn from Marsco

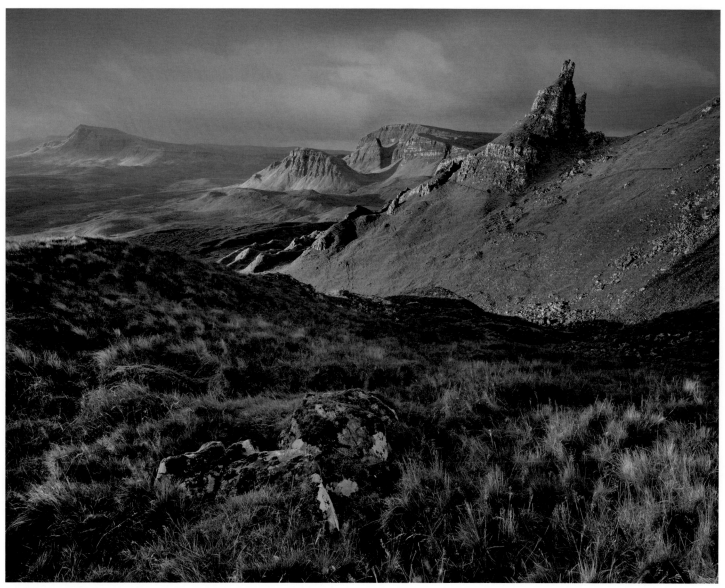

The Prison, Quiraing

TO THE END OF THE WORLD
Hermaness and Unst, Shetland

It is closer to the Arctic Circle than it is to London; closer to Bergen in Norway than it is to Aberdeen, and on the same latitude as the southern tip of Greenland. The isolated peninsula of Hermaness on the Shetland island of Unst is the most northerly point of Britain – and when you walk out onto the cliff tops facing lighthouse-topped Muckle Flugga, it really feels like it's the end of the world.

As might be expected, it's not easy to get to. A twelve-hour ferry from Aberdeen, or flights from Stansted, Glasgow, Edinburgh or Aberdeen, will only get you to Mainland Shetland. It's another two ferries and the 15-mile (24km) crossing of Yell before you even reach Unst, and then another 12 miles (19km) to Burrafirth and Hermaness.

I was lucky on my first visit because I had Rory Tallack, ranger on the Hermaness National Nature Reserve, as my guide. Leaving Burrafirth, we followed the dale of the Burn of Winnaswarta and took the boardwalked trail across boggy Sothers Brecks to reach the bleak high point of Hermaness Hill (656ft/200m). As we crossed the moorland, we were constantly attacked by marauding great skuas – those feathered pirates locally known as 'bonxies' – who dive-bombed us if we approached too close to their nests. We could even hear the whistle of their wings as they swished past our unprotected heads.

When we reached the summit, Rory told me the local story of how the peninsula of 'Herma's headland' got its name. 'It takes its name from the mythical giant Herma, who lived here. He and a rival giant named Saxa, who lived on Saxa Vord, lobbed rocks at each other across Burra Firth, one of which became Out Stack, which is actually the most northerly point of Britain.'

We could clearly see Out Stack, beyond the seabird-haunted skerries of Muckle Flugga, from our viewpoint. We descended west towards the storm-battered west coast, punctuated here by dramatic stacks and geos, to take a closer look at one of Britain's largest seabird colonies. Rory said that the cliffs of Hermaness and the outlying skerries were home to over 100,000 breeding seabirds, including more than 16,000 pairs of gannets, 5 per cent of the European population.

Added to the fulmars, black guillemots, kittiwakes, shags, great and Arctic skuas, puffins and gulls, it was as cosmopolitan a seabird city as you could find anywhere. We spent a pleasant hour eating our sandwich lunch and watching as the cast of thousands swooped and dived in a dizzying aerial display on the very northern tip of Britain.

Under a light drizzle and threatening skies as the Shetland 'summer dim' (i.e. night) approached, we headed back and Rory took me to another of Unst's unheralded NNRs – the Keen of Hamar.

The Keen doesn't look much at first glance, described as 'a heap of old rubble' by one visitor. But actually, the 400-million-year-old weathered serpentine debris here is the closest you'll come to what Britain looked like at the end of the Ice Age, 10,000 years ago.

This sparsest of soils gives rise to an extraordinary range of some of Britain's rarest flowers, such as northern rock cress, spring squill, mountain everlasting, Norwegian sandwort and – rarest of all – Edmondston's chickweed. This insignificant little white-flowered plant was discovered in 1837 by a bright twelve-year-old Unst boy, Thomas Edmondston, who went on to become Professor of Botany at Anderson (now Strathclyde) University in Glasgow.

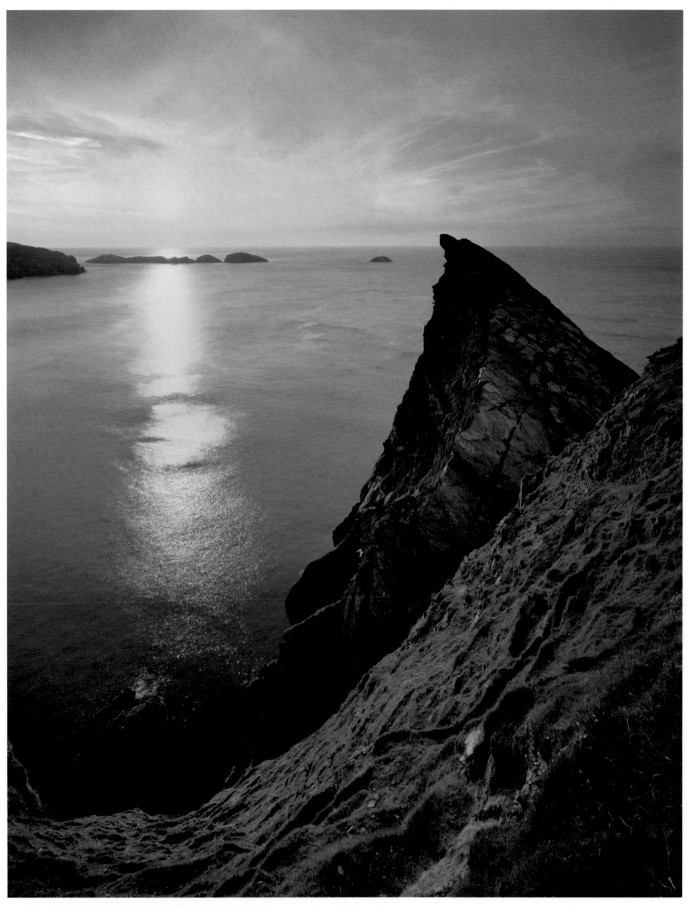

Sunset over Hermaness and Muckle Flugga, Shetland

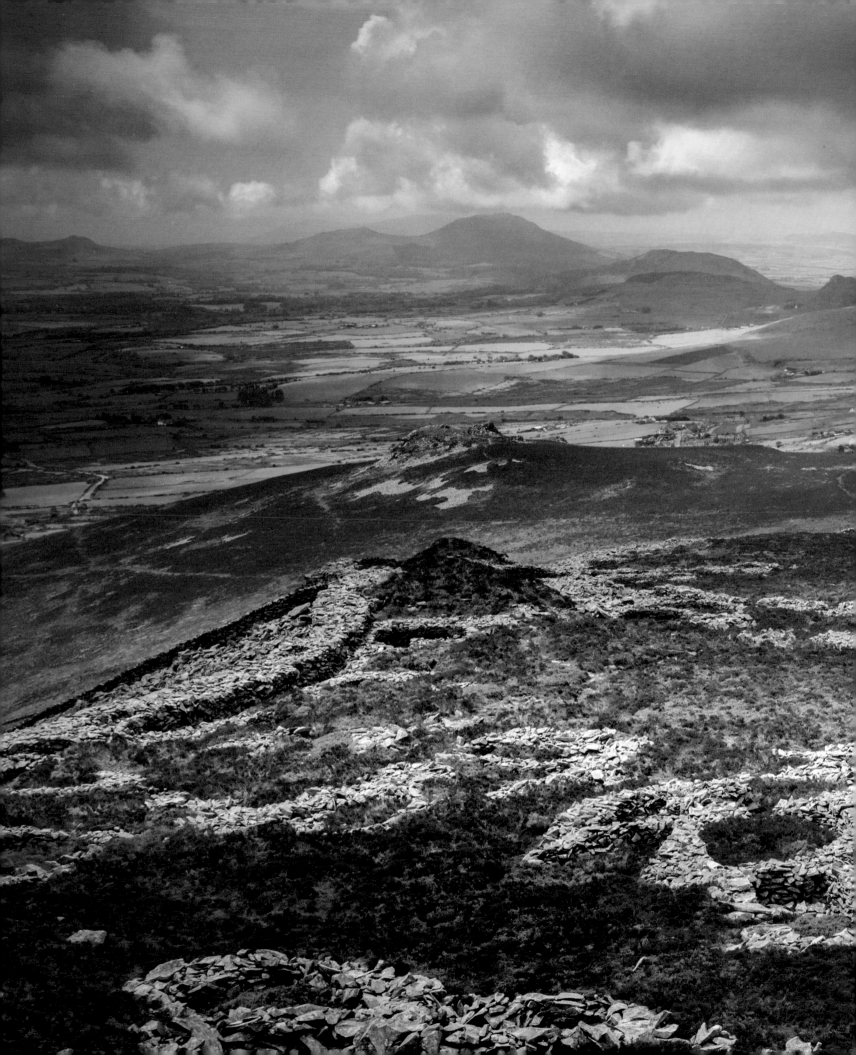

Monuments and Memories

Monuments and Memories

The pioneering landscape historian W.G. Hoskins

said the golden rule of reading the British landscape was

always to remember: 'Everything is older than you think.' Nowhere

else in the world has such a continuity of history – a palimpsest on which

the story of human life has been written over and over again. The earliest

humans left a remarkable record of their passing, from the monumental

stone circles of Lewis and Shetland and the uplands of England.

The imperial might of Rome brought prehistory to a close

and imposed a lasting imprint on the land, with its

still-impressive border barrier of Hadrian's

Wall in Northumberland.

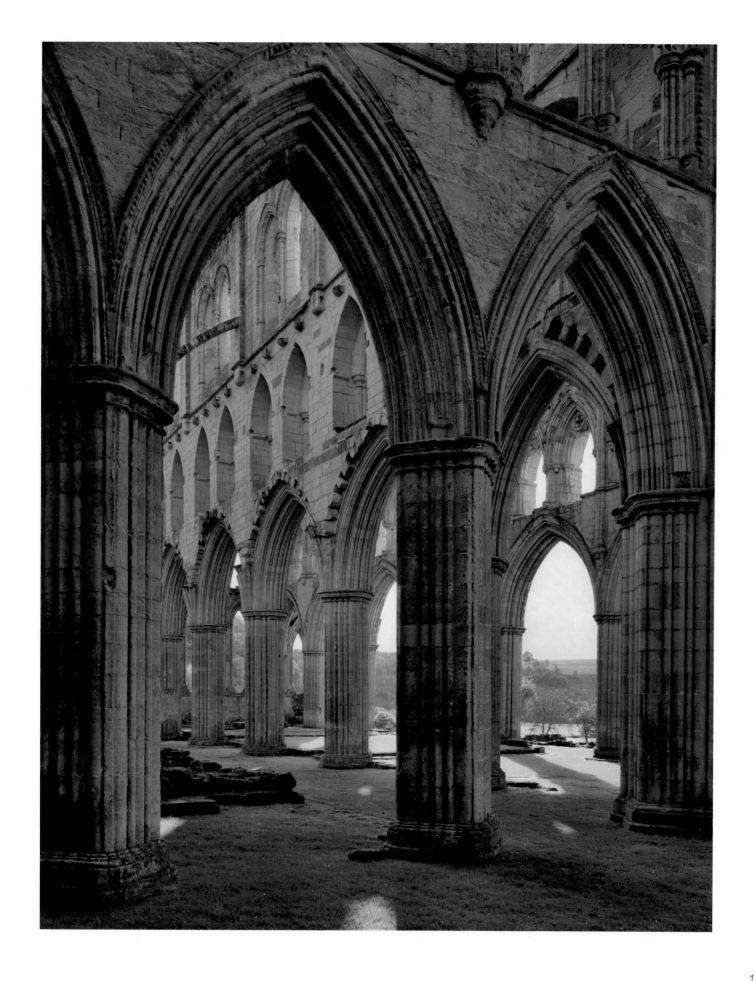

MEGALITHIC CATHEDRAL
Avebury, Wiltshire

One bitterly cold January morning in 1649, as Civil War raged across England, a wealthy young local gentleman named John Aubrey was out foxhunting with his friend and fellow Royalist Dr Walter Charleton. The chase took them across Fyfield Down along the chalky Bath Road (now the A4), around the huge man-made mound of Silbury Hill, and into the village of Avebury. What he saw there had an immediate effect on Aubrey, as he recalled in his posthumously published *Monumenta Britannica:*

> The chase led us at length through the village of Avebury, into the closes there: where I was wonderfully surprized at the sight of those vast stones: of which I had never heard before . . .
> I observed in the enclosures some segments of rude circles, made with these stones; whence I concluded, they had been in the old time complete.

They were, said Aubrey 'the greatest, most considerable & ye least ruinated of any of this kind in the British Isles'. The surprising thing was that, 'though obvious enough', no one seemed to have recorded them before. He was later to make the memorable claim that Avebury, now known to contain the largest prehistoric stone circles in the world, 'does as much exceed in greatness the so-renowned Stoneheng [sic] as a Cathedral doeth a Parish Church'.

And in 1663, three years after the monarchy was restored, Aubrey, by now a noted antiquarian, philosopher and member of the newly formed Royal Society, delighted in taking his new king Charles II to inspect the circles and also to climb to the summit of the massive man-made mound of Silbury Hill. Today, Stonehenge, Avebury, Silbury Hill and their associated monuments form a World Heritage Site, inscribed by UNESCO in 1986.

At one time, I drove daily along the A361 through Avebury and saw it in all seasons: from sunset on a summer's day when the fading light burnished the sarsens in an otherworldly glare, to the foggy days of autumn, when mists wreathed the massive stones, making them seem even more impressive and mysterious.

The great henge at Avebury encloses an area of nearly 30 acres (12ha) within a huge ditch and bank which was once 1,400 feet (427m) wide and 30 feet (9m) deep. Archaeologists have estimated that they would have taken an astonishing 1.5 million man-hours to construct, using only the most primitive of tools, such as deer antler picks and shoulder blade shovels. Such a feat of engineering must have required an enormous amount of organisation some 4,500 years ago.

The original 100 stones of the Great Circle at Avebury enclose much of the modern village. That contrast between a typically English, medieval village and a vast megalithic temple (if that is what it was) is what makes Avebury unique. Nowhere else can you enjoy a pint in the village pub, The Red Lion, and look out at a megalithic monument. The most important difference between Avebury and Stonehenge is that you can walk among and actually touch the Avebury stones, whereas at Stonehenge, once dubbed 'a national disgrace', you are kept at arm's length, along a fenced path.

At least the closure of the A344 and the new, £27 million visitor centre at Airman's Corner involves a ten-minute shuttle bus ride or a 1½ mile (2.4km) walk to the stones, so you can see them in their landscape context. Which, as Aubrey found 300 years before, has always been the case at Avebury.

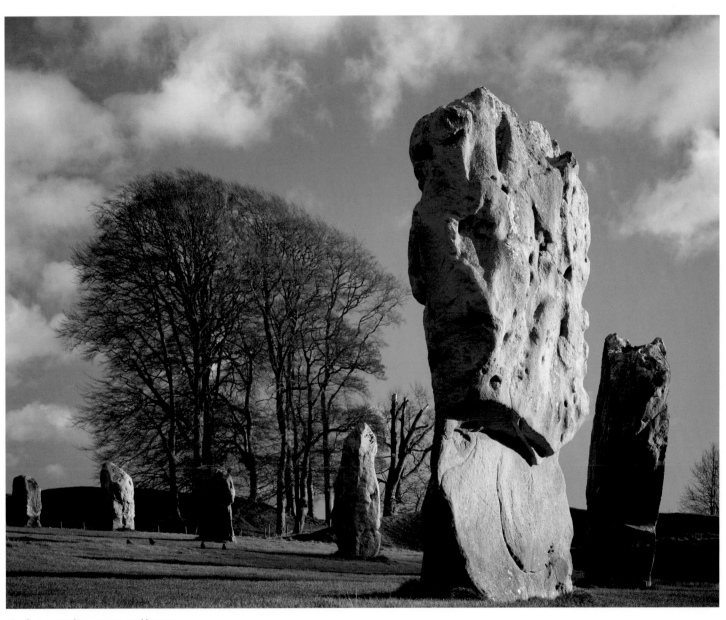

Avebury standing stones and henge

TOWN OF GIANTS
The Llŷn Peninsula, Gwynedd

Archaeologists have never been completely satisfied with the term 'hillfort' for the mighty earthworks, dating mainly from the Iron Age, which encircle 2,000 of our British hills. For them it conjures up entirely the wrong kind of image of Asterix and Obelix-type Ancient Britons holding out against the armoured might of Rome, whereas in most cases, there is no evidence at all of conflict.

A good example is Tre'r Ceiri, on an isolated eastern summit of Yr Eifl (often translated as 'The Rivals' but actually meaning 'The Fork' in Welsh), on the Llŷn Peninsula, near Llanaelhaearn in North Wales. This 5-acre (2ha) hillfort seems to have enjoyed a long and peaceful life as an airy township commanding one of the finest viewpoints in Wales.

Sometimes described as the Land's End of Wales, the Llŷn Peninsula is where the mountain heights of Snowdonia poke a rocky finger out westwards into the shimmering blue waters of the Irish Sea. The all-encompassing views from Tre'r Ceiri extend many a mile, southwards across the waters of Cardigan Bay to Mynydd Preseli, the source of the Stonehenge bluestones, to the dim blue outline of Ireland's Wicklow Hills across the Irish Sea in the west. Nearer at hand, the serrated skyline of Snowdonia's peaks are ranged along the eastern horizon, with the west coast of the holy island of Anglesey marking the north.

The first construction on Tre'r Ceiri was a Bronze Age summit cairn, badly damaged by Victorian antiquaries, and it was followed by the building, probably during the Iron Age perhaps 2,000 years ago, by the dry-stone ramparts of the hillfort. Inside the fortifications, the foundations of about

150 circular huts have been traced beneath the bracken and heather, many of which are still plainly visible. Archaeologists estimate that this lofty hilltop could have supported a population of up to 400 people.

Tre'r Ceiri was probably continuously occupied and re-occupied over many hundreds of years, as buildings were re-used and divided to create 'semi-detached' dwellings, all of which would have been roofed with turves or thatched with heather.

The local name for Tre'r Ceiri is the 'Town of Giants', because massive structures such as this were quite beyond the ambitions of the local population, and were thought to have been the work of a race of giants. But why would the Celtic tribesmen of Gwynedd want to live in such an apparently inhospitable place, when there was plenty of opportunity for easier settlement in the lush valleys beneath? Current thinking is that apart from the obvious ritual significance of such a commanding hilltop, the township may only have been used during the summer, as a seasonal outlook for the community's herds of grazing livestock, but no one really knows.

It's an easy, if steep, 2-mile (3.2km) walk to reach the summit from the B4417 Llithfaen road, a mile south of Llanaelhaearn. As you approach the still-impressive, up to 15 feet (4.6m) high, western ramparts of the hillfort, its entrances and staggered gateways are clearly visible.

After your exploration of the hillfort, it's worth dropping down west to the col that separates Tre'r Ceiri from the reigning, triple-topped summits of Yr Eifl (1,850ft/564m) to the west, from which the views are equally splendid.

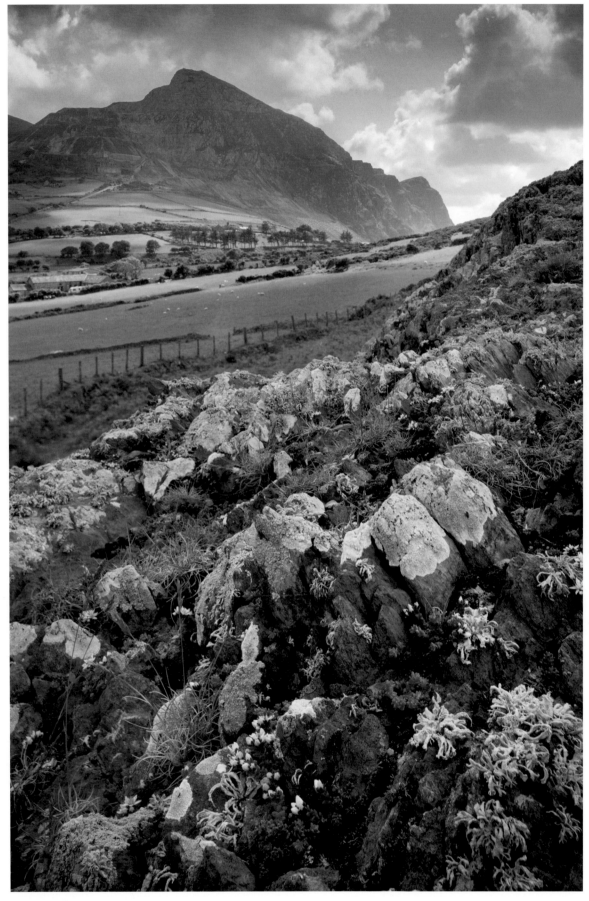

Yr Eifl from Trefor

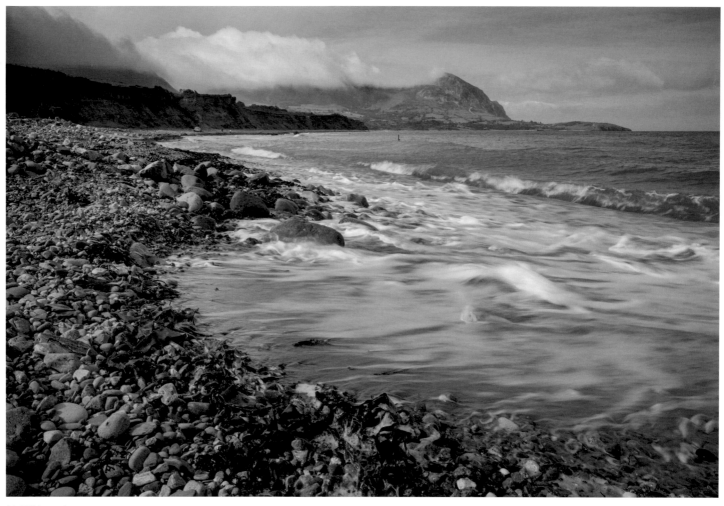

Yr Eifl from the east

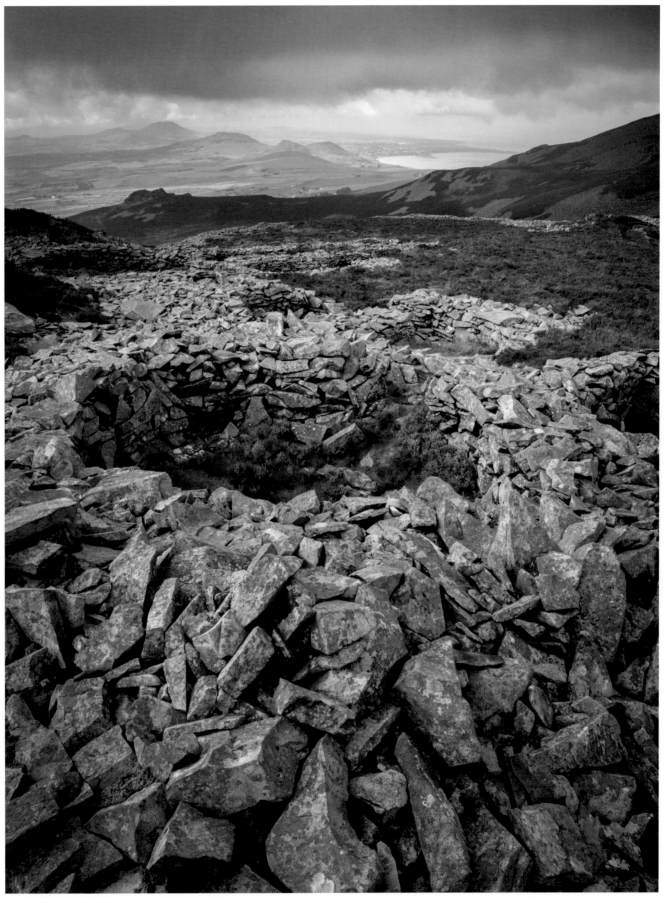

Town of Giants, Tre'r Ceiri

STONY SYNOD
Calanais Stone Circle, Lewis

Islanders know the stones of the Calanais (usually Anglicised to 'Callanish') Stone Circle on the west coast of Lewis as Fir Bhrèige (False Men). And that's exactly what they look like as you approach this extraordinary monument, perched on a prominent low ridge between the grey waters of Lochs Roag and Smuaisaval, with the backdrop of the heather-covered hills of Great Bernera.

This amazing cross-shaped setting of Lewisian gneiss stones, centred on a flattened circle of blade-like monoliths, look nothing more like a stony synod of hoary elders, gathered to discuss their community's business.

At their heart stands a solitary 16-foot-high (4.9m) stone, thought to weigh about 5½ tons, who is obviously the leader of this petrified plenary. Lines of smaller stones radiate from the circle to east, west and south, while to the north runs a 90-yard (82m) avenue of two lines of stones, narrowing as they approach the circle.

Unlike its southern counterpart on Salisbury Plain, at Calanais you can actually go up and touch the stones, and really feel the sacred atmosphere of the place. But it's the *texture* of the incredibly ancient Lewisian rocks – some of the oldest in Britain – which adds so much to that tactile experience. They have been crushed, melted and folded over 3,000 million years to form a hard, crystalline rock which looks and feels like the silvery grains in a well-weathered piece of wood.

Local tradition claims the race of giants who lived on the island and who refused to be converted to Christianity by St Kieran were turned to stone as a punishment. Another local legend tells how during a time of famine, a white cow emerged from Loch Roag and told the local women to take their milking pails to the old stone circle. The cow generously provided everyone with a pail of milk each night, but after a witch had unsuccessfully tried to get two pails, she returned the next night with a sieve – and promptly milked the cow dry. After that, the bountiful bovine was never seen again at the Calanais stones.

Archaeological excavations in the 1980s discovered that the main circle was erected during the late Neolithic period, about 4,500–5,000 years ago. Around 3,000 BC the climate in the Western Isles was much warmer than it is today and sea levels were lower. Salmon ran in the rivers; deer, sheep and cattle grazed the surrounding hills, and barley grew on the broad ridge where Calanais now stands.

Why was it built? The best guess seems to be that it served as some kind of ritual astronomical observatory. Patrick Ashmore, who led the excavations in the 1980s, claimed that the most attractive explanation was that every 18.6 years, the moon skimmed low over the hills to the south. 'It seems to dance along them, like a great god visiting the earth,' explained Ashmore. 'Knowledge and prediction of this heavenly event gave earthly authority to those who watched the skies.'

Having been a focus for prehistoric ritual activity for at least 1,500 years, Calanais was finally abandoned, and climate change resulted in a blanket of peat gradually covering the stones. The peat was removed and the circle taken into the care of the nation in 1885, and it is now managed by Historic Scotland.

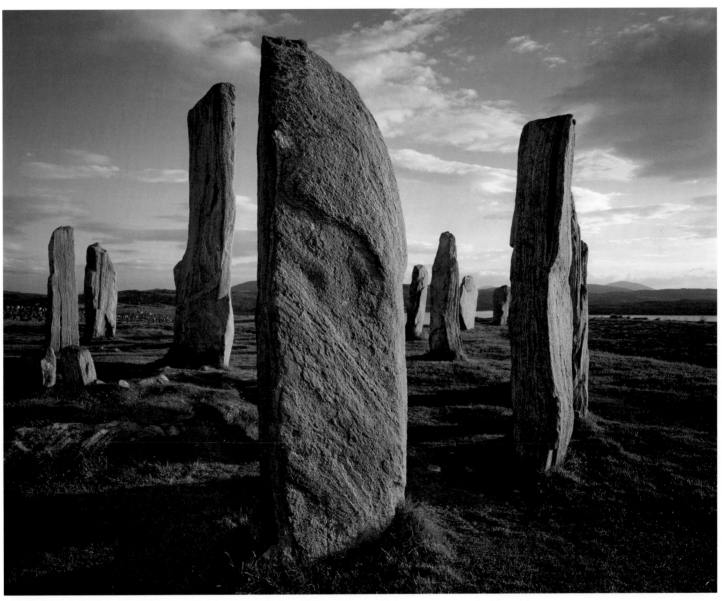

Calanais

EDGE OF EMPIRE
Hadrian's Wall, Northumberland

Just when you think you are at the world's end, you
see a smoke from East to West as far as the eye can turn,
and then, under it, also as far as the eye can stretch,
houses and temples, shops and theatres, barracks and
granaries, trickling along like dice behind – always
behind – one long, low, rising and falling, and hiding
and showing line of towers. And that is the Wall!

Rudyard Kipling, *Puck of Pook's Hill* (1906)

That vivid description of Hadrian's Wall by Parnesius, a
centurion of the 30th Legion in Kipling's time-travelling
1906 historical adventure, gives an inkling of the awesome
impression the wall must have given in its heyday.

Still mightily impressive today, Hadrian's Wall was
a masterpiece of second-century military engineering, and
it remains one of the finest examples of Roman military
architecture in Europe. It ran for 80 Roman miles (73 modern
miles/117km), putting a stone stranglehold across the neck of
Britannia from the Tyne to the Solway.

The wall was built at the behest of the Emperor
Hadrian in AD 120–28, both to mark the northernmost
limit of his empire and as a barrier against possible invasion
by the barbarian Picts and Scoti from what we now know
as Scotland. Current thinking is that the wall served a dual
purpose – for defence certainly, but perhaps more importantly
as a political border.

It is amazing to think that it took a force of about 10,000
professional legionaries (not, as is often suggested, British slaves)
only eight years to build the wall, with its series of turrets,

milecastles, forts and *vallum*. The *vallum* was an open
ditch that acted as a sort of political no-man's-land between
the wall and the military road (now the B6318), which
paralleled it to the south.

Hadrian's surveyors cleverly utilised the natural
landscape when they built the wall. They used the defences
formed by the 300-million-year-old volcanic outcrop, or dyke,
of dolerite known as the Great Whin Sill, which runs west
to east across the southern boundary of what is now the
Northumberland National Park, for much of the most
spectacular central section of the wall. Here it marches along
a switchback, rolling ridge, with the vertical crags of the
Whin Sill forming a natural defensive wall to the north.
These 15 miles (24km) constitute some of the best preserved
and most impressive sections of the wall, including
Housesteads, Winshields, Walltown Crags and Sewingshields.

The most impressive remains are at Housesteads, the
most complete example of a Roman fort in Britain. Covering
5 acres (2ha), it was originally built in AD 120–25 and was
occupied throughout the third and fourth centuries by the
First Cohort of Tungrians, an 800-strong infantry regiment
raised in modern day Belgium.

But the feature which usually attracts the most
attention, especially for younger visitors, is the latrine block,
which would have had a row of wooden seats over the main
sewer channel, fed by water from the adjacent tanks. The
smaller channel was used for washing the sponges – the
Roman equivalent of toilet paper.

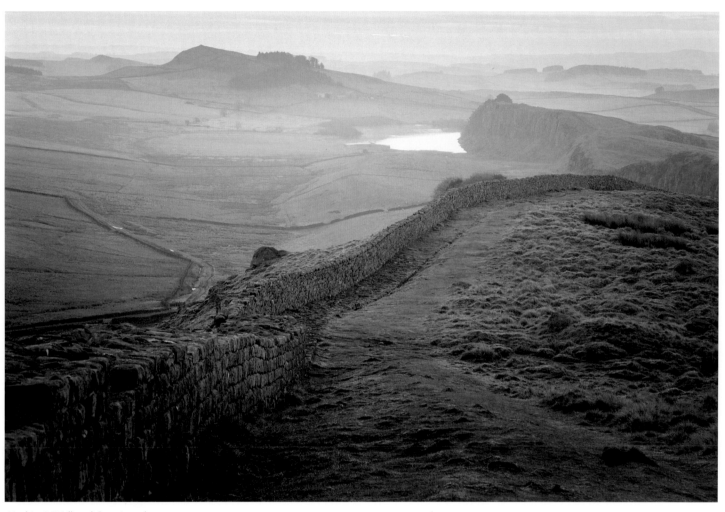

Hadrian's Wall and Crag Lough

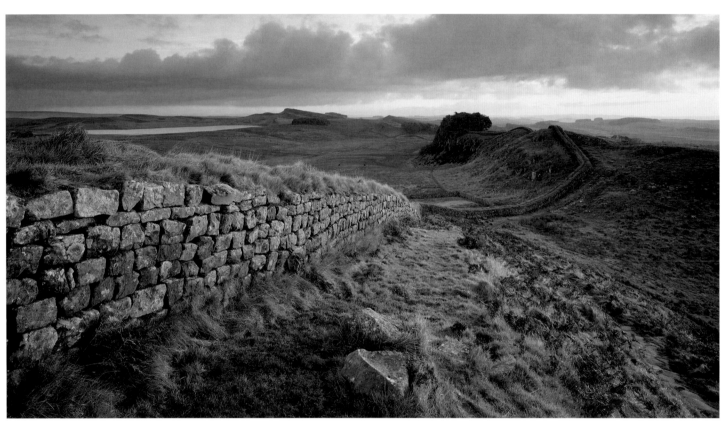

Hadrian's Wall, west of Housesteads

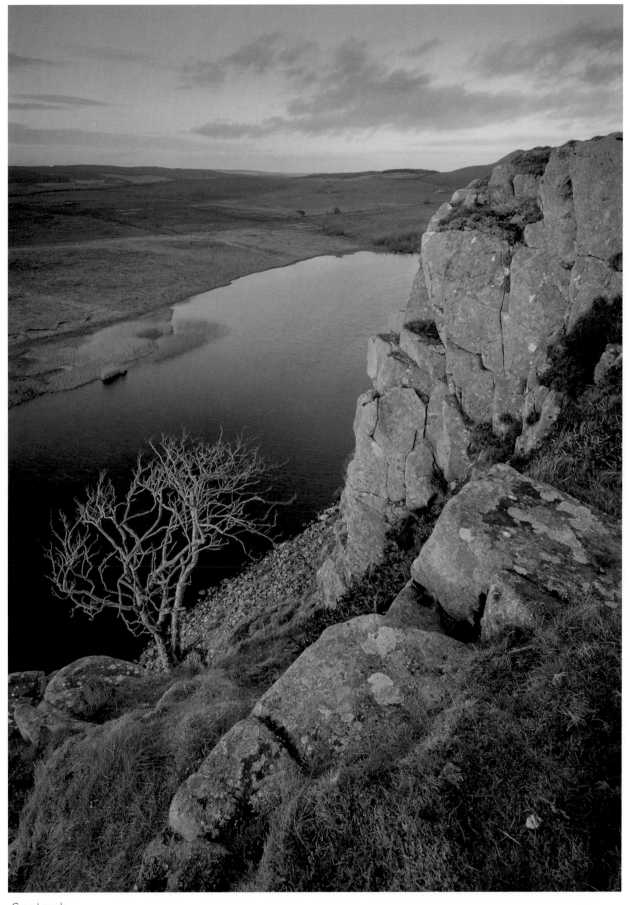

Crag Lough

EVERYWHERE SERENITY
Rievaulx Abbey and Terrace, North Yorkshire

Whenever I walk through the impressive ruins of the refectory in Rievaulx Abbey, in Ryedale on the edge of the North York Moors, I am reminded of Alan Sorrell's superb 1960s reconstruction drawing of it. In his representation of what is generally regarded as the finest monastic refectory building in Britain, he shows how it might have looked like in 1320 at the height of the Cistercian abbey's not inconsiderable power and influence. The fading evening light floods in through the tall lancet windows to light up the lines of tables of the white-robed, tonsured monks, enjoying their frugal vegetarian supper, which probably consisted of nothing more than bread and beans washed down with ale. At the high table at the end of the hall, the prior and senior monks sit on a raised dais, and in the pulpit high on the eastern wall, a monk is giving the day's reading, while his colleagues, observing the strict Cistercian rule, eat their meal in silence.

Although Sorrell's drawing certainly helps, it is hard to imagine today what life must have been like for the community of around 650 monks who gave their lives to Christ in this, the first Cistercian monastery in the north of England, founded in 1132.

The third abbot, Aelred (1147–67), perhaps expressed their philosophy best when he wrote that he found here 'peace, everywhere serenity and a marvellous freedom from the tumult of the world'. Although never formally canonised, Aelred became the centre of a cult in the north of England and was venerated as a saint, with his body kept at Rievaulx. Writing before the destruction of the Dissolution of the Monasteries, the sixteenth-century antiquary John Leland recorded seeing Aelred's shrine at Rievaulx 'glittering with gold and silver'.

Modern visitors can still feel that almost tangible sense of serenity as they walk through the soaring, three-storey high presbytery, the monks' church, rebuilt in the 1220s as a shrine to Aelred. The piers, arcades and lancet windows are adorned with beautiful detailing, indicating the work of a master mason, and the soaring arches at either end provide some of the finest examples of Early English architecture in the north of England.

Of all our rich heritage of monastic ruins, Rievaulx enjoys surely one of the loveliest and most romantic settings. The best way to appreciate how comfortably Rievaulx fits into its landscape is to take a walk above the building and view it from the famous Rievaulx Terrace, constructed by local landowner Thomas Duncombe in the 1750s.

Duncombe was enthused by the new fashion for the Picturesque, and the ruined abbey in the valley below made a perfect focal point for his visitors to admire as they strolled along the grassy, half-mile-long terrace. Mock-classical Palladian temples mark each end of the walk, which is a joy at any time of the year, but perhaps especially so in the autumn, when the beech trees are ablaze, framing the view down to the skeletal abbey with their copper filigree.

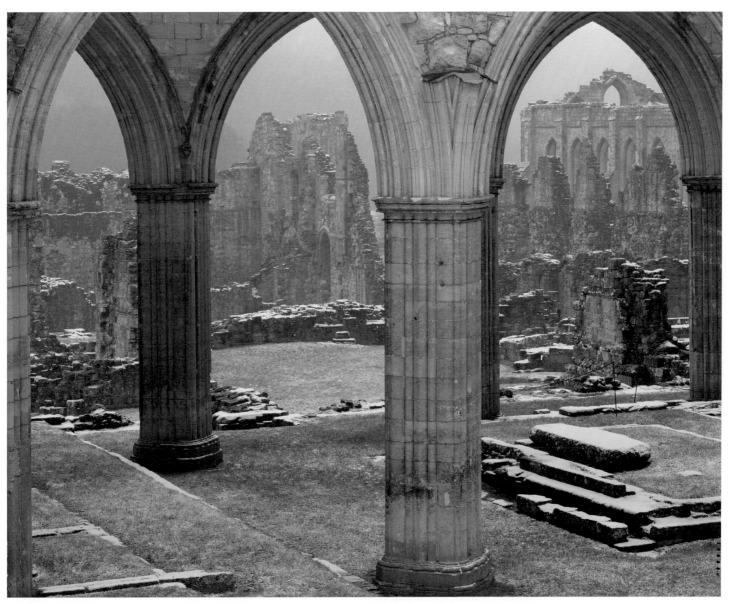

Rievaulx, winter

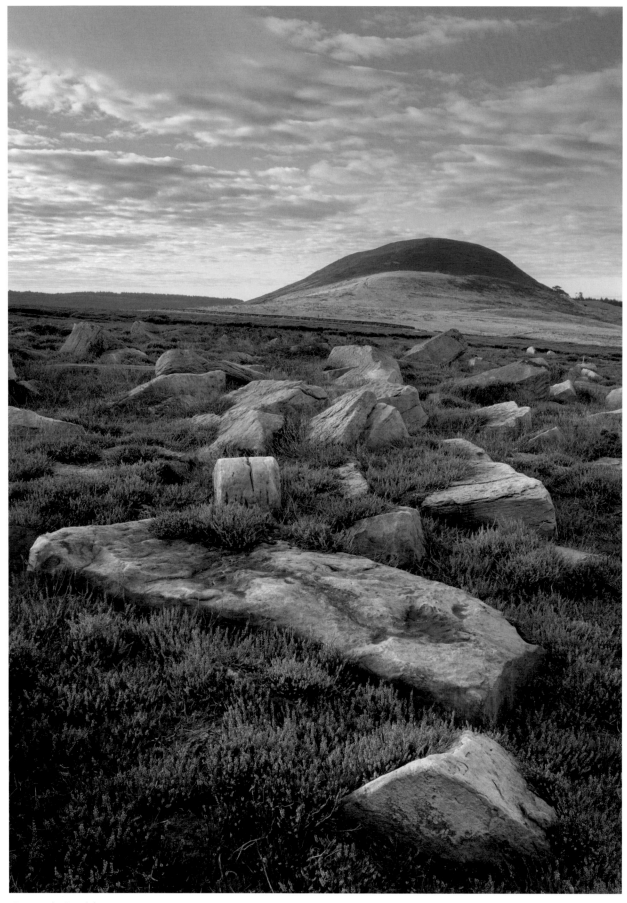

Easterside, Ryedale

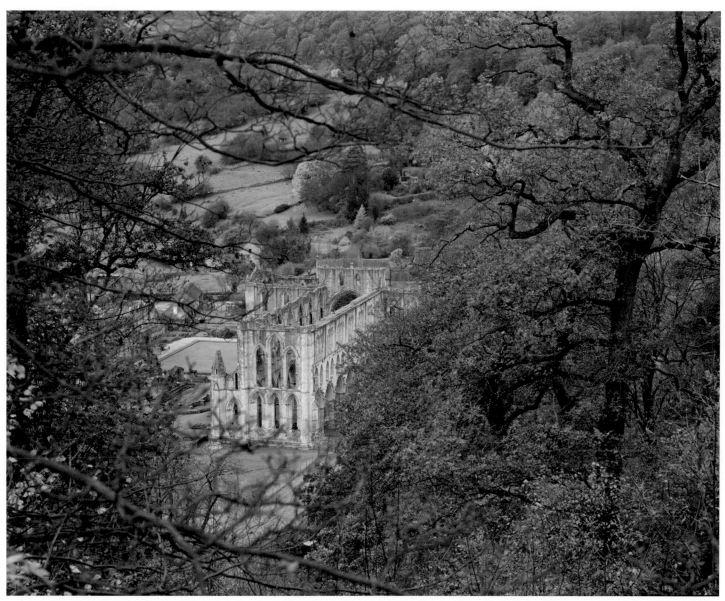

Rievaulx from The Terrace

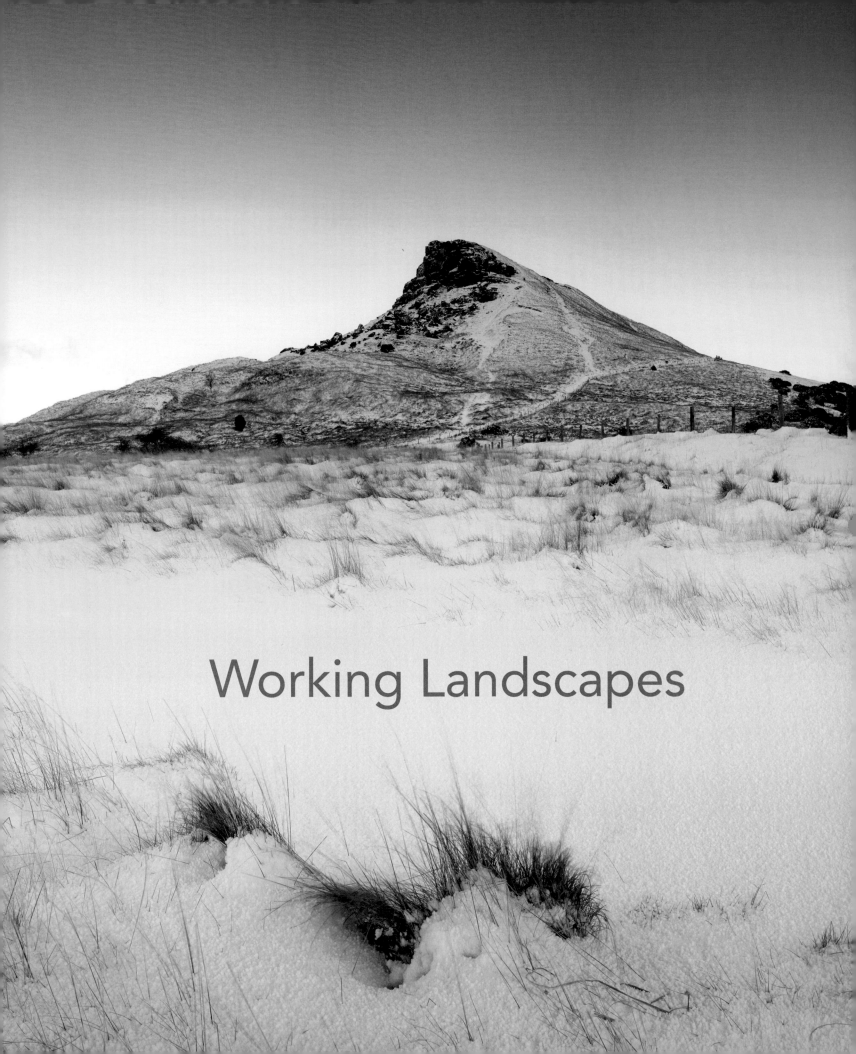

Working Landscapes

Working Landscapes

Apart from the steepest of cliff and crag faces,

every part of Britain has been changed and influenced

to some extent by humankind. For many, it's the fact that the

British landscape has always been a working landscape that makes it

so endlessly fascinating. Farming has, of course, changed our landscape

forever into the patchwork quilt pattern we know and love today.

Many other places we now regard as wild and

untamed – such as the Cornish coast, the Welsh hills and the

Yorkshire and Derbyshire Dales – were once hives of industry, and

rang with the sounds of men and machinery. More recent

changes have seen the effects of war and our

apparently insatiable need for power.

ON THE SLATE
Dinorwig Slate Quarries, Gwynedd

In the late nineteenth century, the vast, black terraces of the Dinorwig slate quarry, which has taken a gigantic bite out of Elidir Fawr (3,031ft/924m), east of Llanberis, was one of the biggest holes in the world. And the fine-grained, purple-grey slate extracted from it in huge quantities was exported across the globe, from Argentina to Australia.

Dinorwig still broods over Llanberis across the valley from Snowdon, its exposed, layered galleries and great, shifting screes of slate waste glistening like polished armour in the not-infrequent Welsh rain. But the quarry and the mountain now hide a fascinating secret inside their cold, dark heart.

Dinorwig is now somewhat bizarrely known as the Electric Mountain because it is the site of the largest pumped storage electricity scheme in Europe. Up to 7.6 million cubic metres (1.6 billion gallons) of water is stored in the upper reservoir of Marchlyn Mawr and then funnelled into a 1,863-foot (568m) drop (eleven times the height of Nelson's Column) to power six turbines and generators half a mile inside the mountain, which feed 400kV electricity into the National Grid.

The water then passes into the lower reservoir, Llyn Peris, and, reversing the system and using the generators as pumps, the water is returned to Marchlyn Mawr overnight using off-peak power – a highly efficient and eminently sustainable system.

You can take a bus tour into the underground power station to view the enormous chambers – some of which are so vast that they could hold St Paul's Cathedral – inside the mountain. The power station has one of the fastest response times of any in the world – generating 1,320MW of electricity in an astonishing twelve seconds – and is used as an emergency backup for the Grid.

Dinorwig quarry, which once employed over 3,000 men, was worked for 200 years until it closed in 1969. The new underground power station took ten years to build and required the excavation of 12 million tons of material before opening in 1984.

The fortress-like site of the workshops of the former quarry at Gilfach Ddu is now the home of the National Slate Museum, where you can watch the age-old skill of slate-splitting the 500-million-year-old Cambrian rocks. It's a skill that still can only be done by hand and a practised eye. I watched Evan Thomas split the machine-cut, squared-off blocks into sixteen slates of regular ⅛-inch (3mm) thickness with a wide-bladed chisel and an African oak mallet – and a dexterity born of thirty years' experience. The slates, I learned, were graded in size according to the ranks of the British female aristocracy. Thus the largest were Princesses, grading down to Duchesses, Countesses, Narrow Countesses, then Wide, Broad or Narrow Ladies. Evan told me that an eighteenth-century quarry owner, General Warburton, had illusions of grandeur, and liked to suck up to the landed gentry. 'Not that he paid his workers very much,' he added. 'Tuppence [1p] a slate was all they got.'

The galleries in the quarry also all had their own names, again sometimes linked to royalty, such as Princess Alice and May, but more often linked to historical events or geographical places, such as Crimea and Sebastopol. Dinorwig quarrymen could boast that they had visited Abyssinia and California on the same day! Their beautiful, hand-crafted slates certainly travelled that far, as they were exported to roof the world.

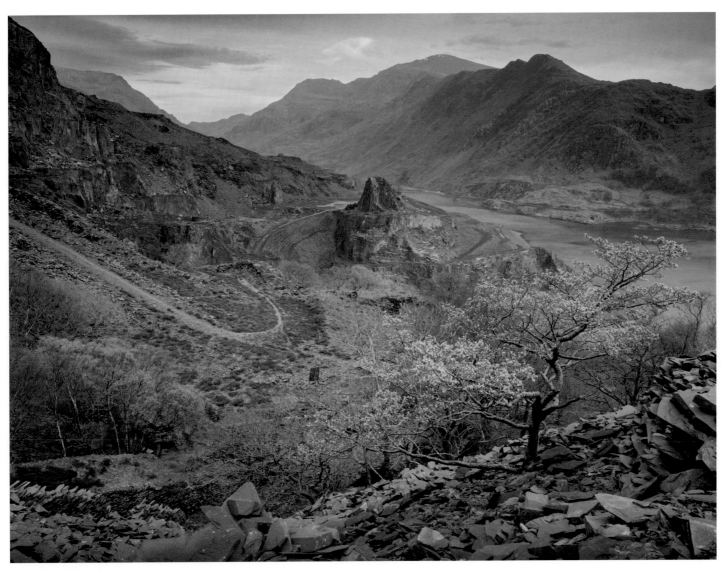

Snowdon from Dinorwig

THE LEAD RUSH HILLS
Swaledale, North Yorkshire

Swaledale is my favourite Yorkshire dale, simply because this wildest and northernmost of the Dales was my introduction to the hills of northern England half a century ago. It will always, therefore, hold a special place in my memory.

We were on a school youth-hostelling holiday from the flatlands of East Anglia, most of us heading north for the first time in our young lives. As our coach swung off the Great North Road – as the A1 used to be more romantically known – we entered the perfect, castle-crowned and cobbled market town of Richmond: the gateway to Swaledale. The coach carried us on up the winding valley road, past exciting, northern-sounding villages like Applegarth, Marske and Marrick. My nose was pressed eagerly against the steamy window as the horizon of misty hills seemed to crowd in on either side.

Eventually we entered the pretty, stone-built village of Grinton and turned up what seemed to be an impossibly steep and narrow by-road, which eventually led to the impressive mock-Gothic pile of Grinton Lodge Youth Hostel, a former Victorian shooting lodge overlooking the dale.

I can still vividly remember the barely contained sense of excitement we felt as the coach pulled up. We'd never seen anything like this before, and the thought that we would actually be staying in this fairy-tale castle in the heart of these imposing hills was exhilarating. I remember we all tumbled out of the coach and released our pent-up energy from the long trip by rolling stones down into the gill below, before being restrained by our hapless geography teacher.

Of course, I've been back many times since, and although the hills may have lost some of that virginal awesomeness, I still feel that same *frisson* of excitement whenever I leave Richmond and head west up the dale, through the fields and barns which make Swaledale and its northern neighbour, Arkengarthdale, the most archetypical and beautiful of the Yorkshire Dales.

That harmonious blending of the work of Man and Nature – the lush, alder-lined flood meadows rich in wild-flowers; the greystone villages clustered around an ancient arched bridge; the formulaic one barn for every two dry-stone-walled field, as the slopes rear up to the crags and moorland heights above – is nowhere seen to better effect than in Swaledale.

But like so many of our northern dales, Swaledale was not always as peaceful as it is today. Just over a century ago, the dale was the Yukon of Yorkshire. At the height of the 'lead rush' of the 1880s, more than 4,000 miners were employed in the frantic search for the glistening, blue-grey 'gold' of galena in literally scores of mines under these now quiet hills.

The best place to see the remains of the lunar lead mining landscape of Swaledale is in the upper reaches of Gunnerside Gill, where an industrialised landscape on a colossal scale still exists, often coming as a shock for people who have only seen the dale from the valley below. Because of the high levels of lead contamination in the soil, no vegetation grows in the huge gullies known as 'hushes', created by damming a beck then releasing the water to excavate large areas exposing the precious ore.

The impressive old mine buildings in Gunnerside Gill remain as silent witness to the days when Swaledale echoed with the sights, sounds and smells of heavy industry. But despite that industrial past, it will always hold a special place in my heart.

Calver Hill and Healaugh

Angram, Upper Swaledale

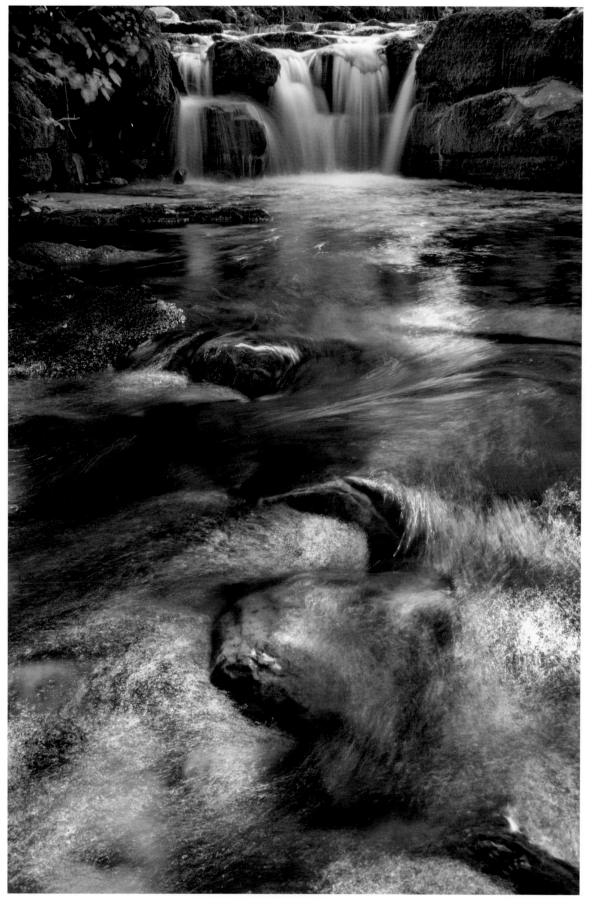

Oxnop Beck

OTHERWORLDLY ORFORD
Orford Ness, Suffolk

Local author Stuart Bacon describes the bracing sea air at Orford Ness as 'always . . . clear, keen and exhilarating'. But he wisely qualifies his statement, 'although at times in the winter it might be better described as "raw" rather than "keen".'

I know I've never been quite so chilled to the bone as when exploring the coast of my homeland of East Anglia, especially during winter when the bitter easterlies seem to come straight from the Urals. My mother used to call it 'a lazy wind' – it doesn't bother to go round; it passes straight through you.

Orford Ness, on the Suffolk coast between Benjamin Britten's Aldeburgh and the container portropolis of Felixstowe, is an extraordinarily wild and atmospheric place, unlike anywhere else in Britain. It has been described by outdoor writer Robert Macfarlane as a desert, where 'the only moving things are hares, hawks and the sea wind'. It is technically a flint-shingle cuspate (pointed) spit, known locally as 'The Island'. This may be geographically incorrect, but somehow it manages to convey the otherworldliness and separateness of the Ness.

But surely the one thing to be said about any shingle spit, like Orford, Spurn Point or Dungeness (see page 224) is that it is never, ever, actually still. This is a dynamic, constantly shape-shifting landscape, its form dictated day to day by the irresistible forces of wind, tide and longshore drift. Stand on its squeaking, rattling and hissing shingle as the tide comes in, and it can almost feel as if you are standing on quicksand.

The Ness is up to a mile wide and extends for 10 miles (16km) from Slaughden in the north to North Weir Point in the south. It effectively sealed off the entrance to the once-thriving medieval port of Orford, a harbour which it once protected from the worst of the North Sea gales. The red-and-white barber's pole lighthouse on the Ness, built in 1792, still flashes a warning to shipping.

Because the Ness was in the hands of the Ministry of Defence and later the Atomic Weapons Research Establishment for eighty years, a strange mixture of Cold War detritus litters its shingle surface, encouraged by the National Trust's enlightened policy of what it calls 'controlled ruination'. Enigmatic and still slightly sinister structures, such as the two famous pagodas (10-foot-thick concrete blast chambers designed to test nuclear weapons); listening stations like the spider's-web, 135-acre (55ha) Cobra Mist radar system (set up to monitor Eastern Bloc radio communications); Brutalist concrete barracks, watchtowers and bunkers all add an air of uncomfortable insecurity to the landscape. It's as if the ghosts of the military past – a past which goes back to a First World War airfield and a Second World War bombing range – still hang tangibly in the air. And to complete the chilling feeling of threatening nuclear technology, just up the coast to the north stand the Brutalist blocks of the A and B Sizewell Nuclear Power Stations, soon to be joined by Sizewell C.

Orford Ness is worlds away from the brash, kiss-me-quick resorts of the rest of the East Coast, such Clacton, Walton-on-the-Naze and Great Yarmouth. Long may it remain so.

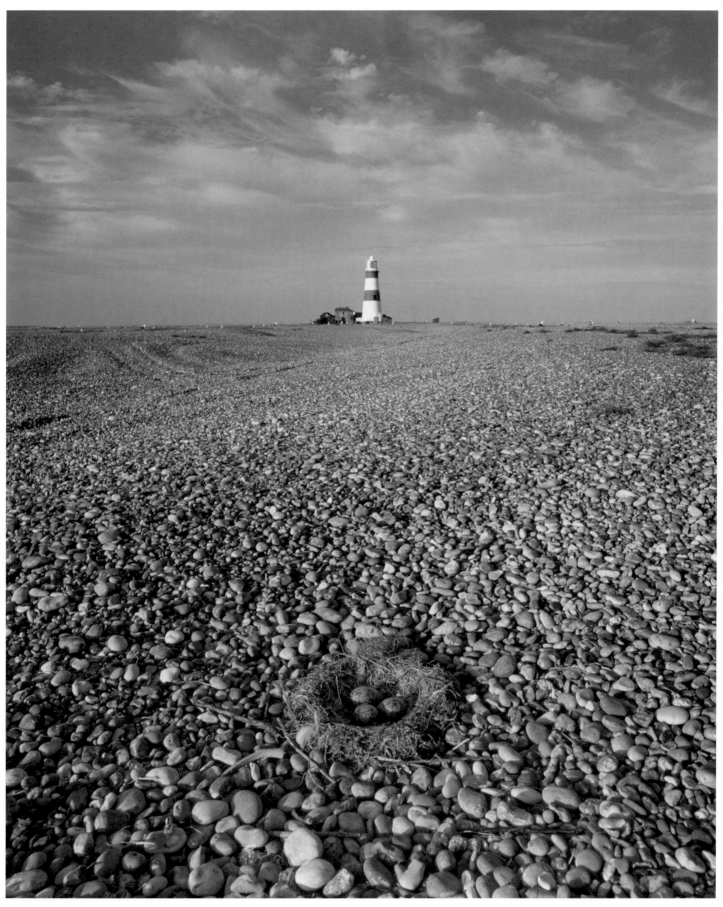

Orford Ness lighthouse

River Alde estuary, Orford

The Pagodas, Orford Ness

A LANDSCAPE 'TURNED INSIDE OUT'
Rosedale, North York Moors

The monumental aisle of stone arches of the abandoned calcinating kilns of the former Rosedale East ironstone mines, on the southern slopes of the North York Moors, stand like some long-forgotten Aztec ruin. But the only human sacrifices made here were in the name of profit for the ironmasters. A letter written in 1869 from a resident to relatives who had recently emigrated to America gives some idea of the human cost:

> It's like a little city now, but it is a regular slaughter place. Both men and horses are getting killed and lamed every day. When I am writing this letter they are carrying a man home past our house either killed or badly hurt.

It's hard to imagine today the dramatic effect the iron mines must have had on this once-quiet valley of the River Seven. The letter goes on to explain:

> If you had to see Rosedale now you would hardly know it. It is very nearly turned inside out since you were here. There are railroads both sides of the dale now and two great big ironstone kilns to burn ironstone. The ground is hollow for many a mile underground and houses built in all directions.

The excavation of iron ore from the Jurassic Middle Lias rocks had come to Rosedale just four years earlier in 1865. A 4¾-mile (7.6km) branch railway line was constructed from Blakey Junction, and contoured round the head of the dale to High Baring and the Rosedale East mines, which were run by the Rosedale and Ferryhill Mining Company.

However, the ironstone boom days of Rosedale were to be short-lived. In 1851, the population of the farming community of Rosedale had been 558. By the peak of the mining activity in 1871, it had rocketed to 2,839. But it swiftly declined to 702 in 1881, after the mines had been shut for two years following the collapse of the mining company. Increasing costs and the General Strike of 1926 finally killed them off. By 1931, the population had fallen to 962 and to just under 300 by the 1960s. The great Rosedale Iron Rush was over.

Today, Rosedale has reverted to its pre-industrial peacefulness and tranquillity. You can walk along the former railway line embankments and enjoy the solitude that first attracted monks to places like Rievaulx (see page 204), Guisborough, Mount Grace, Newburgh and Byland. In Rosedale Abbey village – once the Deadwood of the North Yorkshire Iron Rush – the sparse remains of a twelfth-century nunnery are built into the walls of the parish church.

Flanked by the high moorland ridges of Blakey and Rosedale Moor, the valley rises to the 1,409ft/429m viewpoint of Rosedale Head, and the iconic medieval waymark of the nine-foot-high Ralph Cross. This is a prominent landmark on the Castleton to Hutton-le-Hole road, and was chosen as the symbol for the North York Moors National Park which was designated in 1952. The correct name of the cross – one of thirty on the North York Moors – is actually Young Ralph. The smaller and more ancient Old Ralph lies modestly hidden amongst the heather on higher ground 200 yards (180m) away.

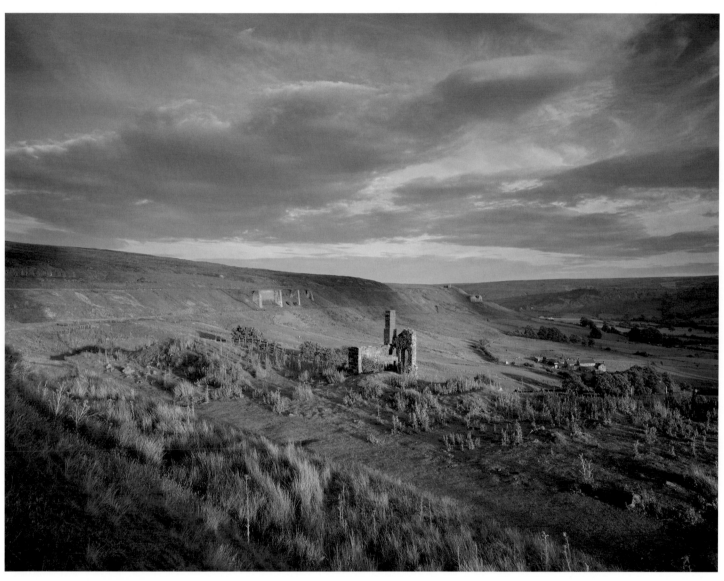

Rosedale, post-industrial landscape

NO STONE UNTURNED
Dungeness, Kent

If you haven't been there before, nothing quite prepares you for the weird, otherworldly landscape of Dungeness. There's nowhere in Britain quite like the bleak, shingle spit which points towards France across the Straits of Dover on the Kentish coast. The 6 square miles (16km²) of ridge upon ridge of mainly flint pebbles built up over 5,000 years constitutes one of the largest expanses of shingle in the world.

The brutalist, slightly sinister, building-brick shapes of the Dungeness Nuclear Power Stations looming in the background add yet another, surrealistic element to this strange, apparently barren landscape, making it a popular subject for films, music videos – and prog-rock album covers.

Because of its dryness – it has only 24 inches (60cm) of rain a year – Dungeness is officially classified by the Meteorological Office as Britain's only desert. But despite that, there's a surprising variety of wildlife, with over 600 different species of plant, a third of all those found in Britain. It is also one of the best places in Britain to find invertebrates such as moths, bees, spiders and beetles, including the industrious dung beetle, many of which are found nowhere else in the country.

The flooded gravel pits on Denge Beach, which are both brackish and freshwater, also provide an important refuge for migratory and coastal birds. There is an RSPB bird sanctuary, and every year thousands of twitchers descend on the peninsula to record that elusive 'mega tick', such as the elegant Slavonian grebe and the secretive bittern.

The first element of the name of Dungeness is probably connected with the neighbouring Denge Marsh, while the suffix derives from the Old Norse *nes*, meaning a headland. Probably the most famous resident of Dungeness, apart from the fishermen and former lighthouse keepers in the now-disused black-and-white lighthouse, was the painter, designer and film director Derek Jarman. Jarman bought Prospect Cottage, a yellow-windowed, black-tarred former fisherman's home, for £750 in 1986, and lived there until his death in 1994.

'Dungeness is at its best in the golden light of summer,' wrote Jarman. 'The black house turns gold and casts a shadow that nearly touches the sea. The pale shingle reflects the light long after the sun has set behind the power station, turning the pink to bone. Twilight here is like no other. It lingers in a perfect calm. You feel as you stand here that tired time is having a snooze.'

Jarman's famous garden, a crazy mixture of flotsam and jetsam, the rusting remains of wartime anti-tank defences and carefully arranged flint circles enlivened with salt-resistant native plants, is a joy; perfectly in keeping with the eccentric landscape in which it lies.

> Here at the sea's edge
> I have planted my dragon-toothed garden
> To defend the porch,
> Steadfast warriors
> Against those who protect their impropriety
> Even to the end of the world.
>
> *Derek Jarman's Garden* (1995)

The success of Dungeness as a community has depended on the successful management and support of this extremely rare and fragile environment, in which Nature and Man have worked together in harmonious partnership.

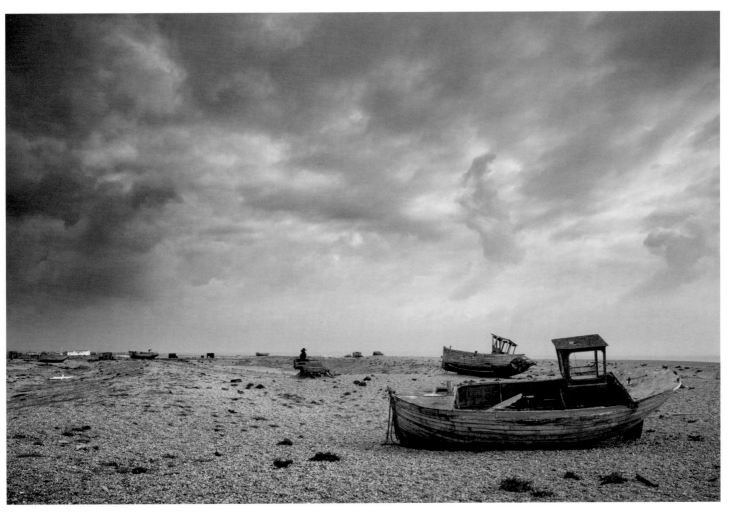

Dungeness, threatening weather

Dripping paint, Dungeness

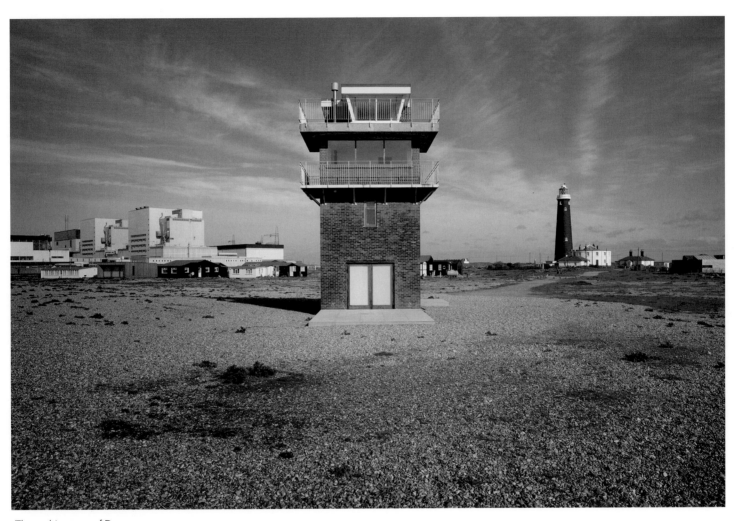

The architecture of Dungeness

THE WIDOW'S CURSE
Magpie Mine, White Peak

It seemed eerily appropriate. As Joe, his wife Jenny and I headed up out of Bakewell towards Magpie Mine, the best-preserved lead mine in the Peak, an eponymous black-and-white crow drifted across in front of us. As I recalled the old nursery rhyme, which forecasts sorrow at the sight of a single bird, Jenny reassured me: 'Don't worry, we are visiting another Magpie, aren't we?'

Even on a bright sunny early summer's day like that of our visit, an air of mournfulness seems to hang in the air over the grey chimneys and limestone engine houses of Magpie Mine, 1,000 feet (300m) up on the White Peak plateau near Sheldon. Perhaps the ancient stones – which seem to exude the ecclesiastical atmosphere of a ruined abbey – have somehow been permeated with the events of over a century ago, when the infamous 'murders on the mine' led to the underground asphyxiation of three miners.

The three Great Redsoil miners died of inhaling the sulphurous fumes 420 feet (128m) below the surface, after they had been 'smoked out' by their rival Magpie miners. The setting of fires made from tar and straw was a common tactic used at the time to drive out competitors for the precious ore. But in 1833 it went tragically wrong, and observers on the surface noted that smoke had poured out of the shafts 'like Manchester factory chimneys'. Twenty-four miners from Magpie were tried for the 'murders on the mine', but all were subsequently acquitted, claiming that the setting of the fires had been done in self-defence. The widows of the three dead miners were said to have put a curse on the mine, which apparently never made a profit again.

Magpie's chequered history goes back over 250 years. Started in around 1740, the mine was last worked by a New Zealand-based company in 1951, and the black-painted corrugated-iron remains of their sheds and winding gear near the 600-foot-deep (180m) Main Shaft remain some of the youngest listed buildings in the Peak District National Park.

The two flue chimneys dominate the mine, one round and the other square. The round chimney and circular powder house were built by a group of Cornish tin miners in 1840, after they had been introduced to employ large-scale, Cornish-style mining. The story goes that the local Derbyshire miners never got on with the Cornishmen, so they insisted on building the other chimney near the former Winding House in their traditional, four-square Derbyshire fashion.

But there's an unexpected floral bonus left by the centuries of industrial activity involving the highly toxic minerals found around Magpie Mine. Flourishing on the lumps and bumps of the spoil heaps are carpets of lead-tolerant (metallophyte) buttercups, yellow and purple mountain pansies, and cushions of the diminutive white-starred spring sandwort, locally and most appropriately known as leadwort.

As we wandered through the flower-filled meadows, we raised a curved-billed curlew, whose bubbling trill and haunting, onomatopoeic 'cur-lee' call somehow seemed to echo the mournful, murderous past of Magpie Mine. Or maybe it was the widow's curse, transposed into that trembling, spine-tingling song.

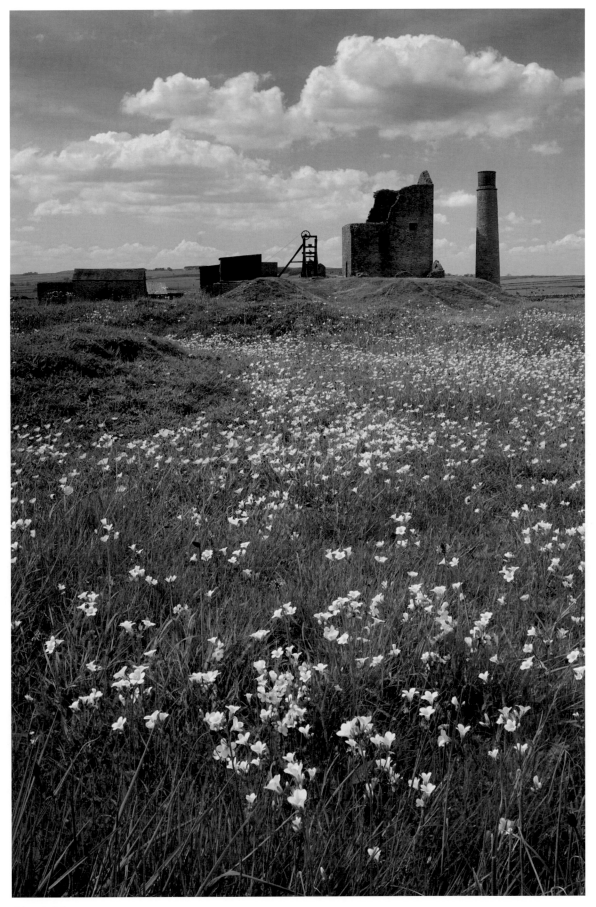

Magpie Mine

ODIN'S HILL
Roseberry Topping, North Yorkshire

'The landscape around Roseberry Topping is my local patch, my backyard, my natural habitat,' says Joe of the iconic western outlier of the North York Moors, sometimes dubbed 'the Matterhorn of Cleveland'.

That distinctive, Rock of Gibraltar profile is a constant landmark in the countryside around Joe's home, and he has photographed it in all its moods. These range from the bitter depths of winter, when a dusting of snow adds immeasurably to its modest, 1,050ft/320m height; through the bright days of spring, when a smoky haze of bluebells washes its slopes; to the bosky days of summer, when the Saltwick sandstone of its sheer south-west face glows golden in the sun, and the final flourish of autumn, when bracken covers its slopes in sheets of beaten bronze.

'The profound seasonal changes of Britain's climate are perfectly reflected here,' explains Joe who, when he's not on assignment in some far-flung corner of the globe, is constantly drawn back to this self-deprecating little hill. It manages to exert an influence on the surrounding landscape which far exceeds its modest elevation.

Early travellers were convinced that its mini-Fuji shape meant that it must be an extinct volcano. But the modern monk's cowl profile is actually due to a disastrous rock fall in 1912, locally thought to have been caused by the extensive ironstone mines which undermine its south eastern flanks.

Roseberry has been the scene of human interest and activity for millennia. The earliest dateable evidence is a hoard of bronze implements, including a two-piece mould for an axe head, some actual axes, gouges and an unusual curved knife,

discovered by a farm labourer on the southern slopes of the hill in 1826. The finds were dated to the end of the Bronze Age, around 600 BC. There are also signs of an Iron Age enclosure, also on the southern slopes, which was probably occupied by the first farmers, in an area protected from northerly winds by the hill.

Roseberry's ironstone seams were extensively worked in the nineteenth century to feed the blast furnaces of neighbouring Middlesbrough. There were also some sandstone quarries near the summit, and small amounts of jet were also extracted from the band of shale, which encircles the summit.

Debate has raged for years concerning the hill's unusual name. Although it still conjures up a vision of some kind of 1960s whipped-cream dessert, its history goes back much further than that. Topping is a common Old Norse name for a hilltop in this part of the world (such as Blakey Topping), and the suffix Roseberry is now thought to have been derived from the Old Norse Othenesberg, meaning Odin's Hill. Thus the Cleveland Matterhorn was named after the father of Norse gods. Odin (or the Saxon Woden) is associated with war, battle, victory and death, but conversely also wisdom, magic, poetry and the hunt, a fact that may have escaped the notice of the Cleveland Foxhounds, which still exercise around the hill.

If you climb to Roseberry's summit on a clear evening and look north towards the twinkling street lights and belching chimneys, flare stacks, cooling towers and furnaces of Teesside, you may think that Odin's fury is still raging in the industrial landscape below.

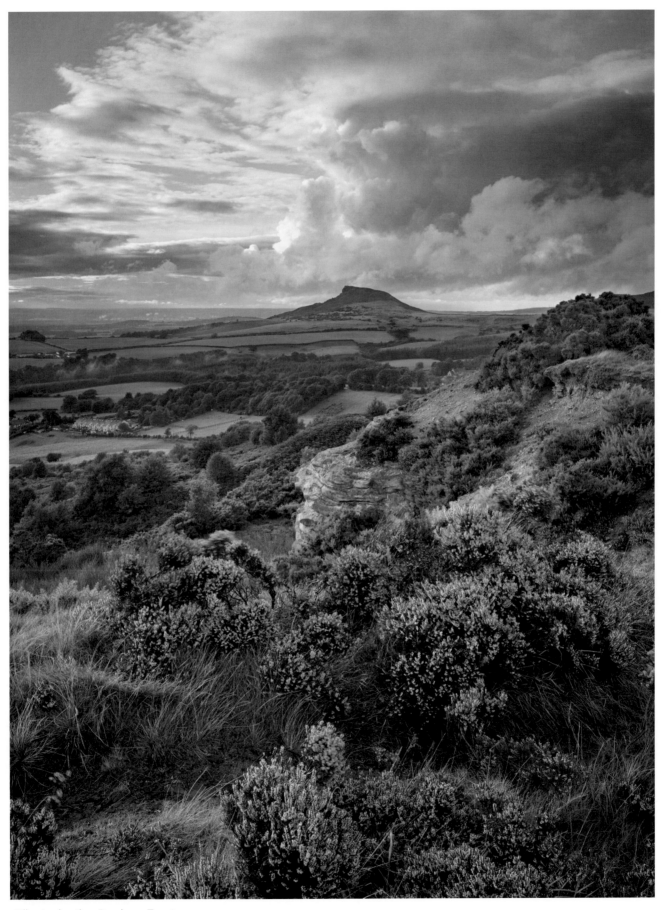

Billowing heather, Roseberry Topping

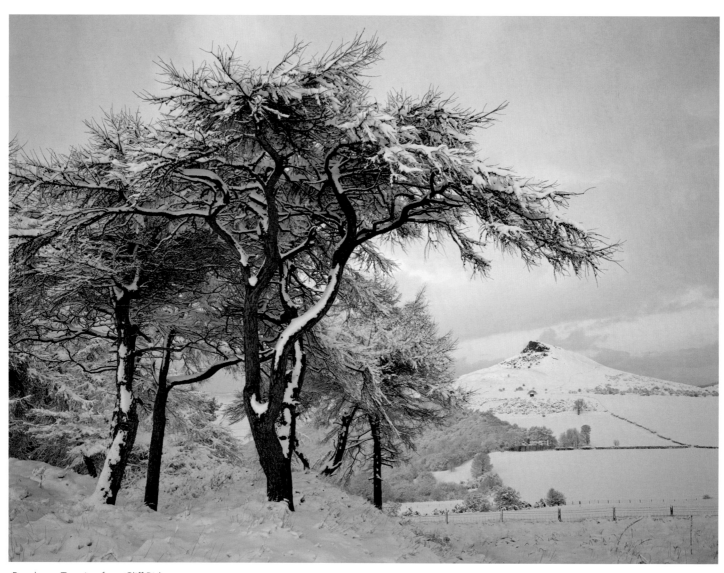

Roseberry Topping from Cliff Ridge

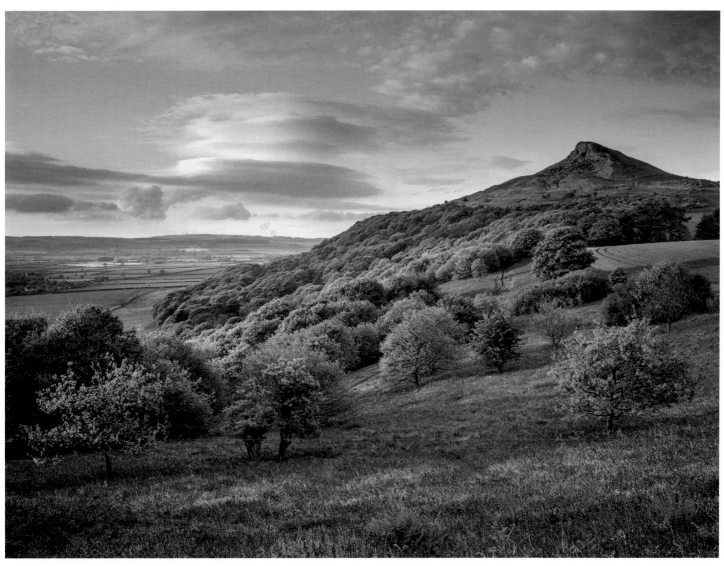

Roseberry Topping, May

COUSIN JACK COUNTRY
Penwith, Cape Cornwall and Porthcurno, Cornwall

Phoenician traders from the far-off eastern Mediterranean are known to have visited the rocky coasts of Cornwall for tin ore (cassiterite) – an essential ingredient in making bronze – during the Bronze Age, some 4,000 years ago. It was such an important commodity to them that they named Britain the Cassiterides, or 'tin islands', and exchanged luxury goods such as pottery, wine and olives for the precious ore.

The Greek historian Diodorus Siculus described the Cornish tin miners around the time of the birth of Christ in his *Bibliotheca Historica*:

> They that inhabit the British promontory of Balerion (modern Cornwall) by reason of their converse with strangers are more civilised and courteous to strangers than the rest are. These are the people that prepare the tin, which with a great deal of care and labour, they dig out of the ground, and that being done the metal is mixed with some veins of earth out of which they melt the metal and refine it. Then they cast it into regular blocks and carry it to a certain island near at hand called Ictis for at low tide, all being dry between there and the island, tin in large quantities is brought over in carts.

Several locations have been suggested for 'Ictis' (literally meaning 'tin port'), but the romantic island of St Michael's Mount, near Marazion, seems to most closely match Siculus's description.

For centuries, Cornwall and the far west of Devon provided most of the UK's tin, copper and arsenic. Originally found as alluvial deposits in stream beds, the tin lodes also outcropped on the coastal cliffs, and the first underground mines were sunk as early as the sixteenth century. The miners were traditionally and collectively known as 'Cousin Jack'.

The tin mining landscape of Cornwall and West Devon, a fascinating area characterised by smelting chimneys, quarries and much disturbed ground, led to its designation in 2006 as a World Heritage Site. Any walker along the South West Coast Path National Trail, especially around St Just in Penwith, can't miss the tell-tale chimneys teetering on the edge of the rugged coast, with the mighty waves of the Atlantic crashing into the granite cliffs beneath. They stand like mute exclamation marks, punctuating the walkers' progress as they round the Penwith peninsula in the south-western extremity of England on Britain's longest long-distance footpath.

Cape Cornwall, west of St Just, was thought to be the most westerly point in England until the Ordnance Survey proved 200 years ago that it was Land's End, 4 miles (6.4km) to the south. Cape Cornwall had its own tin mine which operated between 1838 and 1883, and the mine's chimney near the summit of the cape was retained as a navigational aid. The chimney is now known as the Heinz Monument, after the site was donated to the nation by the famous baked bean company in 1987.

The beautiful bay and dazzling white sand beach at Porthcurno, enclosed by the headlands of Logan Rock and Gwennap Head, has been listed among the ten most beautiful bays in the world. There is evidence of early commercial activity here in the remains of man-made stone tracks. Maybe they provided access to and from the bay for those Phoenician traders.

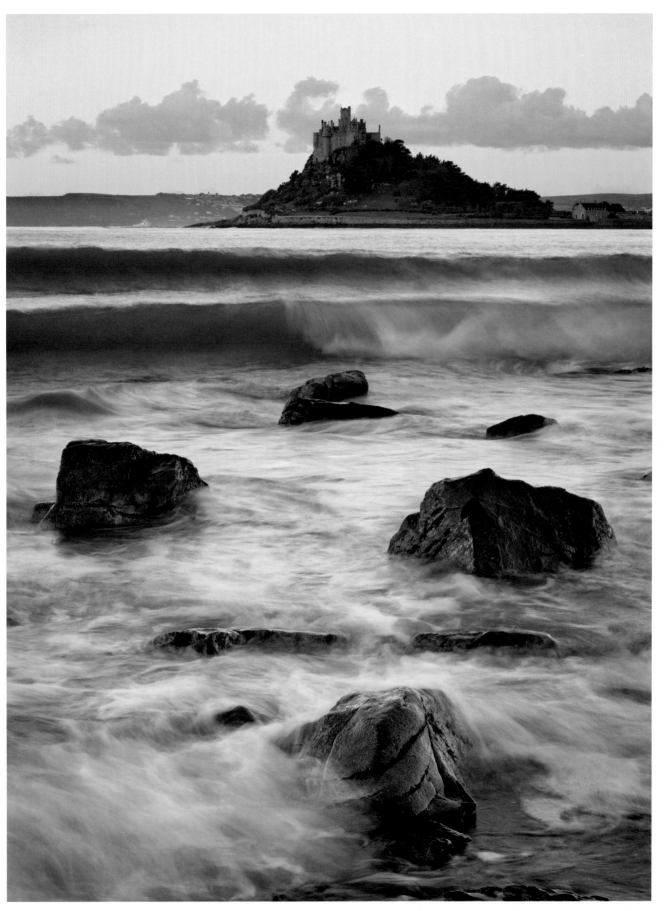

St Michael's Mount from Marazion

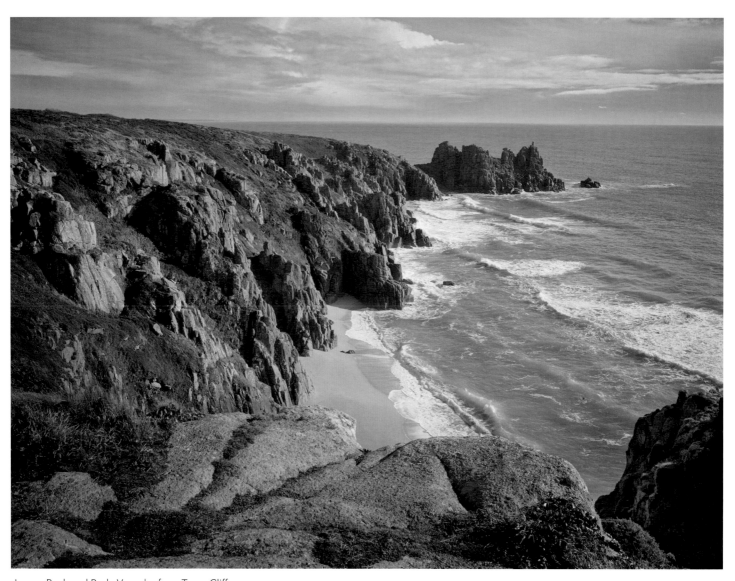

Logan Rock and Pedn Vounder from Treen Cliff

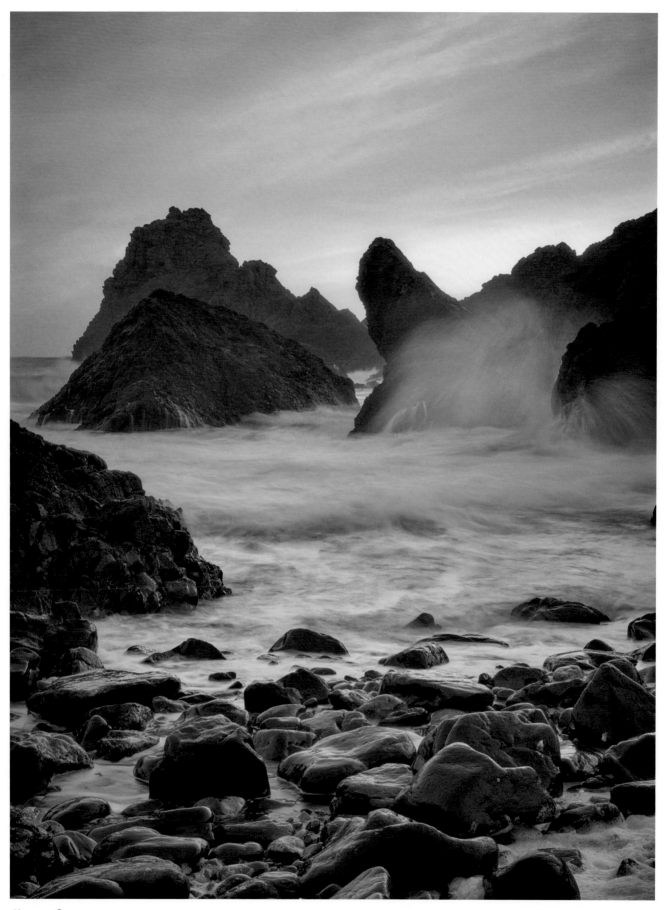

Kynance Cove

Sennan Harbour

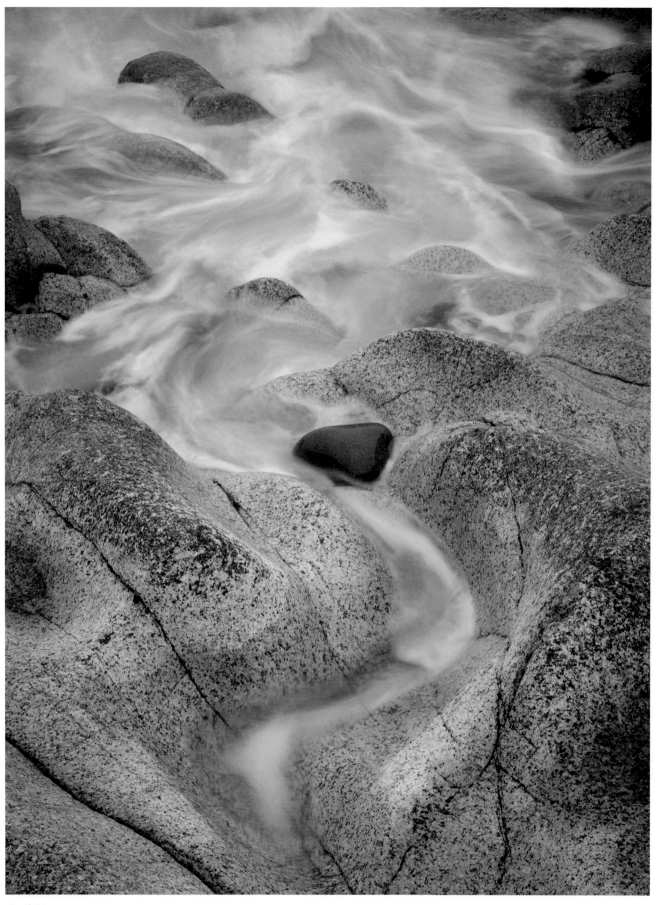

Porth Nanven

HELD IN TRUST
The National Trust

Although it's still perhaps best known for its ownership and preservation of our rich heritage of stately homes, the National Trust is also one of Britain's largest landowners.

It owns over 1,000 square miles (2,590 km²) of some of the most spectacular and beautiful landscapes in Britain, and almost 600 miles (965km) of outstanding coastline – all of which is freely accessible by the public. Most importantly, through an Act of Parliament this land is held inalienably – which means that it cannot be voluntarily sold, mortgaged or compulsorily purchased against the Trust's wishes.

The National Trust was founded in 1895, the vision of three conservation pioneers – social reformer Octavia Hill; Sir Robert Hunter, solicitor of the Commons Preservation Society, and Canon Hardwicke Rawnsley, a Lake District clergyman. The newly formed Trust was vested with the power to 'promote the permanent preservation for the benefit of the Nation of lands and tenements (including buildings) of beauty or historic interest'.

The idea of the new organisation had first occurred to Hunter and Hill a decade before when they were closely in touch with other leading social reformers. With Rawnsley they shared an intense love of Nature and a belief in its healing power, which, in the case of Hill and Rawnsley, had been fostered by their relationship with the Victorian conservationist and Lake District resident John Ruskin.

Now with over four million members – more than all political parties put together – the National Trust is the nation's leading conservation charity, independent of Government and entirely reliant on its membership, visitors and volunteers.

It has been so successful that it has been copied in numerous other countries, from Australia to Canada.

Scotland has its own National Trust, a considerably smaller organisation that cannot exercise the same amount of influence, due to Highland estates still being almost entirely in private hands. But in England, Wales and in Northern Ireland, the National Trust protects many of our greatest landscapes, while crucially welcoming and encouraging visitors.

For four decades, Joe has enjoyed a happy working relationship with the National Trust, supplying hundreds of images for the Trust's extensive picture library. It has been a key influence on his career since 1989, when he was commissioned to make the photographs for Charlie Pye-Smith's National Trust book, *In Search of Neptune*; and commissioned work has followed every year since.

Joe comments: 'The conservation work of the Trust has inspired me greatly and allowed me to make a small contribution to a collective effort far more significant than I could manage alone. My youthful enthusiasm for efforts to protect the earth's ecosystems has been hugely informed and enhanced over the years by observing the work that the Trust does directly, on the ground.

'As with all noble endeavours, conservation is the art of the possible. The National Trust can only achieve what it does with public affection and support, and nurturing this synergy while educating and informing us about its work is a task that never ends. Although it is only one of a variety of different media involved, photography does play a key role

in telling the story of Britain's landscape. It is a privilege to have participated for so long.

'In spite of its focus on landscape and the wildlife that are its natural inhabitants, the Trust is primarily an organisation that serves people: its own employees, its vast army of volunteers, its members and the wider public from the UK, as well as visitors from all over the world.

'Balancing the needs of people, and encouraging access to places, some of which have fragile ecosystems, is an art which the Trust continues to refine over time. The fact that it does so successfully is due largely to its independence from the contaminating effect of short-term political pressure. From the perspective of us, the British public, this actually looks like a minor miracle.

'And from a personal point of view I want to take this opportunity to express my profound gratitude.'

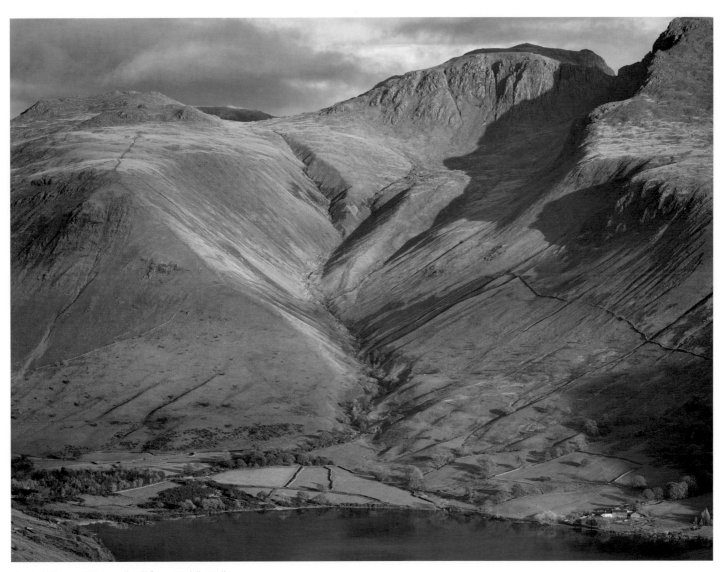

Scafell Pike and Lingmell Gill from Middle Fell

REVOLUTION AND INSPIRATION
Reflections by the photographer

Revolution – a steep learning curve

From the photographic perspective, this book contains mainly contemporary images shot digitally, but also a few from my film archive, shot more than twenty years ago in a different era; in fact, in the last millennium. As the digital revolution unfolded, I aspired to hold true to my core values regarding landscape, whatever the photographic workflow. Yet the technological change has made that near impossible. With those changes my own sense of photography has had to evolve.

The digital learning curve has been steep, rocky and full of obstacles. If I thought the transition would be straightforward, I was mistaken. At times I have despaired of my photography, felt desperate, even that I had lost my way. Yet perhaps in the end to survive a crisis is to emerge stronger, and liberated. Film or digital, photographs remain crystallised encounters, visual notes and recollections, compositions in light.

The equipment is less important than the way they are seen and the intention of the photographer. The art is to develop an understanding of the medium and an accommodation with the process. The photographer needs to know the camera so well that it becomes second nature, and in essence disappears, just as a pianist knows the notes on a keyboard instinctively, by touch.

Film, especially transparency film, has a strong built-in colour character. Once downloaded to computer, digital raw files are, in comparison, still awaiting interpretation. I have learned to think differently, relying much more on memory, on feeling, and on a balanced judgment of tone and colour, rather than relying on the 'signature' of the film to define the look of the photograph. True, there isn't complete freedom with digital, but the flat and often lifeless-looking colour as the file is first opened in the raw converter is simply the starting point.

Post-production can be an exciting, but at times daunting and time-consuming process. Reality and photographs are not the same. If you wish to emulate the appearance of what was there, the 'eye-witness account', the process has never been more accurate; yet for those wishing to engage in flights of fantasy, the tools can certainly facilitate that too. Memory of the landscape and the conditions count a lot, yet they are always balanced by what the picture really needs to make it live.

As the technical notes will show, the images on these pages have been shot with a variety of cameras, each with their own distinctive character. They include the poetic, wooden 5 × 4-inch Ebony film camera; the wide-vision Horseman SW612; the severely mechanical, modernist Linhof Techno; the timeless and flexible Hasselblad 503CW; the well-rounded Nikon D800; the delightful Fuji X-E1; the diminutive yet powerful Sony A7r; and a variety of Sony, Ricoh and Panasonic compact and 'bridge' cameras. The Linhof and Hasselblad have been united with Phase One digital backs that represent the ultimate in digital photographic quality. Whatever the camera used, the aim has been to focus the life force of each image, respect the subject, and create a group

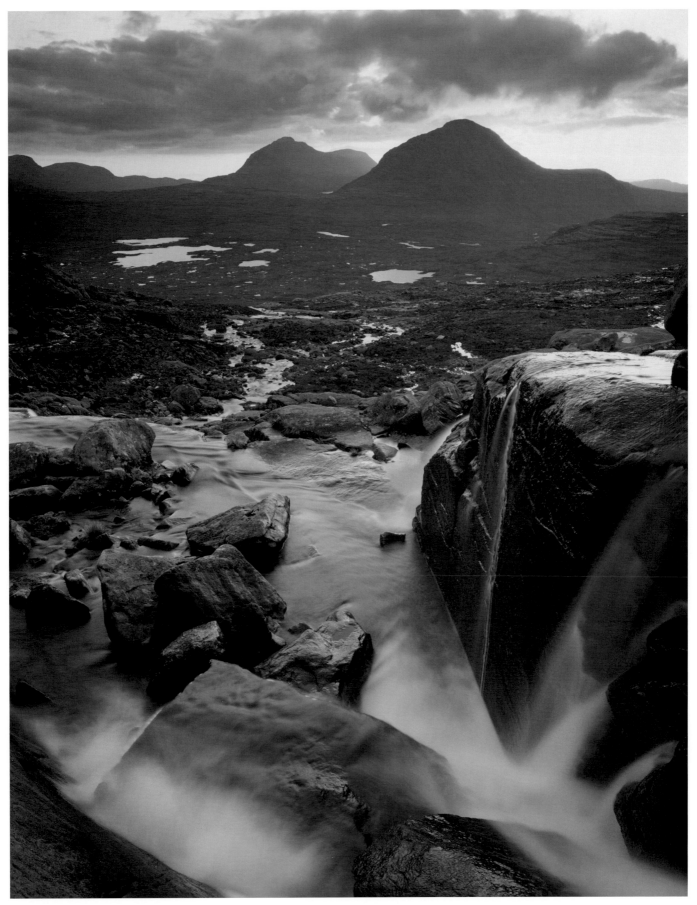

Flowerdale from Allt Choire Mhic Fhearchair, made with the Ebony field camera on 5 x 4-inch film

of photographs that work well together as a whole.

For the chapter openers we decided to use monochrome, and have the pictures bled to the page edges. Primarily this is a design device, but I also love black and white images. My first few years in photography were all black and white, and so are many of my favourite images from photographic history. Being less literal, black and white photography can seem more dreamlike, and the compositional and narrative idea can come through more strongly without the distractions of colour. Yet colour photographs provide a visceral, literal connection to the thing itself, a compelling appearance of reality. Neither is better than the other; they simply represent different expressions and potential within photography.

Inspiration: the light giveth and the light taketh away

I am extremely fond of our brilliant network of footpaths in the UK. Yet inevitably, I seem to spend more time off track than on it. A recent walk on Cadair Idris, my first ever visit, springs to mind. Following several days slaving over a hot computer, it felt good to be on the road to Wales; and then much better again to be on the Minffordd path ascent to Cwm Cau by late afternoon. The route was steep and new to me, yet I was immediately at home on the track, a familiar feeling that my destiny is to walk. Many were descending the path, having had a full day out on the mountain. No one else was walking uphill at this late hour.

I had an idea of what to expect at Cwm Cau, based on the map and on Roly's recommendation, but experience has taught me not to over-anticipate. The day will always decide . . . as it always must. This late afternoon was calm, but high cloud sat over the mountain, and since the sun was now to the west (being late afternoon), the corrie (*cwm* in Welsh) and its beautiful lake were invisible to any light that might appear. Still, I could see potential for the following dawn.

Richard Wilson's famous eighteenth-century painting shows Cwm Cau from a distance, with Craig Cau, the southern peak of the Cadair Idris cirque, poised above it like a Welsh Matterhorn. Although the mountain is sublimely exaggerated, his compositional idea seemed excellent. I resolved to search for that same perspective.

Where the eyes lead, the feet must follow. No path here, but a sheep track convinced me that I could tackle the steep slope. It was an exhilarating walk, and Wilson's viewpoint was vindicated. A lovely waterfall distracted me for a while, but the hour was late, so a short cut to the top from where I might observe the sun setting over the Irish Sea seemed sensible. It was anything but. The slope became so severe that I realised should I fail to make a correct hold or lose my footing, I would fall a very long way. Flustered by my foolishness I retreated and took the longer, and actually more sensible, route.

I made it to the summit of Mynydd Moel, the second highest point on the Cadair Idris horseshoe. Shattered summit rocks might provide the foundations for a composition, and so began the process of attempting to distil some essence from the site. To north, east, and south the distant elements were too flat; only the western view with the northern escarpment of Cadair Idris worked (page 45). As the sun appeared low through a narrowing gap in the cloud, infusing the scene with red and gold, I found the best composition. It took a few minutes to resolve the elements before me: by the time I had the camera exactly positioned the light had almost faded.

It is often thus, for in spite of my intention to seek and express the strong relationship I feel, the landscape itself is indifferent to the photographer, as it must be. The light giveth and the light taketh away. Since evolutionary biology shows us that in most respects we are identical to our hunter-gathering ancestors, perhaps that's part of the appeal of landscape photography; we are subject to the forces of nature, and must take the opportunities as and when they arise.

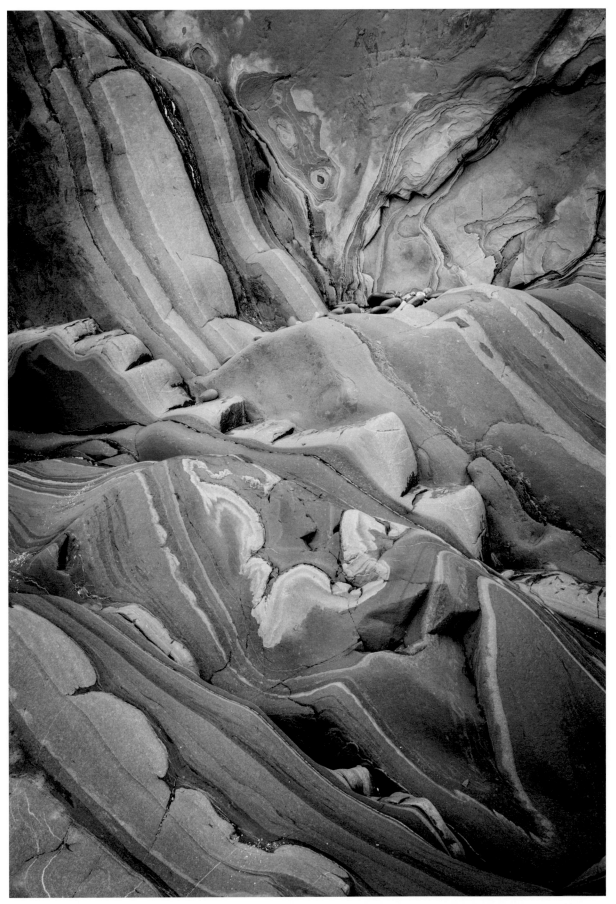

Rock detail, Wrangle Beach, Bude; shot with the Sony A7r, a tilting adapter, and a forty-year-old Nikon perspective control lens

Skill comes with a deeper understanding of those forces, and an ability to use them wisely; for example, the development of tactics that allow us some degree of 'success' in the widest range of conditions, whether it is catching a fish (instead of a woolly mammoth) or making a subtle observation in a woodland (rather than a show-stopping mountain landscape image).

The sun set. The descent proved harder, and longer, than expected. I had failed to notice that Mynydd Moel is 2,805ft/855m (the car park is at 328ft/100m). By the time I reached the final steep descent of the Minffordd path, I was totally dependent on my head torch.

Setting off forty minutes before sunrise the following morning, I ascended the now familiar route, birdsong almost drowning out the trackside waterfalls. I reached Cwm Cau as the first rays struck the mountain. This was the light needed to bring the scene to life, although a convection breeze ruffling the water surface and a complete absence of cloud were far from ideal.

But still, learning to cope with wall-to-wall sunshine is as interesting a challenge as coping with snow, wind and rain (page 46). And at least it is more comfortable. By the time I was heading downhill again, others were on their way up, an amusing reversal of the previous afternoon. It is what happens to those who prioritise light.

It may be stating the obvious, but a fundamental of photography is to bear witness. Other artists can use their imaginations to create work, be they writers, painters or composers. Photographers have no choice but to encounter their subject directly. With landscape, fresh air and exercise come free, yet there is literally a heavy price. A photographer's backpack load exceeds that of every other happy hill walker. But without the image-making impulse, would I walk the miles? The process itself motivates, the endeavour to create is critical.

Photography is very 'literal', especially in colour. Is it possible to make images that do more than simply record the scene? My intention is to make pictures that really express something over and beyond the literal. That aspiration, to find some meaning from what might otherwise be mundane . . . something transcendent, is a form of inspiration in itself.

Perhaps more realistically there is the hope that one of the photographs exposed in a single session can stand alone, having distilled at least some quality of light or form. I still have great faith in the power of the single image, although the photographer may see and make a number of exposures during an excursion. It is a process analogous to the painter who pencil sketches before finally setting up an easel to paint the finished idea. The painter may make further adjustments in the studio, or indeed, do the majority of the creative work there, a parallel with the photographer's post-production workflow.

Photography is much more than just a job. Over the years it has been a form of therapy, a solace, a practice, a training – even a redemption. Photography has been the pathway in an ongoing voyage of self-discovery. Yet landscape itself, that elusive, cyclical, magical theme that underlies all life is inseparable to my focus. A fusion of the two, photography and landscape, is the best of all worlds.

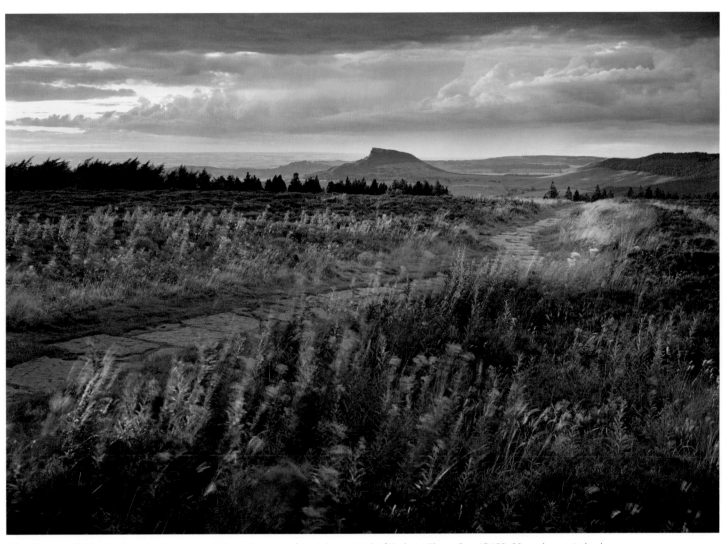

The Cleveland Way, North Yorkshire, within walking distance of Joe's home. Linhof Techno, Phase One IQ180, 90mm lens, stitched

PHOTOGRAPHIC INDEX

Cover **Derwent Water**
Hasselblad 503CW
Phase One IQ280
60mm

Half Title
Avebury beeches
Hasselblad 503CW
Phase One IQ280, 40mm

Title **Rackwick**
Ebony 45SU
Fuji Velvia
90mm

6–7 **Kilt Rock shore, Skye**
Sony A7r
75mm

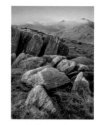

8 **Snowdon**
Linhof Techno
Phase One P45+
40mm

9 **Porth Nanven**
Linhof Techno
Phase One IQ280
50mm

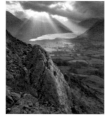

13 **Crummock Water**
Linhof Techno
Phase One P45+
40mm

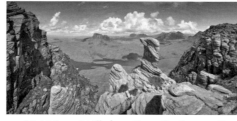

14–15 **Assynt Hills from Sgorr Tuath summit**
Linhof Techno, Phase One P45+
40mm
stitched panorama

17 **Lewissian gneiss,
Dalbeg**
Ebony 45SU
Fuji Velvia, 210mm

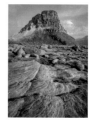

19 **Stac Pollaidh**
Sony A7r
22mm

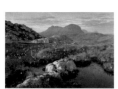

20 **Suilven**
Linhof Techno
Phase One P45+
50mm

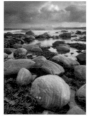

21 **Udrigle shore**
Linhof Techno
Phase One IQ180
50mm

23 **South Stack**
Sony A7r,
24mm

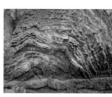

24 **Greenly's Succession**
Hasselblad 503CW
Phase One IQ280
100mm

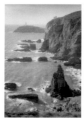

25 **South Stack**
Sony RX10

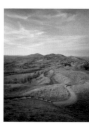

27 **Malvern Hills**
Sony A7r
22mm

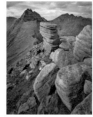

29 **An Teallach**
Ebony 45SU
Fuji Provia
90mm

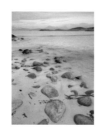

30 **Mellon Udrigle**
Hasselblad 503CW
Phase One IQ280
40mm

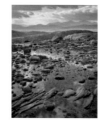

31 **Sgurr Mor**
Ebony 45SU
Fuji Velvia
150mm

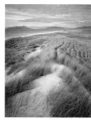

33 **Berneray**
Ebony 45SU
Fuji Velvia
90mm

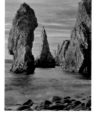

34 **Mangurstadh**
Ebony 45SU
Fuji Velvia
210mm

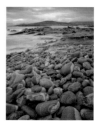

35 **Horgabost**
Ebony 45SU
Fuji Velvia
90mm

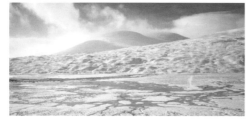

36–37 **River Truim, Drumochter**
Sony A7r
35mm

39 **Loch Clair**
Linhof Techno
Phase One IQ180, 150mm

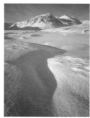

41 **Devil's Point**
Ebony 45SU
Fuji Velvia, 90mm

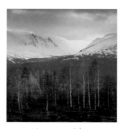

42 **Lairig Ghru**
Sony A7r
70mm

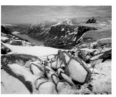

43 **Loch Avon**
Ebony 45SU
Fuji Provia, 90mm

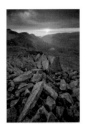
45 Mynydd Moel
Sony A7r
17mm

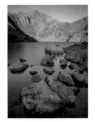
46 Craig Cau
Sony A7r
18mm

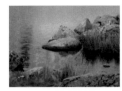
47 Llyn Cau reflections
Sony A7r
85mm

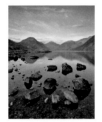
49 Wastwater
Ebony 45SU
Fuji Velvia
90mm

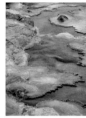
51 Llyn Bochlwyd
Linhof Techno
Phase One P45+
150mm

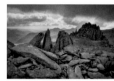
52 Castell y Gwent
Sony A7r
24mm

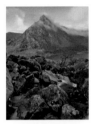
53 Tryfan
Hasselblad 503CW
Phase One IQ280
40mm

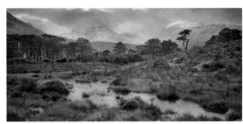
54–55 Beinn Eighe from Grudie Bridge
Nikon D800
50mm

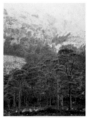
57 Beinn Eighe NNR
Hasselblad 503CW
Phase One IQ280
180mm

59 Beinn Eighe
Sony A7r
31mm

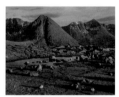
60 Sàil Mhór
Ebony 45SU
Fuji Velvia
300mm

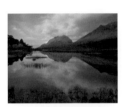
61 Loch Clair
Ebony 45SU
Fuji Velvia
90mm

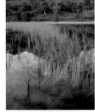
62 Loch Clair
Ebony 45SU
Fuji Velvia
150mm

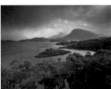
63 Loch Torridon
Hasselblad 503CW
Phase One IQ280
40mm

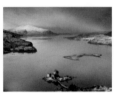
65 Eilean Donan
Linhof Techno
Phase One P45+
40mm

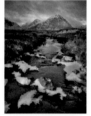
67 Buachaille Etive
Linhof Techno
Phase One P45+
40mm

68 River Etive
Ebony 45SU
Fuji Velvia
120mm

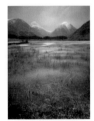
69 Lochan Urr
Linhof Techno
Phase One P45+
40mm

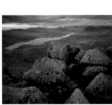
70 Ben Cruachan
Ebony 45SU
Fuji Velvia
90mm

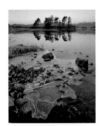
71 Loch Tulla
Ebony 45SU
Fuji Velvia
90mm

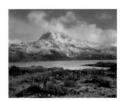
73 Slioch
Sony A7r
55mm

74 Loch Maree
Sony A7r
20mm

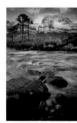
75 River Grudie
Sony A7r
35mm
tilting adapter

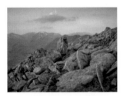
77 From Am Bodach
Hasselblad 503CW
Phase One P45+
40mm

78 Caledonian pine
Linhof Techno
Phase One P45+
70mm

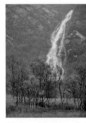
79 Steall Waterfall
Linhof Techno
Phase One P45+
150mm

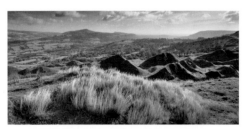
80–81 Sugar Loaf from Ysgyryd Fach
Linhof Techno Phase One P45+
40mm
stitched panorama

83 Bochlwyd
Linhof Techno
Phase One P45+
50mm

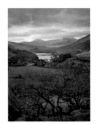

85 Plas y Brenin
Linhof Techno
Phase One P45+
70mm

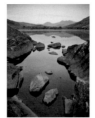

86 Llynnau Mymbyr
Hasselblad 503CW
Phase One IQ280
40mm

87 Watkin Path
Linhof Techno
Phase One IQ280
150mm

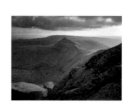

89 Cribyn
Linhof Techno
Phase One IQ180
40mm

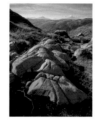

91 Below Gloywlyn
Sony RX10

92 The Rhinogs
Sony RX10

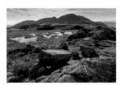

93 Carreg y Saeth
Sony A7r
24mm

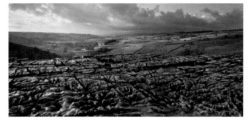

94–95 Limestone pavement, Malham Cove
Linhof Techno, Phase One IQ280
40mm
stitched panorama

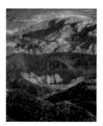

97 From King's How
Sony A7r
55mm

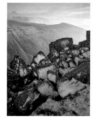

99 High Cup Nick
Hasselblad 503CW
Phase One IQ280
40mm

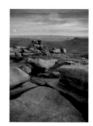

101 The Woolpacks
Sony A7r
24mm

102 Crowden Clough
Sony A7r
24mm

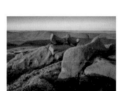

103 The Woolpacks
Sony A7r
29mm

105 Southerscales
Linhof Techno
Phase One IQ180
40mm

107 Back Forest
Sony A7r
55mm

108 Back Forest
Sony A7r
55mm

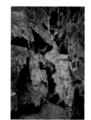

109 Lud's Church
Sony A7r
55mm

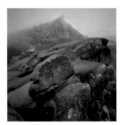

110 Ramshaw Rocks
Hasselblad 503CW
Phase One IQ280
40mm

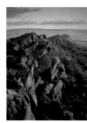

111 The Roaches
Hasselblad 503CW
Phase One IQ280
40mm

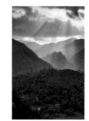

113 Borrowdale
Nikon D800
100mm

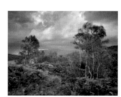

114 Shepherd's Crag
Linhof Techno
Phase One IQ280
40mm

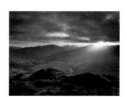

115 Borrowdale
Hasselblad 503CW
Phase One IQ280
40mm

116 Below Castle Crag
Nikon D800
86mm

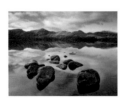

117 Derwent Water
Hassselblad 503CW
Phase One IQ280
40mm

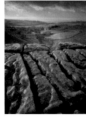

119 Malham Cove
Linhof Techno
Phase One P45+
40mm

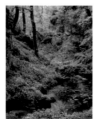

120 Below Janet's Foss
Ebony 45SU
Fuji Velvia
210mm

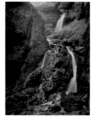

121 Gordale Scar
Linhof Techno
Phase One P45+
40mm

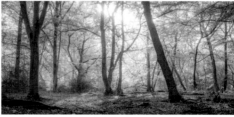

122–123 Burnham Beeches
Sony A7r
35mm
Tilt/shift adapter

125 Kingley Vale
Sony A7r
35mm

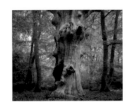

127 Burnham beech
Sony A7r
35mm

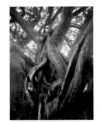

129 Kingley Bottom
Hasselblad 503CW
Phase One IQ280
40mm

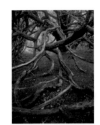

130 Kingley Bottom
Hasselblad 503CW
Phase One IQ280
40mm

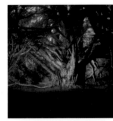

131 Kingley Bottom
Hasselblad 503CW
Phase One IQ280
40mm

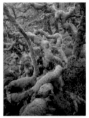

133 Wistman's Wood
Hasselblad 503CW
Phase One IQ280
40mm

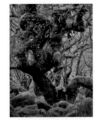

134 Wistman's Wood
Hasselblad 503CW
Phase One IQ280
120mm

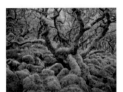

135 Wistman's Wood
Hasselblad 503CW
Phase One IQ280
60mm

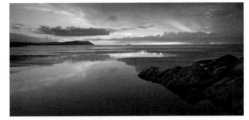

136–137 Stepper Point from Polzeath
Horseman SW612
Fuji Velvia
65mm

139 Sandymouth
Sony A7r
55mm

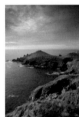

141 The Rumps
Ebony 45SU
Fuji Velvia
58mm

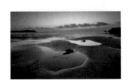

142 Polzeath
Horseman SW612
Fuji Velvia
45mm

143 Greenaway
Panasonic LX3

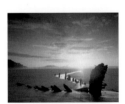

145 Rhossili Bay
Ebony 45SU
Fuji Velvia
90mm

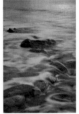

147 Jurassic Coast
Sony A7r
35mm
Tilt/shift adapter

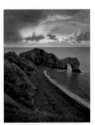

148 Durdle Door
Hasselblad 503CW
Phase One IQ280
40mm

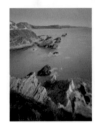

149 Mupe Bay
Hasselblad 503CW
Phase One IQ280
40mm

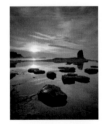

151 Saltwick Nab
Hasselblad 503CW
Phase One IQ280
40mm

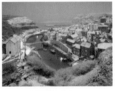

152 Staithes
Linhof Techno
Phase One P45+
40mm

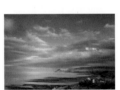

153 Robin Hood's Bay
Nikon D800
24mm

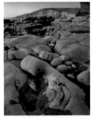

155 Dunraven Bay
Ebony 45SU
Fuji Velvia
90mm

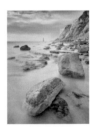

157 Beachy head
Linhof Techno
Phase One P45+
40mm

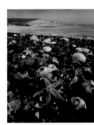

158 Seven Sisters
Ebony 45SU
Fuji Velvia
90mm

159 Barnacles
Ricoh Caplio GX100

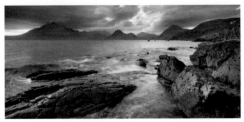

160–161 Black Cuillin and Loch Scavaig
Linhof Techno
Phase One P45+
40mm

163 Arran geology
Ebony 45SU
Fuji Velvia
210mm

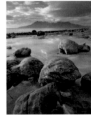

165 Bay of Laig
Ebony 45SU
Fuji Velvia
90mm

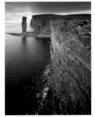

167 Old Man of Hoy
Ebony 45SU
Fuji Velvia
72mm

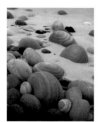

168 Rackwick Bay
Ebony 45SU
Fuji Velvia
240mm

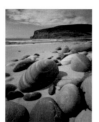

169 Rackwick Bay
Ebony 45SU
Fuji Velvia
90mm

171 Iona
Ebony 45SU
Fuji Velvia
90mm

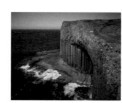

172 Staffa
Ebony 45SU
Fuji Velvia
90mm

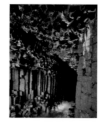

173 Fingal's Cave
Ebony 45SU
Fuji Velvia
72mm

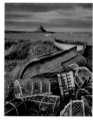

175 Lindisfarne
Ebony 45SU
Fuji Velvia
150mm

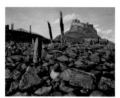

176 Lindisfarne Castle
Ebony 45SU
Fuji Velvia

177 The Causeway
Hasselblad 503CW
Phase One IQ280
40mm

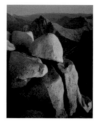

179 Cir Mhor
Ebony 45SU
Fuji Velvia
90mm

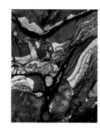

180 Arran geology
Ebony 45SU
Fuji Velvia
120mm

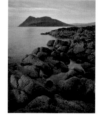

181 Holy Island
Ebony 45SU
Fuji Velvia
110mm

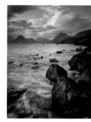

183 The Cuillin
Linhof Techno
Phase One P45+
40mm

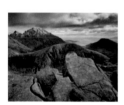

184 Bla Bheinn
Ebony 45SU
Fuji Velvia
90mm

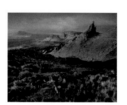

185 Quiraing
Ebony 45SU
Fuji Velvia
90mm

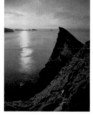

187 Hermaness
Ebony 45SU
Fuji Velvia
90mm

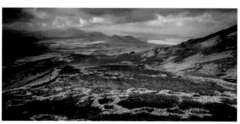

188–189 Tre'r Ceiri, Yr Eifl
Sony A7r
36mm

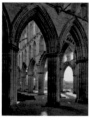

191 Rievaulx
Ebony 45SU
Fuji Velvia
110mm

193 Avebury
Hasselblad 503CW
Phase One IQ280
120mm

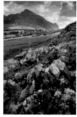

195 Yr Eifl
Sony A7r
35mm
Tilt/shift adapter

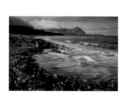

196 Yr Eifl
Sony A7r
28mm
Tilt/shift adapter

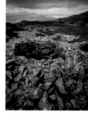

197 Tre'r Ceiri
Sony A7r
24mm

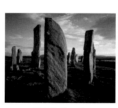

199 Calanais
Ebony 45SU
Fuji Velvia
90mm

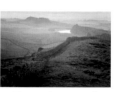

201 Hadrian's Wall
Fuji S5Pro
70mm

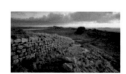

202 Hadrian's Wall
Linhof Techno
Phase One IQ180
40mm stitched panorama

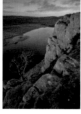

203 Crag Lough
Fuji S5Pro
12mm

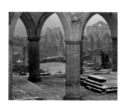

205 Rievaulx
Ebony 45SU
Fuji Velvia
210mm

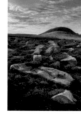

206 Easterside
Sony A7r
32mm

207 Rievaulx
Ebony 45SU
Fuji Velvia
210mm

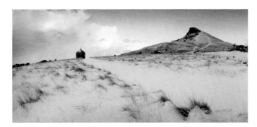

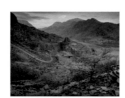
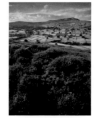
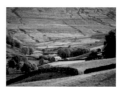

208–209 Roseberry Topping and the Summer House
Linhof Techno, Phase One P45+
40mm

211 Dinorwig
Hasselblad 503CW
Phase One IQ280
120mm

213 Dinorwig
Hasselblad 503CW
Phase One IQ280
40mm

215 Healaugh
Linhof Techno
Phase One IQ180
40mm

216 Angram
Hasselblad 503CW
Phase One P45+
150mm

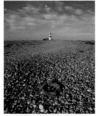

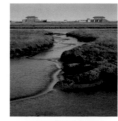
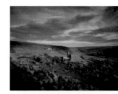
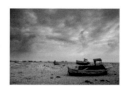

217 Oxnop Beck
Fuji X-E1
20mm

219 Orford Ness
Hasselblad 500CM
Fuji Velvia
50mm

220 River Alde
Hasselblad 500CM
Fuji Velvia
50mm

221 Orford Ness
Hasselblad 500CM
Fuji Velvia
100mm

223 Rosedale
Hasselblad 503CW
Phase One IQ280
40mm

225 Dungeness
Nikon D800
24mm

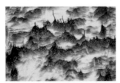
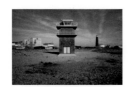
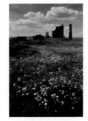

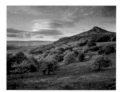

226 Dungeness
Nikon D800
100mm
(image inverted)

227 Dungeness
Fuji X-E1
18mm

229 Magpie Mine
Sony A7r
35mm
Tilt/shift adapter

231 Roseberry Topping
Linhof Techno
Phase One P45+
40mm

232 Roseberry, winter
Phase One DF
Phase One IQ180
45mm

233 Roseberry, spring
Linhof Techno
Phase One P45+
40mm

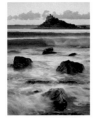
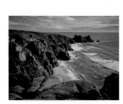
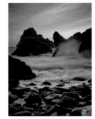
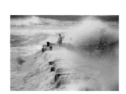

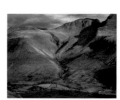

235 St Michael's Mount
Linhof Techno
Phase One P45+
70mm

236 Logan Rock
Linhof Techno
Phase One P45+
40mm

237 Kynance Cove
Linhof Techno
Phase One IQ180
90mm

238 Sennen
Fuji X-E1
128mm

239 Porth Nanven
Linhof Techno
Phase One IQ180
90mm

241 Scafell Pike
Linhof Techno
Phase One P45+
150mm

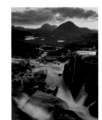
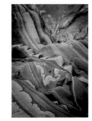
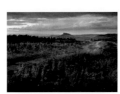
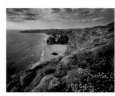

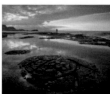

243 Flowerdale
Ebony 45SU
Fuji Velvia
90mm

245 Bude
Sony A7r
35mm
Tilt/shift adapter

247 Cleveland Way
Linhof Techno
Phase One IQ180
90mm stitched

255 Bedruthan Steps
Linhof Techno
Phase One IQ180
50mm stitched

256 Assynt
Ebony 45SU
Fuji Velvia
120mm

Back cover
Saltwick Bay
Hasselblad 503CW
Phase One IQ280, 40mm

ACKNOWLEDGEMENTS: ROLY SMITH

First and foremost, my greatest debt of gratitude is to my loving wife Val and our three children, Claire, Neil and Iain, who allowed me to pursue my dreams often at the expense of my familial duties. Then to my teachers at Hedingham County Secondary Modern School – particularly Fred Pawsey, Harry Theedom, David Thomas and Harry Witton – who encouraged me to follow those dreams, and to Stuart Pountney, whose school youth hostelling trips first introduced me to the hills.

Starting with John Beckwith, Nick Boreham and John Reynolds, my hillwalking companions over the years have been many, and sadly some have since passed on. But I'd particularly like to record my appreciation of Alan Clegg, Peter Beal, Mike Williams, John Cleare, Tom Waghorn and Mark Richards and Ken Drabble, for their cheerful companionship.

For the inspiration given me in their lives and their writing, I will be forever indebted to Kenneth Grahame, John Muir, Tom Stephenson, Benny Rothman, Edward Abbey, Kenneth Allsop, John Hillaby, Richard Mabey, and Jim Perrin.

Our good family friend Ann Hales of Boroughbridge provided warm hospitality and accommodation during the production of this book; Joni Essex was its imaginative and talented designer and Michael Brunström was my sensitive editor at Frances Lincoln.

Finally and most importantly to Joe, to my mind the greatest exponent of landscape photography in Britain today, and an enthusiastic partner in our joint vision for this book.

ACKNOWLEDGEMENTS: JOE CORNISH

The practice of a hill-walking photographer can be solitary. Yet reflecting on these images I frequently had company . . . my friends, family and sometimes workshop groups. Of the former I would especially like to thank Ken Jaquiery and Nicky Kime with whom I have walked and camped in some of the remotest places in Scotland; Kyriakos Kalorkoti, Andrew 'Miff' Smith, Tim Race, Glenn Bennington, John and Rosamund Macfarlane, Jon Brock, David Tolcher, Phil Malpas, Clive Minnit, Roger Soep, Richard Childs, Ted Leeming, Paul Harris, Andy Rouse, Gill Hood, Jay Swent, Richard Holroyd and Sam Cornish. The advice, inspiration and encouragement of Andrew Nadolski, Kane Cunningham, Paul Wakefield, Les MacLean, Alan Sleator, Colin Prior and Alan Hinkes has also been invaluable on the hill, and with the camera, computer and printer.

Leading workshops is a significant part of my life and I am especially indebted to David Ward and Eddie Ephraums, whose loyalty and friendship means so much. In relation to workshops and tours I also want to express thanks and appreciation to Adrian Hollister, Mark Banks, Charlie Waite, Antony Spencer, Steve Gosling, Anna Booth, Dave Mead, Kevin Raber, Mark Carwardine, Rachel Ashton, Roz Kidman-Cox, Warwick Lister-Kaye and Roger Longdin.

Tim Parkin has been an incomparable source of knowledge and ideas, both technical and aesthetic. Chris Lacey of the National Trust, and Jasmine Teer of VisitBritain have

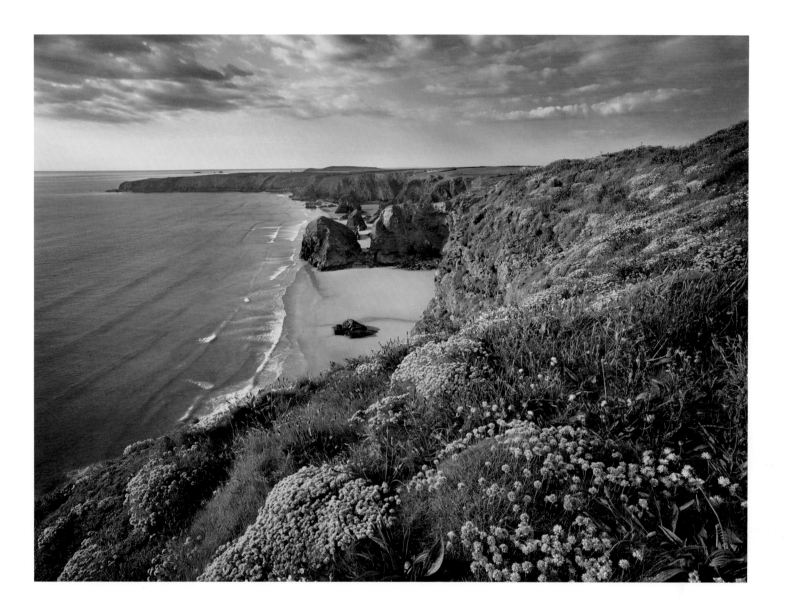

been inspiring clients whose commissions permit me to continue exploring the wonders of Britain.

In the photographic industry I have had huge support and enthusiasm from numerous individuals over the years. I would especially like to thank Graham Merritt, Eddie Ruffel, Ralph Young and Peter Sturt from Lee Filters. Also, thanks to Neil Mackenzie from Epson; Vince Cater and Toby Herlinger from Fotospeed; Paula Pell-Johnson from Linhof Studio; Chris Ireland from Phase One; Helen and Michael Howard, and Catherine Whitehead from Paramo; Rob Cook; Fred Lange from Sony; Neil McIlwraith of Beyond Words.

There would be no *This Land* if Roly Smith had not proposed the concept to me; I am hugely grateful for the challenges and joy the project has brought and only hope I have not let him down. Joni Essex has delivered a brilliant design, as well as managing the gallery that bears my name in Northallerton, all at an age when most people have put their feet up and retired. Thanks too to my colleagues at the gallery, all of whom have been wonderful co-workers. I am grateful to Andrew Dunn at Frances Lincoln for commissioning the book.

My work is only possible with the endless support of my beloved Jenny and our two (now adult) children Chloe and Sam, whose curiosity, integrity and courage is a constant source of inspiration.

Frances Lincoln Limited
74–77 White Lion Street
London N1 9PF
www.franceslincoln.com

This Land

British Library Cataloguing-in-Publication data
A catalogue record for this book is
available from the British Library

ISBN 978 0 7112 3504 5

Printed and bound in China

2 4 6 8 9 7 5 3 1